The Woman behind the Lens

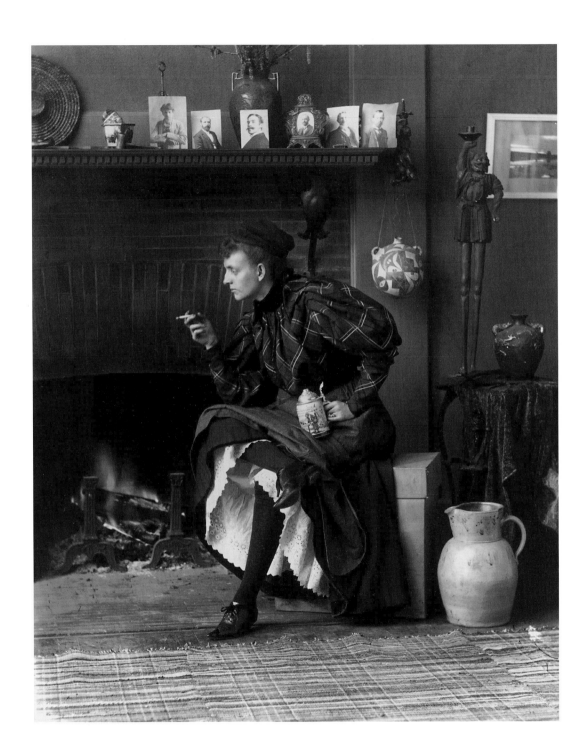

The Woman behind the Lens

The Life and Work *of*
Frances Benjamin Johnston, 1864–1952

Bettina Berch

THE UNIVERSITY PRESS OF VIRGINIA • *Charlottesville and London*

The University Press of Virginia

© 2000 by the Rector and Visitors of the University of Virginia

All rights reserved

Printed in the United States of America

First published in 2000

Frontispiece photo: Self-portrait, c. 1896.

♾ The paper used in this publication meets the minimum requirements
of the American National Standard for Information Sciences—Permanence of Paper
for Printed Library Materials, ANSI Z39.48-1984.

Library of Congress Cataloging-in-Publication Data

Berch, Bettina.
 The woman behind the lens: the life and work of Frances Benjamin Johnston,
1864–1952 / Bettina Berch.
 p. cm.
 Includes bibliographical references and index.
 ISBN 0-8139-1938-X (alk. paper) — ISBN 0-8139-2009-4 (pbk. : alk. paper)
 1. Johnston, Frances Benjamin, 1864–1952. 2. Women photographers—
United States—Biography. 3. Photographers—United States—Biography. I. Title.

TR140.J64 B47 2000
770'.92—dc21
[B] 00-022173

In honor of my father,

Julian Berch (1916–2000),

who lovingly supported all my work,

I dedicate this work to my daughter,

> *Seferina Berch.*

> *Such a person!*

Contents

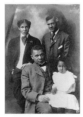

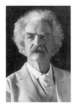

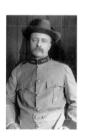
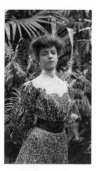
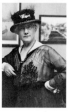

Illustrations

Acknowledgments

The following people have helped me with this work in various ways: Julia Ballerini, Hannah Borgeson, Julie K. Brown, Carla Cappetti, Janet Mullaney, Daniel Pool, Terri Rochon, Ellen Satrom, Sarah Schulman. Thanks are also owed to the very professional staffs of the microfilm section of the New York Public Library, the Prints and Photographs and Manuscripts Divisions of the Library of Congress, the Smithsonian Institution Archives, and the Avery Library at Columbia University; and to Virginia Dodier and her staff at the Museum of Modern Art. Unless otherwise specified, all photographs in this book appear courtesy of the Frances Benjamin Johnston Collection, Prints and Photographs Division, Library of Congress.

I also must thank the Berch clan: my parents, Mollie and Julian Berch, plus my siblings, Mark, Paul, and Margo and all their spouses and offspring, especially Ezra Berch. My New York near-family, Quandra Prettyman and Johanna Stadler, have helped me in countless ways, both logistical and inspirational. Quandra deserves special thanks for her editorial assistance. Let me also thank here my wonderfully reliable friend and agent, Malaga Baldi. Finally, I am grateful to my most perspicacious critic and friend Elena Davis.

Thanks to you all, this book was written.

The Woman behind the Lens

Introduction

TRY TO PICTURE MARK TWAIN, OR UNCLE REMUS, or even Theodore Roosevelt. More than likely, you have a Frances Benjamin Johnston image in your mind's eye. Students of African American history can reexamine life at Hampton or Tuskegee using the hundreds of photographs made by Frances Benjamin Johnston at the turn of the twentieth century. Students of women's history might see those famous Lynn shoe-factory workers proudly standing by their tools.

Thanks to Johnston we can visit a U.S. mint before mechanization and watch workers coining money by hand. We can see Admiral Dewey on the deck of the USS *Olympia,* young cadets training at West Point, and the Roosevelt children playing with their pet pony at the White House. Because of Johnston's work we can also enjoy the gardens of Edith Wharton's villa near Paris or the castles of the French countryside. Those interested in historic preservation can study the early architecture of the American South from her surveys, which contain images of scores of buildings no longer preserved except by her film. American estates, Du Pont and otherwise, have been forever frozen in their 1920s elegance by one woman's camera.

We know Johnston's photographs in many ways, even if we know very little about the person who made them. Why did she choose these subjects? What did she bring to the frame? How did her aesthetics, her life experiences, her very particular consciousness shape her vision?

Our approach here, as these questions suggest, is biographical: We shall examine Johnston's work in the context of the development of her life and her own particular aesthetic concerns. This biography uses a different point of view and methodology than postmodernist studies, which tend to focus on the reader or the viewer and not on the actual author or creator of the work. With Johnston, to consider her work, her thousands of photographs, without the context of her unfolding life story is to be left with an inchoate chimera, part feminist and part reactionary, part radical and part retro.[1] Against the backdrop of her family roots, training, and work experiences, however, Johnston's photographic output takes on a more coherent shape and direction. By studying her life, we can begin to understand how this varied body of work—from celebrities to slave quarters—came to be made. Here we have the story of a career that developed over many decades, a very full life's journey.

Johnston entered her first photographic darkroom in the mid-1880s, when the craft itself was relatively new.[2] The earliest photograph in existence today was made by Joseph Niépce in 1826. William Henry Fox Talbot produced paper negatives in 1835, but it was Louis Daguerre, in 1839, who gave the world its first commercially viable technique for "drawing with the aid of the sun." Producing those first daguerreotypes required a huge amount of equipment and patience, and each impression was unique and nonreproducible. As experimentation continued, a variety of techniques were developed based on coating paper with sensitive chemicals and exposing it to light. All these paper- or metal-based processes were marginalized in 1851, when the wet-plate collodion process revolutionized photography. Using this method, the photographer coated a glass plate with the sticky collodion material, gave it a silver nitrate bath, exposed it in the camera, and then processed the plate before it dried. The chemical coating was not terribly light-sensitive, so the exposures were several seconds long. Even with these refinements, however, the process was far from easy: The glass plates were heavy and easily broken, and the working photographer had to bring along a full darkroom in order to process the plates before they dried. Gelatin-coated dry plates, developed in 1871, were easier to work with, although they were still glass.

The popular revolution in photography came in 1888, with George Eastman's No. 1 Kodak camera, which was lightweight and portable and came complete with preloaded (paper) film on a roll, enabling photogra-

phy to move out of the studio and into the streets, the workplace, or the home. This lighter and cheaper technology opened the field to amateurs, who in the late nineteenth century were as dedicated as bicycling enthusiasts. The two hobbies were even thought quite complementary.

Photography was not the only field affected by rapid technological change in this time period; many different types of equipment were being made cheaper and lighter. Such changes were often accompanied by the replacing of male labor by female labor as well. Even fields like medicine with little real technological change seized the opportunity to rewrite their gender rules, but photography was still an emerging profession in the 1880s, when Johnston started work, and thus did not carry any clear gender label. The issue was open: Would the photography profession accept women wholeheartedly? Could it be an ideal field for women, as Johnston described it so persuasively in her *Ladies Home Journal* articles? Or might rumors of complex technology and harsh chemicals be used to drive women away? The influential social critic Henry Adams, for one, was said to have opposed women doing photography, because his wife had committed suicide in 1885 by swallowing the cyanide in her darkroom.[3] Beyond the chemical hazards, might the sensuality of the study of the human body or the attendant suggestion of voyeurism keep photography—like other fine arts—a male preserve?

To understand the gender issue as it applied to photography in the late nineteenth century, the larger question of women's roles in this era must be considered. As liberated as some may argue the Victorians to have been, late nineteenth-century women were surrounded, then as now, by a host of prescriptions governing proper female behavior.[4] These varied by class and culture and race, and while followed by most, they were challenged by many. The forms of challenge ranged from financial independence to sexual heterodoxy to political outspokenness.

Without labeling the Victorian era as positive or negative for women's liberties, we still must evaluate Johnston's particular choices of profession and lifestyle in terms of the cultural norms for her class and gender.[5] Specifically, when Johnston decided in the 1880s to become a professional photographer, was this considered a suitable choice for a well-brought-up young woman of the upper middle class?

Many in her social circles spent their late teens and early twenties going to cotillions, calling on family friends for their "at homes," and making other forays into the marriage market. If a young woman had "mod-

ern" stirrings, the model of choice was often Howard Chandler Christy's "American Girl."[6] Mainly a leisure ornament, the Christy girl was usually depicted going shopping or watching some sporting event. Rarely did she roll up her muttonchop sleeves to go out to earn a living.

With this in mind, the differences between Johnston and many of her contemporaries become more pronounced. Johnston never focused herself on the marriage market and never regarded leisure as an activity. She was quite determined to make her own living as an artist, even though she could have married money and freed herself from such concerns. Taking responsibility for one's life was the fundamental axiom of Johnston's personal philosophy. A more radical proposition in many ways than the more explicitly feminist platforms of her day, her freedom was defined in terms of individual, not collective, activity.

To define gender equality in economic terms was not an easy position for a woman artist to take in the late 1880s. The art world still prohibited women from studying in art classes using nude models and barred women's admission to certain arts academies altogether. Then as now, a certain financial cushion was necessary for the professional artist. Johnston supported herself by her work, but she made her first studio in her parent's large townhouse. Her first clients were well-connected Washingtonians who also happened to be family friends. So economic independence is a relative concept, but it was how Johnston defined being liberated and was a standard she held all her friends to, male or female.

Whether the choice of any career in the arts would have been considered appropriate for young Johnston raises the question of the role of women in the avant-garde subcultures of the late nineteenth century. The bohemian men are well known, but were not women there, too, all along? We have celebrated the suffragists, rediscovered the strong women of the political Left . . . but the women artists? Those who come to mind—Rosa Bonheur, Cecilia Beaux, Mary Cassatt—were all very proper indeed, neither making self-portraits with their skirts hiked up to midthigh nor portraying frankly nude subjects, male or female. And yet rebellious women did exist. They had their salons in Paris, their coffeehouses in Greenwich Village, and, yes, their studios like Johnston's in Washington, D.C., and New York. The story of these scenes is interesting in itself, but it also helps us to understand how Johnston came to be the artist she was.

Apart from the historical context of her life story, the actual path of Johnston's career interests is fascinating. Many photographers, such as

Gertrude Kasebier or Jessie Tarbox Beals, picked a single theme or genre and explored it for the rest of their careers. Johnston moved through a series of interests, from celebrity portraiture to documentary work, to estates and gardens, to architectural preservation. What is the meaning of these transitions? And what of the self-portraits Johnston made throughout her career? How did she present herself to her camera? To the viewer?

In the end, one would also like to evaluate the impact of this artist on her field. Did Johnston change the course of photography in any way? What other photographers or artists found themselves working in her manner? What does Johnston have to offer to students of photography today?

These are all good questions, but none of them compelling. So let us pose the question differently:

How did such an idiosyncratic, unconventional, creative woman come to flower in an era famous for its repressiveness in general, and for its repression of women in particular? What gave Frances Benjamin Johnston the nerve to make the choices she made . . . and why was she so successful? Here, finally, we have the question that made me decide to write this book. I hope I have found at least a few answers.

I

The Birth
of a Bohemian:
1864–1885

ALTHOUGH BIOGRAPHIES OFTEN OPEN WITH AN ACCOUNT of the subject's various ancestors, in the case of Frances Benjamin Johnston it is a natural place to start, as she was preoccupied with tracing her ancestry. She saved newspaper clippings about conjectural relatives, commissioned elaborate versions of the family tree, and did extensive genealogical research to establish her D.A.R. (Daughters of the American Revolution) credentials. She photographed her family together in her studio, as seen in figure 1. Late in life, Johnston even tried to retrace the journey of her great-great-grandfather and his "Traveling Church" across Virginia and into Kentucky, which she hoped might form the basis of a book on those eighteenth-century backwoods Baptists.

What was she trying to prove? Not her "racial purity," certainly, since she made great efforts to include Pocahontas on her family tree.[1] Nor did she use her research to troll for better social connections. Her interest in her forebears seemed to be rooted in a desire to see herself in some greater historical context. And since it is the rare genealogist who gives equal attention to all the branches on the tree, it is the picking and choosing of various ancestors to highlight that can be revealing.

Frances Benjamin Johnston's mother was Frances Antoinette Benjamin of Rochester, New York, born January 24, 1837.[2] Frances Benjamin's Revolutionary-era roots were traced to her great-great-granduncle, Cap-

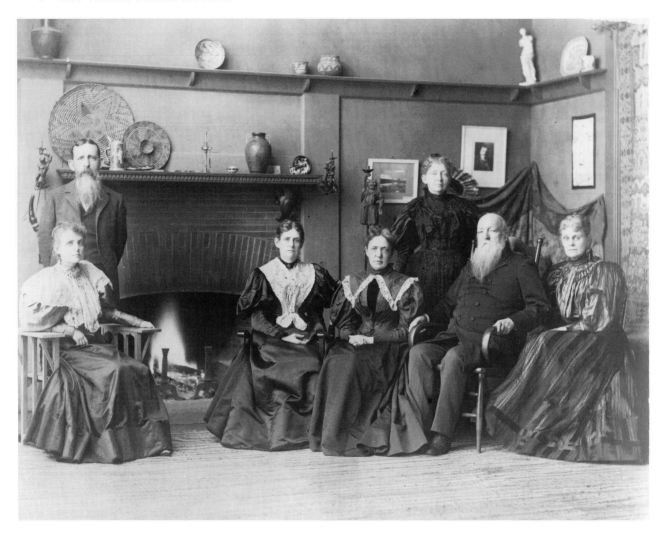

FIGURE 1

Johnston's family in her studio, 1896. From left to right: Anderson Doniphon Johnston (standing); Frances Benjamin Johnston; Frances Antoinette Benjamin Johnston; Aunt Sarah, wife of Judge Johnston; Aunt Elizabeth Bryant Johnston (standing); Judge Sanders Johnston, her father's brother; Cornelia Hagan, or "Aunt Nin," her mother's sister.

tain John Clark, who was born in Framingham, Massachusetts, in 1730. A captain in the revolutionary militia, he served as a delegate to the First Provincial Congress of Massachusetts. A handful of other related Clarks also served in the American Revolution. Reverend Jonas Clark and family of Lexington, Massachusetts, offered hospitality to various Revolutionary leaders, such as Hancock and Adams, and cared for the war wounded.

Joanette Clark (born 1815) was the mother of Frances Antoinette Benjamin. In 1833, Joanette married Zina Hitchcock Benjamin (born 1807), and they had three children: Samuel Clark Benjamin (born 1834), Frances Antoinette (born 1837), and Cornelia J. Benjamin (born 1839). This side of the family appears to have been very patriotic, but that finding may have been colored by Frances Benjamin Johnston's citing the Clark great-

granduncles to substantiate her claim to D.A.R. status. Still, the Johnstons—her father's side of the family—present a very different picture.

The Johnston family can be traced back to a Scotsman, the Reverend James Johnstone (born 1749), who came to the Americas to fight for the British in the French and Indian War. After Major General John Burgoyne's surrender at Saratoga, Johnstone remained in the colonies, moving to Virginia. In 1781 he married Margaret Keith, said to be "fifth in descent" from "Queen" Pocahontas.[3] Soon after, Johnstone entered the Baptist Church and became one of its leading preachers. His preaching took him through Virginia to Kentucky, where he and Margaret finally settled. Their oldest son was Dr. William Bryant Johnston (he dropped the final *e*, although his granddaughter—Frances Benjamin Johnston—used the *e* through her teenage years), who married Asenath Craig, the eldest child of John Craig, son of the Reverend Lewis Craig.

Reverend Craig, William Johnston's father's maternal grandfather, was a major figure in Virginia Baptist history and is the subject of a few scholarly monographs as well as the inspiration for one popular novel. Born in 1740 in Orange County, Virginia, Craig founded Craig's Church in Spottsylvania County, Virginia. From his willingness to go to jail rather than pay for a license to preach, Elder Craig soon had a reputation as a militant in the struggle for religious freedom. In September 1781, Craig led a pilgrimage of his flock, known as the "Traveling Church," from Virginia through the Blue Ridge Mountains and the Cumberland Gap into Kentucky, which they considered their Promised Land. Over the next three decades, Craig helped establish Baptist churches in Kentucky, where he died in 1825. Both the Craigs and the Johnstones lived in Mason County, Kentucky, and both came from preaching, Baptist families.

How their descendant, Anderson Doniphon Johnston (born 1828), managed to meet and marry Frances Antoinette Benjamin of Rochester, New York, is unclear. In his portraits, Anderson Doniphon Johnston appears to have been a quiet, bearded man with sensitive eyes, given to plain, vested suits with no jewelry or other foppery.[4] The two married on January 24, 1860, in Rochester, and their first child, Katharine Joanette Johnston, was born on July 17, 1861. This baby died before her second birthday, on April 15, 1863. Frances Benjamin Johnston was born next, on January 15, 1864, and was followed three years later by Joanette Clark Johnston, who died less than a year later. A son was born on July 17, 1869, but died, nameless, the same day. Thus Frances Benjamin Johnston was, as

she wrote in her family account, the "only surviving child" of her mother's four childbirths.

It is unclear when Johnston's family arrived in Washington, D.C., from Rochester; most accounts simply say "before 1875." Her father had been appointed head bookkeeper for the Treasury Department, which may have occasioned the move. The family bought a townhouse at 1332 V Street in downtown Washington from the naturalist John Burroughs, who had designed its rose gardens.

Frances had her early education at home, although by the time she was fifteen she was taking classes in Washington with a group of eight other young ladies. "Poetic" essays were either a standard assignment or a particular passion of young Fannie, as she called herself then; we can still read her "Snow in Abyssinia" or fragments of her "Dolls."

A single passage in one of her notebooks gives us a glimpse of her teenage self: "Mama and Papa and Aunt Nin and Aunt Nettie went to Mrs. Ransome's reception so we were left alone. Winnie and I went over and got Maggie and Rosie and Will Hibbs to come over to spend the evening and we made lemonade and Winnie spoke all of her horrid old recitations and disgusted Will and I am afraid he won't ever come over again while she is here."[5]

In her various accounts of her life, Johnston characterized her upbringing as ambitious and stimulating. "Fortunately," she noted, "I had spent my girlhood in a family circle which bounded the very best of the social, literary and artistic life of the National Capital." Growing up in Washington, she continued, taught her self-reliance, never to make "any appeal that savored of the clinging vine," but to go for results by starting at the top.[6]

It is interesting to note that, with all the religious leaders among her father's ancestors, there is hardly a mention of religion in Frances's own upbringing. Her late-life interest in the Reverend Craig and his flock came more from a sense that he was a rabble-rousing independent than from any curiosity about his theology.

At eighteen, Frances was enrolled as a "collegiate A" student in the Notre Dame Academy of Govanston, Maryland, near Baltimore. The next year, 1883, her class was designated "senior class-graduating department," so this may have been a two-year program. Although the Notre Dame Academy was a convent school, there is no indication from Johnston's exam books that students in the collegiate class took courses in religion.

Indeed, their course of study was remarkably worldly. Johnston was examined on a wide range of subjects, including double-entry bookkeeping, ancient history, rhetoric, and botany. Students were expected to have essay-writing fluency in one foreign language and working knowledge of an additional language. There were courses in astronomy, geography, chemistry, and what was called "mental philosophy." In an era often dismissed as intellectually restrictive for women, it was a surprisingly varied education.[7]

That Frances was educated at all, much less so thoroughly, was due to the influence of her mother. A "lady correspondent" for the *Baltimore Sun* in the 1870s, Frances Antoinette Johnston was one of the leading political journalists of her day. Her reportage was also featured as the "Washington Letter" in the *Rochester Democrat and Chronicle*. She specialized in chatty but pointed coverage of congressional activities, plus any tidbits of Washington inside information that she could broadcast.

A feminist in her own way, Mrs. Johnston refused to toe anyone's party line. In her November 23, 1877, piece in the *Democrat and Chronicle,* for example, she defended female civil service workers against the snideness of some "lady writers" and the outright opposition of displaced male workers.[8] But her articles covering the sometimes sensational antics of various suffragists took a noticeably ironic, distanced tone. A believer in equal rights for all, Mrs. Johnston nevertheless had a great distaste for flagrant behavior.

In her own life, Mrs. Johnston acted as if equal rights for women were already a fait accompli. She was a professional journalist, after all, not marginalized to the society pages, but writing about the powerful—about men. She had access to virtually anyone in official Washington she wanted to see. Politics was always the focus of Washington, D.C., life, and Mrs. Johnston was at the center of the nation's political whirl.

Frances knew her mother's work very well and admired it. During the 1870s and 1880s, she prepared a series of albums of her mother's work, laboriously cutting out and pasting into scrapbooks the hundreds of articles she had saved. Either she or Mrs. Johnston had gone through each piece, painstakingly correcting all the typographical errors and dropped phrases and then highlighting particularly favored passages.

Frances's father, with his desk job at the Treasury Department, was certainly no embarrassment, but his career was rather colorless compared to his wife's. A few photos show him on vacation with the family by the

New Jersey shore, but his wife, daughter, and sister-in-law, Cornelia Hagan, went to Europe by themselves, sending long letters back to "poor Papa" at home working.

Between her mother and the ever-present "Aunt Nin," as Cornelia was known, Frances was raised in a fairly gynocentric milieu. Her father was distant and mild, and there were no brothers or dominant-male-type relatives to dilute this woman-centered atmosphere.

Mr. and Mrs. Johnston were affluent enough to offer their only child various luxuries. They paid to enroll Frances for at least two years in a boarding school, after which she was treated to a couple of years in Paris— but not for the conventional shopping or sightseeing. Frances had chosen to train herself to be an artist.

In Paris she enrolled in the leading arts institution for the non-French, the Académie Julian. The Académie was founded in 1868 as a decidedly modern school. Unhampered by the elitism and xenophobia of the hegemonic École des Beaux-Arts, it enrolled students from all countries. More important, especially for female artists-in-training, students at the Académie Julian learned to draw or paint using live, sometimes nude human models. Over the years, the Julian program became more structured, with assigned teachers and courses, but its ambiance was never as rigid as that of the École des Beaux-Arts. And since the Beaux-Arts did not accept women students at the time, the Académie Julian was undoubtedly the preeminent art school for women in Paris.

The Académie opened to women in 1873, after a woman was discovered to be posing as a man to get into the exclusive Gobelins tapestry school, proving that women really did want professional training. Mixed male and female classes were the rule at Julian until 1877, when a separate women's studio was set up on rue Vivienne. Many women studied art at Julian during Johnston's years there, although some of the more famous, like Cecilia Beaux, arrived shortly after she left. Women's fees were more than double the men's, and apparently ability to pay was the main criterion for admission for men and women alike. By admitting women, foreigners, and anyone else who could afford tuition, Julian was able to expand successfully. Such a nonrestrictive admissions policy also added to the general camaraderie of the student body, which was known for its lively social life.[9]

Johnston attended the Académie Julian from 1883 to 1885, a period when Monet was at Giverny and many art students—the Americans

Twachtman, Henri, Metcalf, and Tarbell, among others—were feeling the pull of impressionism.[10] Apparently Johnston was not one of them; the traditionalism of the dominant Julian style was fine with her.

From Cecilia Beaux's description of life at the Académie Julian, its lively bustle is remarkable. By her account the studios at Julian were so jammed with students that each easel had a chalk-drawn boundary to keep it from encroaching on a neighbor's space. Never a word of art theory or history was to be heard from the teachers; the Julian was to be a studio experience exclusively. Every week a new subject or theme was announced, and students could enter their rendition of it in a general competition. There were monetary prizes, but the highest honor for a student was to have one's work exhibited on the studio walls.[11]

Although Johnston never wrote much about her student days at the Académie Julian, she did learn the basic drawing and composition skills that she used in her illustration work when she returned to the United States: She gained an appreciation for symmetry and the conventions of perspective and learned to notice gesture, geometric forms, and other symbolic elements.

Johnston was fond of mentioning her "formal French training" as if it were something much more structured or theoretical than it actually was. Still, in the late 1880s, there were very few art schools in the United States where a woman could even enroll for classes, much less learn to sketch using nude models. If nothing else, her experience at the Académie Julian made her more worldly in many ways than most of her friends back home. Amid the partying, the carousing, and the generally bohemian lifestyle of the Académie Julian, young Frances must have enjoyed herself immensely.

2

A Studio of Her Own: Washington, D.C., 1885–1900

TWENTY-ONE YEARS OLD WHEN SHE RETURNED TO Washington, Johnston had had three good years in the art circles of Paris. Unlike many young women of her social class and background, she had not traveled Europe in "grand tour" fashion, nor was she returning home to the arms of an expectant suitor. What was on Johnston's mind was her art, and how to make a living from it.

Her timing, in many respects, could not have been better. The period from 1875 to 1915 has been called Washington's "golden age" of the arts. Inspired by Paris, encouraged by the growing National Museum (a.k.a. the Smithsonian Institution), and funded, in part, by Washington's territorial governor, Alexander "Boss" Shepherd, the Washington art scene flowered.[1] The Corcoran Gallery began in 1859, followed by the opening of the popular Corcoran School of Art in 1877, thanks to a large bequest from W. W. Corcoran. The school did not charge tuition and was especially well attended by women. The Washington Art Club was founded in 1877, the Art Students' League around 1884, and the Society of Washington Artists around 1890.[2] Johnston taught courses at the Art Students' League and used its studios for her own work as well. It was at the league that she found a set of like-minded friends, a necessity for re-creating her Parisian lifestyle in Washington. One of her league friends, the artist Elizabeth Sylvester, steered Johnston to her first freelance commissions, illustrations for popular magazines.[3]

In the late nineteenth century, the magazine world was going through its second major revolution. The first came earlier in the century, when the readership of magazines expanded to a mass audience. The second, which involved the technology of photoduplication, coincided with Johnston entering the field. Her first magazine jobs entailed making line drawings to illustrate articles, but changes in photographic technology were on the verge of making those detailed, hand-drawn illustrations much less common.

In the 1870s, the introduction of dry plates meant that photographers did not have to transport an entire darkroom to every job. In the late 1880s, celluloid film began to replace the heavy glass-plate negatives that usually meant the camera needed a tripod for support. Finally, the 1888 Kodak camera let the user snap the shots and have someone else develop the film.

With these technological changes, photography became lighter and easier. It also became relatively inexpensive to assemble the equipment needed. In 1890, the basic setup of camera, tripod, lens, plates, and chemicals could be bought for approximately the equivalent of two weeks' wages of the average female factory worker.[4]

These lower costs in photography and changes in printing technology led more and more popular magazines to be eager to illustrate their articles with photographs. Johnston, who was interested in trying the new medium, was well positioned to experiment. In later years, she was fond of telling people that when she got up her courage to write to George Eastman to ask about his new camera, he just sent her back her very first Kodak.

Whether this was actually the whole story is unclear. Johnston's mother's family probably knew the Eastmans, as they were all Rochester-based. In any event, Eastman definitely sent Frances her first Kodak, whether it was complimentary or not. Thomas Smillie of the Smithsonian trained Johnston in camera use and darkroom work right at the museum. Johnston used Smillie's connections on an 1890 trip to Europe, during which she visited various photographers and picked up a few items for the museum's collections.[5]

Johnston was entering the field at its ground-floor. While she experimented with various possibilities—freelance illustration, government documentary work, Kodak agentry—she always saw herself as a professional artist supporting herself through her art. In these early years, work

with the Eastman Company was tempting. She proposed a few different articles that she could write and illustrate for company publications and suggested an advertising campaign to promote the new Kodaks.[6] For a few years, Johnston did serve as the Washington agent for the company, forwarding film from area customers back to the factory and handling their problems with the camera or its lenses.

This middleman role was probably not so much lucrative as educational; Johnston learned which lenses gave trouble and why, and what problems people had with film or light. Thanks to feedback of this sort from Johnston and other field agents, the Eastman Company was able to rapidly improve its cameras and film. The agent's job was not always pleasant, of course. Eastman's correspondence with Johnston is full of squabbles over her commissions and urgent requests to be paid for various jobs. And though arguments over payments may characterize the correspondence of many self-employed people, then as now, the pettiness of these exchanges is remarkable.

At the same time, Johnston was selling more of her own work—not just her photos, but the stories they illustrated. For a young woman with both art training and literary facility, this shift from photographing the subjects of an article to also interviewing them and then writing up the story was a natural one.

Johnston launched her magazine career with a two-part article in a densely written, general-interest monthly, *Demorest's*, starting in December 1889 and continuing into January 1890: "Uncle Sam's Money." A chatty walk-through of the various processes of minting the nation's currency, the printed article was illustrated with two photographs and a series of line drawings made from Johnston's photos.

For the present-day reader, at least, Johnston's photographs are the real revelation in these articles. It comes as a shock to see actual nineteenth-century workers—elderly matrons with wispy buns, gents with flowing beards—turning out the currency by hand. Before the institution of mandatory retirement, many civil service employees worked long into old age. Men and women worked side by side, as did workers of different races. Figure 2, featuring an African American white-collar clerk working beside an apparently white worker, serves as a reminder that the segregation of the civil service was a twentieth-century development.

The piece was well received and was followed in May and June 1890 by a story on the White House illustrated with photographs. From July to

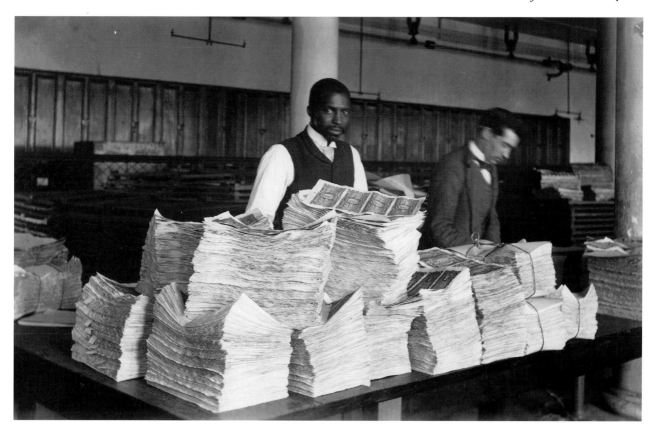

FIGURE 2

Worker at the United States Bureau of Printing and Engraving, 1890. As Johnston's photos reveal, the work force at the mint in the late nineteenth century was integrated.

December 1890, *Demorest's* ran a four-part Johnston series, "Some Homes under the Administration," which featured the homes of the vice president, the postmaster general, Senator Hearst of California, and Senator Sawyer of Wisconsin.[7]

Considering these early journalistic efforts, it is fortunate that Johnston did not immediately settle into doing "homes of the rich and famous." The articles on the coining of money are infinitely more appealing than her "home beautiful" essays: By taking the reader step-by-step through a work process, she made something complicated very clear. She also took seriously the workers she met on her shoots. Personal correspondence after many of her trips included notes from people she had photographed or requests for extra copies of particular poses. Indeed, Johnston's rapport with her subjects brought life to her stories; readers could feel they had entered these people's lives.

Johnston followed up the mint articles with a few more that brought readers to unfamiliar sites and introduced some of the people behind the scenes. In June 1891, W. Jennings Demorest wrote to Johnston to ask her

to try a photo essay on coal mining. Knowing how dangerous mines could be, even without a photographer setting off flash powder, he wondered, "Could not a mine be selected that might possibly be free from these gases?"[8] In March 1892, *Demorest's* ran "Through the Coal Country with a Camera," followed in April by "The Evolution of a Great Exposition" (on the setup of the World's Columbian Exposition in Chicago), and a crowning piece, "Mammoth Cave by Flashlight," in June 1892.

Johnston's article on Mammoth Cave made news everywhere because in it she explained in detail how she managed to light an underground cave without causing a disaster. Apparently, a photographer who had previously tried shooting in the cave had used four ounces of explosive powder for a single exposure. Johnston finished her whole shoot, about twenty photos, using a total of twelve ounces. She explained that she used a mixture of three parts magnesium to one part chlorate of potash. She carried these powders separately to the cave, mixing them in a twist of newspaper once she was ready to shoot. Then she set fire to the newspaper.[9] Apart from the fact that people thought she would kill herself setting off such flashes in caves known to be full of ignitable gases, the photos themselves are remarkably sharp and artfully composed—especially considering that most of the preparatory work must have been done in dim light at best.

A dull piece on salt production, "From the Depths of a Crystallized Sea," followed; Johnston was using her travels for all the articles she could. Returning to Washington, she did a long, four-part series for *Demorest's*, "The Foreign Legations at Washington," which ran from April through July 1893. "A Day at Niagara" (August 1893) was slightly more lively, but it was not until "Small White House Orchids" in *Demorest's* June 1895 issue that Johnston was fully engaging, as she discussed various White House gleanings, gardening lore, and gardeners' personalities.

Johnston was publishing illustrations (first drawings, then photos) in a variety of outlets. Much business came her way because she was Washington-based: Budding press agents like George Grantham Bain found her handy, as did various non–Washington-based magazines like *Harper's* and *McClure's*. For her own use, she maintained a scrapbook of various views of Washington—mostly postcards or publicity folders produced for the tourist trade. These were useful for planning her work, as she could see which angles worked well for which sites.[10]

Given Johnston's access to official Washington, it is not difficult to understand why certain commissions came her way, like the job of illustrating the Smithsonian's annual report, or the project of photographing

the cabinet. Theodore Dreiser, as editor of the New York magazine *Every Month*, wrote to Johnston in 1889 to ask for a photo of the poster artist Ethel Reed, probably because Johnston's own poster collection was famous.[11] The reasons behind other commissions, like the diagrams she made for an article on how to use chopsticks, or the nearly surreal photos of the visitors' lobby of the Convent of the Visitation in Washington, remain less obvious.

It is possible that Johnston's personal enthusiasm for the Arts and Crafts movement was why she was asked to photograph the Roycroft community in New York. The leader of the Roycrofters, the epigrammist Elbert Hubbard, was a welcome visitor at Johnston's Washington studio, as seen in figure 3. Her studio was furnished in the Mission style (so-called because it suggested a "mission of fullness") being produced by Hubbard's

FIGURE 3

Johnston entertaining at her studio, c. 1895. To her left, the Roycroft leader, Elbert Hubbard. To her right, Mills Thompson, the artist and Johnston intimate.

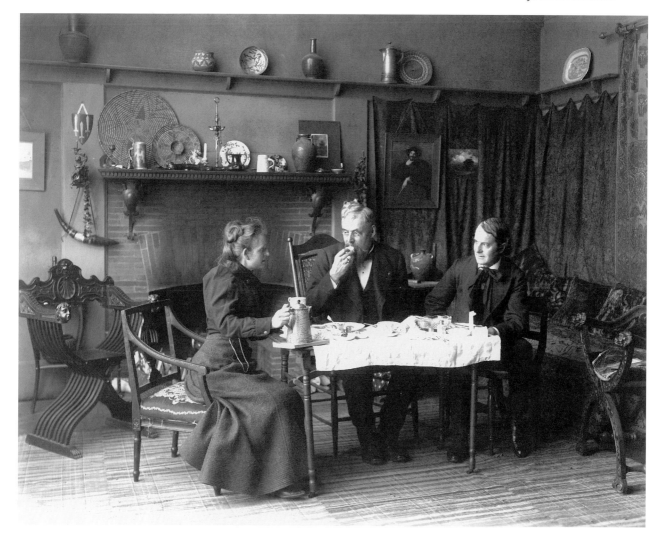

Roycroft workshops. Hubbard, too, celebrated the unconventional, although his passion was the building of a utopian community based on anticapitalist, pro–Arts and Crafts lines. National leaders as diverse as Booker T. Washington and Henry Ford, Carl Sandburg and Theodore Roosevelt, came to spend time at Roycroft studying Hubbard's great experiment. In 1898, Johnston, too, made a pilgrimage to Roycroft—with her camera, of course.[12]

Her photos show us the "characters" of the place, such as Ali Baba (a.k.a. Anson Blackman), as well as its ambiance. It is a peaceful haven that she depicts, full of earnest craftspeople, hand tools, and honest labor. In a subtle way, these timeless scenes of the Roycrofters' preindustrial stables and studios prefigure the idyllic quality of Johnston's Hampton Institute series of the following year. It is as if she had discovered a visual language capable of conveying a positive image of social experiments. Generally, her focus is close enough to capture detail, yet far enough back that individuals' features rarely distract.[13] Her talent for balanced composition in her frames reinforces the impression of stability and competence. Roycroft may appear anachronistic, given the ongoing industrialization elsewhere in the country, but it does not look unpleasant.

Like any good freelancer, Johnston looked for work wherever she could, and when she got a commission, she made it stretch as far as possible. For example, in 1892, she was hired to photograph the U.S. Naval Academy in Annapolis, Maryland. She was paid $133.50 for sixteen days' work (at this point, she was charging $6 per day plus general expenses).[14] These photographs were later exhibited at the World's Columbian Exposition on "The Brick Ship," a brick replica of the naval ship *Illinois*.[15] Together with research done at West Point, this material also became the basis for Johnston's June 23, 1894, article in the *Illustrated American,* "Students in the Art of War."

At the same time, Johnston was maneuvering to win a prize that *Demorest's* was offering for the best photos of military academy life. The only problem was that the contest was only open to cadets. Demorest, however, liked Johnston, so he sent her a very confidential note saying he would rewrite the entry rules to make them more ambiguous, such that all entries would have to be from cadets, but not necessarily by cadets. As he wrote to her, "If you are acquainted with any who are preparing such an article, it might be a good plan for you to communicate with him and in that way have a certainty of your designs being used . . . whoever had the advantage of your work, would be almost certain of the prize."[16]

If there is a whiff of dishonesty about the way Demorest was offering to run his contest, it is an odor given off by even the most straitlaced magazine editors of the day. There is a marvelous letter from the muckraker Ida Tarbell asking Johnston if she could not "fix up" her shot of the Bible to make it more "effective" for an upcoming article in *McClure's*.[17] From the very earliest days of photography, clever magazine editors seemed to have known how to manipulate an image to get across their own angle on the truth.

Much of Johnston's appeal to magazine editors was based on her reputation for having access to high government officials, particularly in the White House. The origins of this connection are somewhat vague. According to an article in the *Woman's Tribune,* Johnston said she photographed a certain Dr. Scott, President Benjamin Harrison's father-in-law, and that the results were so pleasing that she gained entrée to Harrison's cabinet.[18] Other sources mention that Johnston's mother was distantly related to the Clevelands. Whatever the initial contacts were, Johnston was able to earn her own welcome by working well with official Washington.

Johnston was well aware of the publicity value of her government connections. In 1893, she ran ads in the *Washington Post* advertising: FOR SALE — THE WHITE HOUSE — $1! The fine print advised readers that Johnston's photographic album of the White House made an ideal souvenir of the First Family's home.[19] Although the photos are somewhat stiff—the most exciting are the before-and-after redecoration shots of various rooms—they do foreshadow the architectural work of her later life.

On August 12, 1898, she was present in the cabinet room of the White House for the signing of the Spanish-American War peace protocol. By the terms of the treaty, the United States would pay $20 million to Spain for the Philippine Islands. As Johnston told the tale, she had gotten a contract with a news weekly to photograph each of the four $5-million warrants. Secretary of State John Hay was apparently as gracious as ever when she asked permission. "Why certainly Miss Johnston, if that is agreeable to his excellency," he said, indicating the French ambassador.

Together Johnston and Hay pinned the $20 million in warrants to the wall for the shot. The photographic prints were almost dry when the Secret Service showed up and confiscated everything—negatives and all—informing her that it was a "penitentiary offense" to reproduce a government draft.[20] Johnston told and retold this particular chestnut with great pleasure; not only did it underscore her Washington connections, but it was amusing that she was the object of the Secret Service's attentions.

Johnston's busyness promoting herself professionally did not preclude a lively social life—indeed, the two were highly complementary. Her group at the Art Students' League seems to have given quite a few parties, some of them fund-raisers, to be sure. Johnston's Art Students' League memorabilia contain frequent reports of costume balls and *foires aux croutes* (bric-a-brac sales). From the sound of one of the toasts, Frances was the life of more than one party:

> Frances is our hostess, Frances is our joy,
> She gives us many a party, likewise many a toy.
> So here's to Frances' great success, with coal and bread and butter,
> Long may she wave and entertain,
> And often snap the shutter.[21]

From January 1, 1895, onward, Johnston's new studio was a favorite spot for parties. Johnston hosted smaller-scale entertaining on Wednesday afternoons, when she was "at home" to callers. Unlike many other cities, Washington did not have a well-defined artists' district, although many studios did cluster in a few downtown locations: around Judiciary Square and the old Patent Office, in the Corcoran Building (15th and F), and on Vernon Row (10th and Pennsylvania Avenue).

As was sometimes the custom among the more well-to-do Washington artists, Johnston built her studio as an addition to her home. Thus, her studio at 13th and V Streets was downtown but not particularly near any of the artistic hubs. That made little difference, however; friends and clients found their way to her door anyway.

Outside her studio, Johnston could be found socializing at and photographing some of the other leading studios. Alice Pike Barney's Studio House on Sheridan Circle, Parker Mann's Tanglebank, and George Fort Gibbs's studio all appear in her work.[22] Alice Pike Barney herself was the subject of several Johnston portraits, as was her daughter, Natalie Barney, seen in figure 4. Shortly after posing for this debutante shot, Natalie decamped for Paris, where she ran her own salon and broke many hearts, mostly female.

Johnston's addition to the family home was a relatively costly proposition. By her own account, she spent $7,000, which at the time could have bought an entire three-story brick house in downtown Washington.[23] Johnston both designed and furnished her new quarters, which overlooked

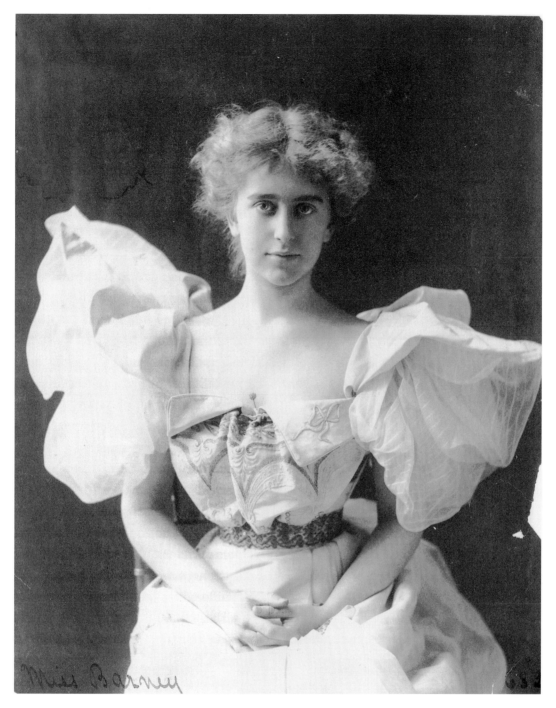

FIGURE 4

Natalie Barney, c. 1900. The daughter of the Washington artist Alice Pike Barney,
Natalie poses in a Worth gown.

the John Burroughs–designed rose garden behind the family house. Her studio was two stories, with office, workroom, and darkroom on the ground floor. The whole seven hundred square feet of the second floor was designed as open studio space. For the convenience of visitors, a special covered staircase provided access to the second floor directly from the outside.

The studio itself was striking. A 12'-by-14' skylight (designed by Kuebler of Philadelphia) filled the north wall of the studio, floor to ceiling. Its custom-designed cloth shade could be adjusted to control the lighting. The east end of the room featured a blazing fireplace, complete with carved-wood mantel and picturesquely tarnished andirons. English windows illuminated the south side of the studio, which with a simple pegging of the drapery could be muted or brightened. A cushioned window seat made a perfect perch beneath the leaded-glass bay window. The terracotta walls were lined with specially grayed burlap, and woodwork and exposed ceiling rafters were stained a dull Japanese green for subtle contrast. Cashmere paisley shawls were artistically draped on the furniture, with a few "good" Japanese prints here and there, and a richly patterned Oriental rug on the floor. A large spinning wheel decorated the hearth. Johnston displayed various curios and bijous from her travels on a high shelf going around the whole room, and choice photographs from her personal collection were also mounted. The window seat could be flipped over, converting to a work table for camera gear. A door behind a piano on one side of the studio led to a small apartment that could also be used as a dressing room for customers. Various screens and draperies covered recessed areas where photographic equipment was stored when not in use, although Johnston liked having a candid camera setup available for informal sessions.[24]

When customers arrived for their appointments, the studio would be ready for work but infinitely more cozy than the average photographic business. It is not hard to picture McKinley's cabinet wives arriving at 1332 V Street for a sitting and then sipping tea with Johnston by the fire, passing polite gossip about Representative So-and-so. Johnston's first customer in her studio was the writer Frances Hodgson Burnett, who sat for what she called her "only authorized poses."[25] Later, artists like Benjamin Constant, society ladies like Phoebe Hearst, politicians, businessmen—all sorts of people—came to have their portraits made.

Having a studio both comfortable and proper was a prerequisite for

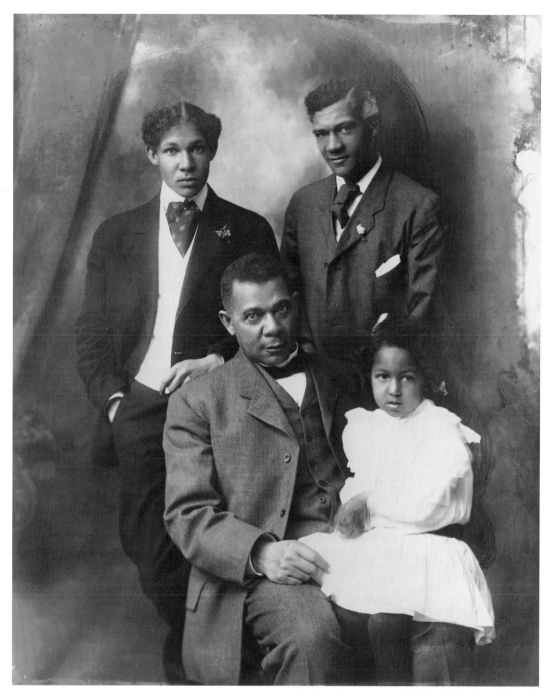

FIGURE 5

Booker T. Washington and family, Tuskegee, 1906. Ernest Davidson Washington stands on the left, Booker T. Washington Jr. is on the right, and his niece Laura Murray Washington is perched in the lap of Booker Sr.

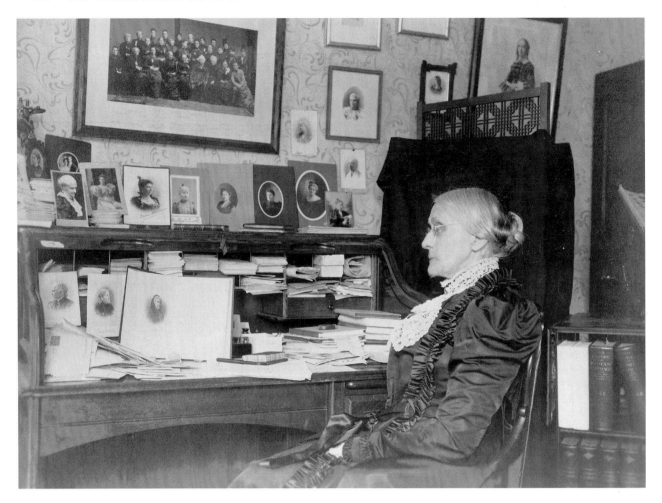

FIGURE 6

Susan B. Anthony in her study, 1900. With the photographer's black cloth setting off her profile, Anthony is surrounded by pictures of supporters.

securing paying customers, but it was the way Johnston made her portraits that kept her business expanding. As she explained: "Avoid emphasizing the peculiarities of a face either by lighting or pose: look for curves rather than angles or straight lines, and try to make the interest in the picture center on what is most effective in your sitter."[26]

By not focusing on the bizarre, the photographer could study the subjects' strengths undistracted by surface qualities. Johnston's portraits of Madame Wu and her child highlight the dignity of their relationship to each other. Her portraits of Booker T. Washington, as in figure 5, convey his single-minded determination, his familial focus, and his seriousness. Her Susan B. Anthony, figure 6, is every inch the matriarch of a movement surrounded by her troops. Her Mark Twain, figure 7, is heroic, even prophetic. For all subjects, she worked to bring out their personality, their essence.

Johnston's studio was as suitable for entertaining as it was for work.

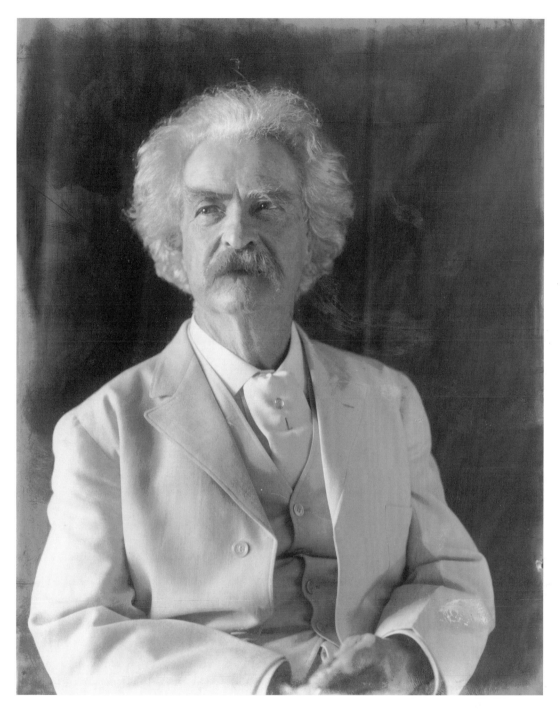

FIGURE 7
Mark Twain, 1906.

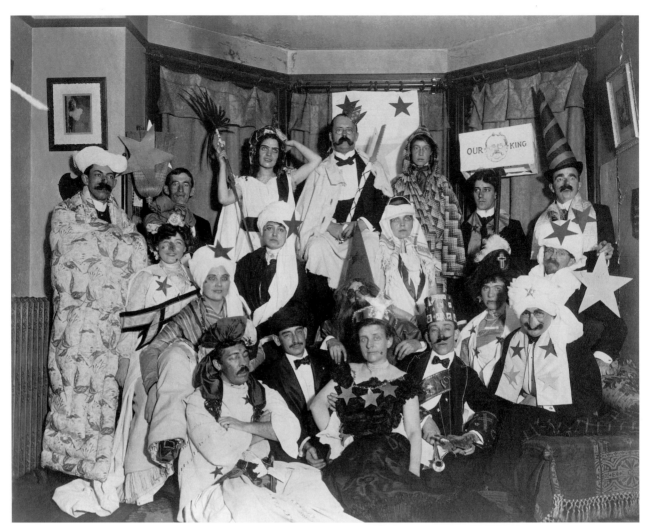

FIGURE 8

Costume party of "the Push,"
c. 1902. Johnston is in the front
row, center.

For large parties, especially those involving dancing, the furniture was
moved back and the rugs rolled up. For more intimate occasions, a tea
table could be set before the fireplace. At least for the smaller gatherings,
Johnston usually left out a brass tray with a selection of recent photos for
visitors to browse. With the gaslit chandeliers glowing, and the wittiest,
most artistic people in Washington raising glasses together, it must have
been a convivial scene. In time, this scene found a name for itself: "the
Push." Parties of the Push often involved elaborate costumes and makeup
and silliness, as can be glimpsed from the group portrait in figure 8.

As a young, single, professional woman, Johnston sought to create
around her a social milieu that would serve her needs. One year before
opening her own studio, she was a founding member of the Business
Woman's Club, an eclectic mix of self-supporting women in various occu-

pations. When the club quarters opened in January 1894, Johnston's photos of the 1893 Columbian Exposition lined its walls. This was a strategic move on Johnston's part, since her photographs were mentioned by most of the newspapers that covered the opening.

Of course, one purpose of clubs—male or female—is to provide members with useful business connections, a function they served for Johnston over the course of her career. The second vice president of the Business Woman's Club was Edith Westcott, the principal of Western High School, and it was through her that Johnston landed a career-establishing commission, photographing the Washington, D.C., schools. In 1895, with the backing of the prestigious Cosmos Club—where contacts were highly advantageous for any Washington freelancer—Johnston curated a major poster-art show for the Business Woman's Club with the artist Ethel Reed.[27] Johnston's membership in the D.A.R. provided her with useful connections as well.[28] In the mid-1890s, she became the first female member of the Capital Camera Club, and she showed her photos in their exhibitions.

The Washington club scene was far from the hub of the greater art world, however; Johnston would have to extend her reach if she wanted a national reputation. Her appointment to the five-person jury for the second annual Philadelphia Photographic Society exhibition in 1899 was her first success in the larger art world. Both Johnston and Gertrude Kasebier were asked to serve alongside the male photographers F. Holland Day, Clarence White, and Henry Troth.

At the time, the main dispute at photography shows was not gender (at least not overtly) but the artistic credentials of the jury members: Were they photographers or painters? Was photography supposed to imitate painting or do something different? The underlying assumption was that if painters were jurying a photographic show, they would be inclined to favor work that dwelled on high-art themes, work that looked interpretive rather than documentary.

The Philadelphia jury that Johnston served on was the first all-photographer jury for any major photography show in America. Even the jurors showed, although in a separate room.[29] According to Joseph Keiley's account in the January 1900 issue of Alfred Stieglitz's *Camera Notes,* Johnston and Kasebier's work was awful, as was Sarah Sears's.

Stieglitz's camp was given to snubbing Sears, possibly because she was wealthy enough to move the photographic capital of the nation to her hometown, Boston, if she chose, which would have threatened Alfred

Stieglitz's New York–based hegemony.[30] As for Johnston, Stieglitz was opposed to her from the outset. He wrote to F. Holland Day, discussing the Philadelphia jury: "I like you as a Juror—but Miss Johnston! and even Troth. Why not Day to represent the East, Kasebier the Middle States, and White the West? Of course, that would leave Philadelphia out, which would be a good thing for obvious reasons."[31] Apparently Troth was too deeply involved with Philadelphia politics, and Johnston was written off as someone who produced "posed tableaux," not a direction that Stieglitz wished to encourage. Kasebier's "art photography" was considered womanly and thus acceptable to Stieglitz. Whether her images were traditional or subversive is a question raised by modern feminist critics, not by Stieglitz's Photo-Secessionists. It was only several years later that Kasebier herself moved away from the Stieglitz embrace.

Such forays into the national photography scene were still exceptional in the early part of Johnston's career. Most of her art world was Washington—in particular, the Art Students' League. Although predominantly male, the league was a source of some female friendships.[32] There was one "Boo" to whom Johnston "lovingly" dedicated an album of her first photographic attempts, titled "Pinkey's Blue Book—or—the Indigo Agonies of a Photographic Amateur."[33] "Pinkey" was Johnston and "Boo" was probably Elizabeth Sylvester, but there are certainly many other women whose names appear regularly in Johnston's datebooks.

One of the most intriguing clues to Johnston's female subculture in Washington comes courtesy of a lawsuit threatened by the father of one of these women against Johnston, in February 1898. One night, Alice Berry, a young Washington society lady already notorious for her escapades, including her recent arrest at a dogfight, met Johnston and asked her to do her portrait. This was not to be the usual armchair sitting, however: Berry wanted herself photographed nude. Johnston, it was reported, agreed to the job—both because she was "thorough" and because she believed "in art for art's sake." As the newspaper article pointed out, Miss Berry was a "remarkably pretty girl" so Johnston "had no hesitation in consenting to pose Miss Berry in various stages of deshabille." Johnston developed the photos in the privacy of her own studio, so no "prying male eyes looked upon the plates of films."

The completed photos were so beautiful that "even Miss Johnston was surprised at their beauty, for Miss Berry has a fine figure, and Miss Johnston photographed her in a number of artistic poses, several of them rep-

resenting her as she emerged from the bath." The incident would have passed unnoticed, the newspaper account went on, except "Miss Berry exhibited several of the photographs to girl friends." These women were said to be "jealous," so they talked and whispered about the photographs at society functions. Miss Berry was apparently unfazed "and even persisted in showing the photographs to friends. In some manner a male friend of hers secured a set of the photographs." At that point, Johnston was accused of being the source of the leak, although she would only admit to having mailed "two of the more modest posings" to an art magazine. Berry's father, furious, threatened a libel suit, but he then came to admit that the photos were no libel on his daughter's beauty. At that point, he announced that he would sue Johnston for besmirching his daughter's reputation, a difficult undertaking.[34]

Somehow, the idea of young women in their twenties passing around nude photos of a friend hardly fits the conventional image of late nineteenth-century Victorian womanhood. True, late twentieth-century scholars have cautioned that verbal outpourings of affection should not be confused with sexual interest or activity. Perhaps some would argue that these young women were passing around nude photos of Miss Berry for "art's sake," whatever that might mean. The fact remains, however, that there was a circle of women around Johnston, at least some of whom enjoyed looking at pictures of an attractive nude woman.

The two people in her Washington life that crop up most often in her personal photos, however, were men: Mills Thompson and Frank R. Phister.[35] Mills Thompson was a Washington artist some eleven years younger than Johnston who had studied at the Corcoran School and the Art Students' League. He did some decorative work on the Library of Congress in 1896, but he left Washington for New York soon thereafter. In the end, he settled in Philadelphia, where he worked as an editor and illustrator for a number of leading arts magazines.

Frank Phister was about five years older than Johnston, and though he was not an artist, he was said to be "well acquainted among the artistic set" and was an amateur photographer. Since his father had come to Washington as a Kentucky congressman, the young Phister had been given a series of government clerkships at the Smithsonian and the Indian Bureau.

From the photos in Johnston's personal collection, it is clear that Phister, Thompson, and Johnston were a real trio—they posed comfortably together. They were all single. Johnston did a number of shots of Thomp-

son in drag or blackface, and her archives have at least one photograph of Phister "in the altogether."[36]

It is not clear whether Johnston was romantically involved with either man, but the end of the trio is a matter of record. Sometime in the early hours of the morning of December 16, 1896, in the privacy of his boardinghouse bedroom, Frank Phister shot and killed himself with his own "pearl-handled revolver." The news reporter was unable to identify a reason for this suicide apart from the fact that Phister was known to drink to excess. Since Johnston was in some manner very close with Frank, many friends sent her condolences. Johnston exchanged sympathy letters with Frank's sister and was depressed over his death for some time. Either as a friend or a lover, she felt the loss deeply.

Johnston had other intimates apart from Thompson and Phister, but only the distant ones left a trail of letters for us to follow. One case in point is the sometimes ardent Charles Dudley Arnold, chief photographer of the 1893 World's Columbian Exposition in Chicago. It is likely that Johnston first met Arnold when she went to photograph the setup phase of the fair in November 1891. December 1891 letters from Arnold mention little gifts he was sending Johnston. Subsequent letters debate the dates of her visits to Chicago and offer updates on how the Demorests, friends of Arnold's, were reacting to the articles she had started doing for their magazine. From his offers to send the Johnston family any photos of themselves they liked, Arnold seems to have been accorded at least one family visit in Washington. The tone of his letters to "Miss Fanny" is decidedly flirtatious. He scolds her for offering to pay for photos, rails at her for not writing to him often enough, and refers to himself as the "gent who is playing second violin."[37]

Personal relationships aside, Johnston learned a lot from Arnold about photographic technique and politics. The Columbian Exposition was an important and controversial event in its day. While subsequent generations criticized the open racism of the "anthropological" exhibits, contemporary critics had other complaints.[38] From a business point of view, people suspected the fair was being run for the benefit of a few well-greased palms, with very little left over for the "little guys." In contrast to previous world's fairs, where a wide range of petty entrepreneurship had been allowed, the organizers of the Chicago exposition kept close control over the various moneymaking concessions.

Consider their policy on photography.[39] Before the fair was officially

opened, photographers could come and photograph whatever they liked, just as Johnston did. But once the Photography Division was formed, under Arnold's direction, things changed. The new policy was that no camera larger than a 4"-by-5" view camera (which weighed more than thirty pounds) would be allowed on the grounds. Nor would tripods be allowed, effectively ruling out large cameras in any case. Anyone who wanted to publish a guidebook, postcards, or even articles reviewing the fair would have to apply to the photography office to purchase Arnold's reproductions.

Other photographers, including Stieglitz, mounted such vociferous attacks on Arnold's monopoly that in the end, another photographer, William Henry Jackson, was hired by the exposition to make the final album of photos showing the fair's closing.[40]

All the same, Arnold's vision of the fair had its impact on all who could not come to Chicago to see it for themselves. His effect on the aesthetics of his student and confidante, Frances Benjamin Johnston, is also clear. It is impossible to examine Arnold's large-format, platinum prints of the various edifices and vistas of this exposition—magnificently Palladian views—and not see the influence he had on Johnston's work. Figure 9, Johnston's view of the Louis Sullivan–designed Transportation Building, brings out both the detail of the ornate entryway and the European charm of its reflection in the pool facing it.

From the Chicago fair on, all of Johnston's photos of big fairs have that same Italian Renaissance composition that Arnold was famous for. There are few crowd scenes. More often than not, there are no people at all other than the occasional handful, artfully placed to emphasize the monumental scale of the buildings. Johnston's world's fair photos can be seen as the roots of her later garden photography. There is that same eye for graceful composition unmarred by human vagaries.

One of Johnston's only disappointments with her experience at the Columbian Exposition was her attempt to get the attention of Mrs. Potter Palmer. Bertha Palmer was not only one of the richest women in America, but she was widely considered the "first lady of the Chicago Fair." As president of the Board of Lady Managers, charged with organizing the representation of women's work at the fair, Palmer is credited with guaranteeing that women would get the commissions for designing and furnishing the Women's Building. Under Palmer's direction, Sophia Hayden was hired as architect and Mary Cassatt was commissioned to paint a mural for the

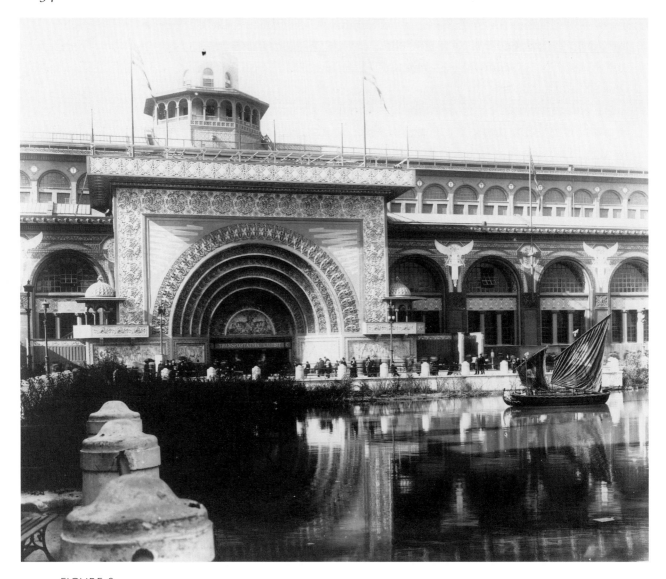

FIGURE 9

Archway of the Transportation Building, Chicago World's Fair, 1893. (Courtesy Smithsonian Institution Archives, record unit 95, Photograph Collection, box 64, folder 3)

Women's Building.[41] To many women artists of the day, Mrs. Palmer promised important "matronage."

Johnston, aware of Palmer's power, wrote to her to ask if she might come to call, perhaps to photograph her or her home. She enclosed some of her work so that Palmer could appreciate her skill. In May 1892, Mrs. Palmer sent her first round of regrets, followed in September by another note, advising that she never let anyone photograph her home or write about it.[42] Although she did not receive the invitation she sought, Johnston did not give up on Mrs. Palmer, and by 1900, she was going to Paris at Palmer's behest.

There is evidence that Johnston ended up making contact with a num-

ber of other women who had important roles in organizing the Women's Building. The Connecticut delegation used her photographs to illustrate the book they published on the fair and thanked her especially for giving them one more opportunity to showcase women's work.[43]

While contemporary feminists debated the "100% woman-made" rule for exhibiting in the Women's Building, there was great support for the social services that the women's committees devised. Their "dormitory plan" was typically ambitious: to construct a building adjacent to the exposition that would be capable of housing and feeding five thousand women at a time, to be financed by female stockholders. A Children's Building was planned as an adjunct to the Women's Building, to provide child care and to educate the public in progressive child-rearing ideas.[44] Not only did the planners want a major showcase for women's accomplishments, but they were willing to undertake the social arrangements— child care and housing—that would make it possible for thousands of women to attend. While Johnston had no documented participation in the explicitly feminist undertakings, her cooperation with the Connecticut women's report suggests her approval.

After her preliminary coverage of the exposition for *Demorest's* in 1891, Johnston returned in 1893 as part of a three-person photographic team for what was called the Board of Management for the U.S. Government Exhibits. Johnston's friend and mentor Thomas Smillie of the Smithsonian directed the team, which was to document the exhibits that the various government departments had mounted. This was the first time the government set out to do its own documentation at a world's fair, rather than relying on commercial sources.[45] The official status of this team exempted them from Arnold's ban on independents, which had prevented Johnston from returning to photograph in 1892. Smillie, Johnston, and Lieutenant Henry Harris, the third team member, together made an estimated 734 photographic negatives in a variety of sizes. With some exceptions, most of this work was not directly attributed to a particular photographer.

After the on-site photography was finished, Harris and Johnston returned to New York and Washington, respectively, to print the negatives. Johnston's forte was the platinum print; hers were greatly admired for their range of gray tones, which seemed embedded in the soft paper surface.[46] In her bathroom (this work predated her studio) she printed most of the board's large 20"-by-24" negatives, as well as a number of the 8-by-

10s and the 11-by-14s. Harris, in his darkroom, was using the new emulsion-based printing papers and having much less success, as he acknowledged in complimenting Johnston on her platinum prints.[47] Various prints were collected in sets and mounted in folios for archival as well as presentation purposes.

Apart from her darkroom work, Johnston's actual camera skills were remarkable. Her habit of "bracketing" her shots—making successive exposures only minutes apart—was extremely useful for ensuring a good selection of usable material.[48]

Once the exposition was over, Johnston turned her attention again to drumming up new business. Sometime around 1893, she started working with the agent George Grantham Bain, more or less the inventor of the "press agency." Bain acted both as a middleman between photographers and the press and as story-maker, urging his photographers to make stories happen by covering them. He was always trying to teach Johnston to get out in front of an event, to be the first one there to get the scoop.

The partnership peaked in 1899, when Bain got word that Johnston was intending to vacation in Europe. Bain had also found out that Admiral George Dewey, fresh from his victory in Manila Bay, would be anchoring in Italy on his way back to the States. If Johnston could somehow get aboard his ship, they would have the scoop that all America was dying to see.[49]

Johnston did not have to think too hard to figure out that her best ticket to getting aboard Dewey's battleship might be issued from above. Theodore Roosevelt, who only a year earlier had donned his Rough Riders uniform for Johnston's camera, was then the assistant secretary of the navy responsible for dispatching Dewey to Manila. Johnston hastened to Long Island, where Roosevelt was vacationing with his family, and left her card at their Oyster Bay compound. It came back with the following message scrawled around her name:

> My Dear Admiral Dewey,
> Miss Johnston is a lady, and whom I personally know. I can vouch for, she does good work, and any promise she makes she will keep.[50]

Armed with this introduction, Johnston boarded Dewey's battleship, the USS *Olympia,* and proceeded to make herself at home. According to her entertainingly faked enlistment record, she enlisted on August 5, 1899, at Naples, Italy. She listed her trade as "snapshots," giving herself a 5 (the

highest mark) in her own trade, and in seamanship, ordnance, marksman-
ship and obedience—everything except "sobriety," where she downgraded
herself to 4.9. According to these pseudopapers, she was discharged from
the navy on October 17, 1899, a fairly long "tour of duty."[51]

There is some controversy as to why Johnston did not get her Dewey
photos back to the States as quickly as her competitors did. Apparently she
entrusted her film to one of them, who handled it in a most unsportsman-
like manner. Nevertheless, when they finally reached the American
papers, her photos were sensational. Bain sold some $900 worth of John-
ston's *Olympia* shots, a goodly sum in 1899.

It is easy to see why. Bain had told her to take plenty of photos of

FIGURE 10

Sailors tattooing aboard the
USS *Olympia, 1899.*

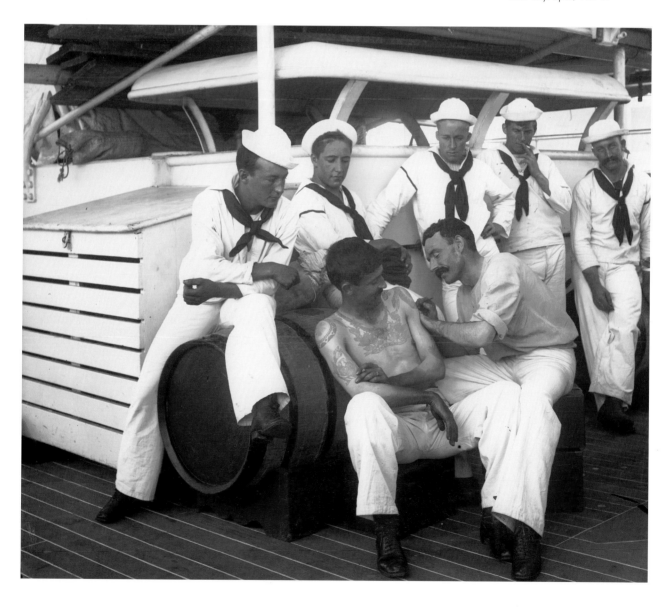

Dewey himself, which she did—on deck chatting with her, sitting with his dog, posed at his desk in his private quarters. Johnston did not stop with Dewey, though; she went on to take a look at daily life aboard the ship. Once again, her ease with common working people animated her shots. There are sailors slouched in their bunks, sewing each others' clothes, waltzing with each other on the top deck, and, as in figure 10, tattooing each others' bodies.

Her shots are intimate; her subjects seem at ease with the process. Perhaps the time she spent at Annapolis and West Point had given her a familiarity with the military lifestyle. Certainly her open fondness for liquor cheered up many an evening on board. She was considered a good sport: a woman, but someone willing to adapt to the constraints of daily life on a battleship. Was there no darkroom for changing her photographic plates? Well, she would just make do with the torpedo chamber!

3

Showing America to the World: Paris, 1900

THE PARIS 1900 EXPOSITION HAS BEEN CALLED THE greatest in world history—in one year, there were more than 50 million visitors. Even the hugely popular New York World's Fair of 1964–1965 barely topped 51 million in its two years combined.[1] Beyond the numbers, there was an incredible sprawl of exhibition spaces, an exhilarating mix of progress-through-science and Art Nouveau. It was a fair for a world readying itself for a new century.

Frances Benjamin Johnston was thirty-six years old in 1900; in many ways, she was at the peak of her creative and physical powers. She exhibited two huge portfolios of her own work at the 1900 expo, some 500 8-by-10 photographs. In addition, as the official U.S. delegate to the International Photographic Congress in Paris, she curated a show of 142 photos by twenty-eight American women photographers—an exhibit she assembled in just six weeks.[2] The story of these groups of photographs is the subject of this chapter.

The invitation to do a show on women had its roots back in 1892, when Johnston was trolling, unsuccessfully, for an audience with Mrs. Potter Palmer. Apart from her social power, Mrs. Palmer was well known as a patron of the arts, a vital contact in this era before the large charitable foundations were established. On April 12, 1900, Mrs. Palmer's secretary,

Mrs. Ellen Henrotin, wrote to Johnston explaining that she was supposed to organize various contingents of American women to go to the expositions in Paris that year. Could Johnston be a delegate for the photography-related events? Could she bring some work by American women? Did she speak French?

Johnston was so eager that she used the back of Henrotin's letter to start jotting down the names of women she could include. Two weeks later, Mrs. Henrotin wrote to say that unfortunately no funds had been allocated for Johnston's expenses. Mrs. Palmer might personally subsidize some of the costs of purchasing the actual photos, however.[3]

Johnston knew this was too good an opportunity to worry about being paid. Back in 1893, she was quoted in *Cosmopolitan* as saying, "there are great possibilities in photography as a profitable and pleasant occupation for women, and I feel my success helps demonstrate this."[4] In 1897, her *Ladies Home Journal* piece called "What a Woman Can Do with a Camera" again advanced an argument in favor of the appropriateness of photography for women. The Paris show would give her a chance, finally, to make her point to the world.

In May 1900, Ellen Henrotin confirmed Johnston's delegate status, advising her to prepare a fairly technical paper to deliver to the congress. She added that Miss Beatrice Tonneson would be the other woman delegate, and that she planned to offer a more practical sort of paper.[5]

Johnston immediately contacted every important woman photographer she knew, asking each if she wanted to send some prints that could be shown in Paris. She appended a short list of questions asking each about her work: What was her first photographic experience? What other aspects of her career or style did she want to discuss?[6]

In the effort to reach all the women she could (and perhaps for a little self-promotion), Johnston contacted the important men in the field as well, in order to get leads on any women they knew. Juan Abel, editor of the *Photographic Times*, sent her some names and asked for a copy of her speech.[7] Alfred Stieglitz's response, in light of her subsequent experiences with him, was remarkably positive. He told Johnston her list of names was quite complete, and that women in America were certainly doing "great" photographic work and ought to be commended. He closed by adding that he, personally, was "overworked" and "used up physically and mentally" and needed a rest.[8]

His exhaustion may have resulted from aggravation over not getting

his way regarding the status of photography at the 1900 fair. He had been pushing the idea of boycotting shows that did not categorize photography as a fine art on the same footing as painting or sculpture. When the Paris organizers insisted on classifying photography in group 3 (letters and sciences) rather than group 2 (fine arts), Stieglitz himself refused to participate and urged his followers not to show there either.[9]

Since the International Photography Congress was contiguous with but not part of the 1900 expo, the boycott was not relevant to its proceedings. Perhaps Stieglitz's health was bad, as he complained, or maybe he decided that it was not in his best interest to attend, but he was listed as a delegate. Beatrice Tonneson was also listed but did not attend, in her case due to the sudden death of her mother.[10]

Almost all of the women who were prominent in photography at the time seem to have cooperated with Johnston's requests; she had replies from Eva Watson, Mathilde Weil, Sarah Sears, Alice Austen, Zaida Ben-Yusuf, Mary E. Allen, and many others. The chance to show in Paris was tantalizing even for the most modest amateurs. Gertrude Kasebier, who maintained that she really did not have anything ready to show on such short notice, was the only significant holdout. Johnston "called" at Kasebier's studio and pleaded with her to cooperate, resorting to tears and making "a melodramatic scene," and apparently even trying to buy a print Kasebier had just sold to another client.[11]

Most of Johnston's contacts wrote back as she had asked, with descriptions of their areas of specialty. Many mentioned specific genres like weddings and botanical subjects, though the majority were in broader fields like portrait work. Some rhapsodized about photography as a field well suited to women in particular; others saw it as an ideal choice for a partnership with husband, sister, or other lifetime companion.

When the International Photography Congress opened in Paris on July 23, 1900, Johnston's photos had arrived but she had not, so her presentation was postponed until the next session. According to the minutes of the congress, Johnston then exhibited some two hundred photos by thirty women, mostly artistic portraits and genre scenes.[12] Johnston told the gathering that American women photographers were well versed in the latest photo techniques, that they were usually members of camera clubs, and that they showed in all the major exhibitions. She emphasized that some of these women photographers were among the best paid in the profession.

The audience was impressed with the photos. Indeed, the Russian delegate W. I. Sreznewsky arranged on the spot to take the show to St. Petersburg and Moscow in the fall of 1900, since this "pictorial" style of the women had not been seen in Russia. The Paris Photo-Club borrowed the exhibit in January 1901, but Johnston never found an American venue for the show.

It was prestigious to be the only woman delegate from the United States at such an august international gathering, and Johnston had worked hard for the honor. In the year previous, she had turned out more than five hundred important photos on two large projects, one documenting the Washington public schools and the other showing education at the Hampton Institute. The Hampton photos were shown in the "Negro Exhibit" in the American Social Economy division at the Palais des Congrès. Johnston's Washington photos were most likely shown on the first floor of the Musée Centennal, in the photography section (formally class 12), which also included some live-action photography from the Lumière brothers, filmmakers who became useful to Johnston's career in the next decade.[13]

Of the two projects, the first (on the Washington schools) was probably the more taxing, since it involved covering a large number of schools in the short amount of time left in the 1899 spring term. In six weeks Johnston made some seven hundred prints, an impressive number given the nascent technology of the day. Indeed, given her time constraints, it is unlikely that her shots were as "posed" as one might ordinarily assume.

The 350 photos selected for the show depict children of all ages, all schools, white and nonwhite, and all subjects.[14] She showed high-school girls in bloomers doing vigorous climbing exercises (figure 11) and youngsters squatting in formation in the fresh air of a schoolyard (figure 12). Activities that were not visually interesting, like spelling or history, were livened up with backgrounds of blackboards covered with subject matter.

The mission of the Washington series was to show the public what was meant by "new" or "progressive" education, by presenting a carefully selected series of illustrative photographs. This was not intended to be a comprehensive view of public education in Washington, but rather a diagram or blueprint for a particular educational philosophy.

That this progressive agenda did not extend to racial integration seems to have gone without much comment in this era of "separate but equal." In figure 13, Johnston showed a class of young, African American schoolchildren gazing up at a statue of George Washington in a Great White

FIGURE 11

Gym class, Western High School, Washington, D.C., 1899. Physical education in the progressive method could sometimes look like a form of medieval torture.

Father sort of pose. The statue was notorious because its sculptor, Horatio Greenough, had depicted the president draped in Grecian garb, and Washingtonians were scandalized by his "nakedness."[15] Perhaps this was why Johnston chose to photograph this scene. Her particular angle on the shot, however, emphasizes the racial ironies.

Also notable in this series is the great number of field trips the students seem to have taken. Children of all ages were depicted outside their classrooms in a variety of settings, learning about the world by direct experience. In Johnston's photos, students peer at ethnographic exhibits in museums, huddle around gullies, sketch trees, and collect shells at a beach. Sometimes artifacts are brought to class. One teacher holds up beaded moccasins for her students to examine; another shows them a swaddling board. Science experiments conducted in the classroom demonstrate various principles, rather than relying on textbook information. Students learn about math by measuring things in the schoolyard. There

FIGURE 12

Physical education outdoors, Washington, D.C., 1899. Progressive educators favored outdoor exercise. Johnston photographed such scenes in Washington and at Hampton.

are hardly any schoolbooks in sight in Johnston's hundreds of frames. The new practice was learning by doing, not learning by rote.

Despite their progressive methodology, the new thinkers still fell into old gender stereotypes; for the most part, girls were sent to sewing or cooking classes while boys attended woodworking or metalcraft shop. "Manual training" was supposed to exercise the pupil's "expressive powers" instead of keeping exclusive focus on the "receptive" ones and was seen as a method of learning about the world directly, eliminating the filtering screen of words. "Technical education" only prepared a student for a trade.[16]

Johnston expected to be paid for her work, but it was not until a year later that she was told that her fees might be paid out of the "national

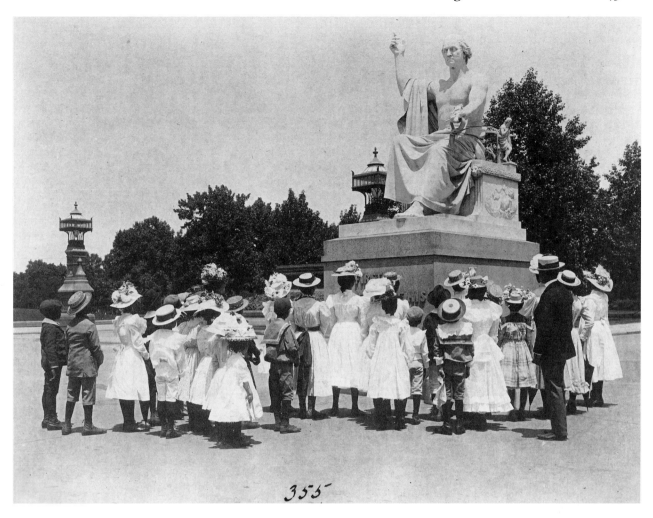

355

FIGURE 13

Students viewing Greenough's statue of George Washington, 1899. The irony of segregated but "progressive" schools is suggested by this crowd of African-American children gazing up at the white marble figure.

appropriation for the Paris Exposition."[17] Meanwhile, she was also selling prints directly to interested parties (perhaps the origin of the school-picture business).

Johnston's most lucrative sideline was supposed to be the book version of the project, a sixteen-booklet set covering four basic units: primary education, geography, manual training, and arithmetic. *The New Education Illustrated* was published in 1900 by B. F. Johnson Publishing Co. of Richmond, Virginia. Edith Westcott, Johnston's old friend from the Business Woman's Club, who was principal of Washington's Western High School, wrote the text for the series, although Johnston's photos carried equal weight. Despite the publisher's heavy publicity for Johnston (they were "booming her as 'the greatest photographer in America,'" B. F. Johnson wrote[18]) the series never sold very well. The greatest profit Johnston made

from her Washington series was the respect it brought her in Paris and the entrée it provided to the Hampton Institute.

Johnston was hired to come to Hampton Institute in 1899 by the Reverend Hollis Burke Frissell, head of the school following the 1893 death of General Samuel Chapman Armstrong. Armstrong, who had commanded African American troops in the Civil War, went on to found the Hampton Normal and Agricultural Institute in Hampton, Virginia, in 1868, with the objective of educating the newly freed ex-slaves of the South. Native Americans were enrolled some ten years later. By 1900, the school's population numbered one thousand: seven hundred African American students, two hundred Native American students, and one hundred white staff and their relations.[19]

Student life at Hampton was organized along the same Victorian lines as any comparable all-white institution—maybe even more so, since it was both coeducational and residential. Social contact between males and females was strictly regulated. Student dress was relatively formal, fitting with late nineteenth-century custom.

Descriptions of education at Hampton tend to reflect more about the attitudes of the observer than anything else. Albert Shaw, editor of the prestigious *American Monthly Review of Reviews,* was so impressed with Hampton when he wrote about it in 1900 that he declared he could not find a private school in New York, even for $10,000 a year, that would offer his own child such a fine education. How ironic, he mused, that it is only in prisons and "certain schools for negroes and Indians" that the best and most effective schooling is offered. As he amplified his remarks, his own biases became clear. He was pleased that girls at Hampton started learning domestic skills in kindergarten, since such "real world skills" were more important than reading and writing. A thorough knowledge of "honest work" was more valuable than "artificial bookishness," as he put it.[20]

Whatever Shaw thought he saw, the academic program at Hampton was significant, especially in its mission to train new teachers. And although the school was founded as an agricultural institute, the pedagogical method was decidedly progressive. Routine farm work was used as a laboratory for math and science lessons. Cooking and other housekeeping skills were taught in the new mode, with a grounding in physiology and chemistry. Both girls and boys had classes in "sloyd," or manual arts, where they wore appropriate protective clothing and learned to use tools

properly as they learned how their materials responded to various manipulations. Students went outdoors for field studies in the woods or at the shore. The staff made an effort to integrate the knowledge taught in academic subjects, like math, into the shop work or the agricultural studies.[21] By approaching all aspects of daily life in a scientific fashion, Hampton taught its students a great deal—but it was such useful knowledge that some outsiders overlooked it as not being "real learning."

Hampton's detractors saw its focus on technical education as being at the expense of Latin and the classics, which would have been typical at schools for upper-class whites. Modern-day critics have amplified this critique, seeing the Hampton model as one of pacification and subjugation. Rather than preparing students for entry into the professions, they argue, Hampton was sending its students to the fields or the kitchen for such long hours of labor that no academic or social progress was possible.[22]

Johnston's photographic survey of Hampton offers a more complex picture of the school by including a wide range of settings and subjects. Apart from the extensive agricultural training programs, a variety of academic courses were central to the curriculum. Johnston's photos include a class in economics learning to generate a demand curve, a class in hygiene studying nutrition, a group of students on a field trip studying soil formation in various geological settings, and, in figure 14, a "current events" class studying South Africa.

When the Hampton photos are compared to the Washington school series, the similarities are more striking than the differences. Students are taking the same sorts of classes and showing the same sort of focused interest. With Hampton being rural and Washington, D.C., urban, there is a livestock focus in the former and a museum element in the latter. Then, too, Hampton students do not physically touch each other, as do the white young men and women in the Washington school scenes. For the most part, however, there are more parallels than differences. The fact that they were taken in the same year by the same photographer is certainly part of the explanation. But it may also be true that the actual educational program at Hampton was a lot more "progressive" than usually thought.

As might be expected of two large projects executed in the same year, Johnston's style shows a certain consistency. There is a deliberateness in the balancing of all the elements in the frame; nothing is lopsided or disturbing. She often chose to distance her camera from the scene slightly, to suggest that these are not personal portraits so much as illustrations of ideas. At

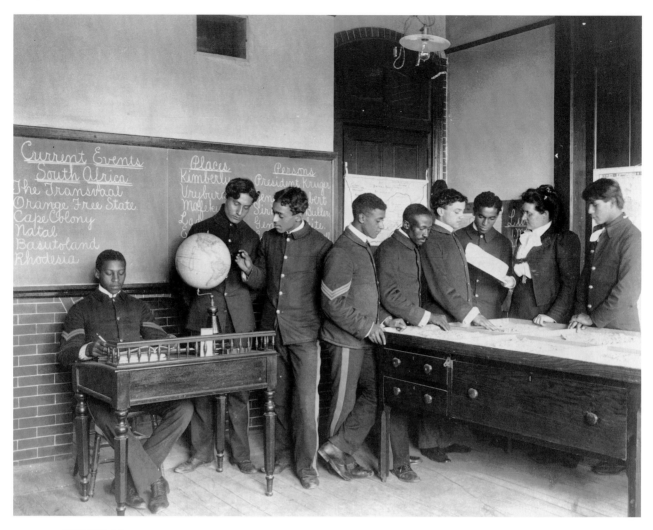

FIGURE 14

A class in current events, Hampton, 1899. While many charged that Hampton sheltered its students from the racist realities of the day, these Hampton students are studying South Africa.

times, Johnston's frames were so serenely composed that they appear didactic. For instance, her image of student carpenters repairing a staircase (figure 15) stands as an example of the sublime virtues of cooperative labor.

The terms of the Hampton job were certainly less shaky than those of the Washington project. Johnston charged Hampton $1,000 plus living expenses for herself and an assistant, who seems to have been her mother. In return she furnished 150 8-by-10 negatives with three prints of each, a set of duplicate negatives, and miscellaneous extra prints. The work occupied Johnston for all of December 1899 and part of the following January.

Some scholars have wondered why Johnston was offered the Hampton job: Why was a white woman chosen and not an African American?[23] Availability may have been a reason. It is hard to come up with the name of

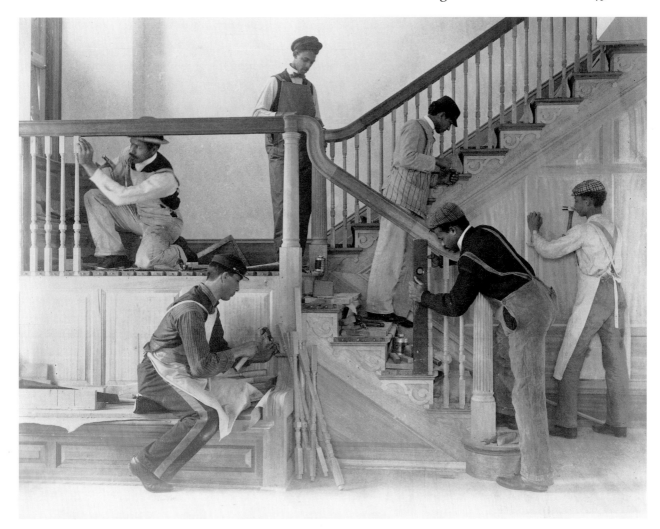

FIGURE 15

Students repairing staircase, Hampton, 1899. The students labor like angels on a Jacob's ladder to heaven, an apt visual metaphor for the Hampton mission.

any contemporary African American woman photographer who was both able to travel to Hampton for a month or two and capable of generating such a large number of photos in such a short time. Then again, most women photographers, whatever their color, were doing either studio work or sentimental scenes, rather than documentary reportage.

As far as African American male photographers were concerned, many were trained a decade later at Tuskegee, in part due to Johnston's 1902 and 1906 work there, but also thanks to Cornelius M. Battey, who in 1916 founded Tuskegee's photography division. There were men available in 1899, of course. Harry Shepherd comes to mind, since he showed photographs of Tuskegee at the Paris 1900 Exposition, although it is noted that he was "discharged" from the fair for "revolutionary utterances."[24]

If Hampton did not have a great number of African American photographers to choose from, the white candidate pool was not large either. At least Johnston's work did not exhibit the racist stereotypes so common during the period after the Civil War. African Americans were usually portrayed as childish, servile, and unable to look after themselves, especially in advertising art.[25] Such stereotypes even appear in the work of social critics commonly considered liberal, like the Dimock brothers, who visited and photographed Tuskegee Institute and Booker T. Washington when they passed through in 1906. A brief survey of the Dimock photos might raise no immediate concern, apart from the excessive romanticism of their portraits of students at work. On closer inspection, however, one finds the stereotypical "mammy" poses they arranged. Arthur Dimock's essay on the South—"The South and Its Problems," which appeared in the *Metropolitan Magazine* in October 1907—is positively nostalgic for plantation days and slavery, which, he laments, is as "dead as the fantastic chivalry of the Middle Ages."[26] If the Dimocks were the alternative, Johnston begins to look even more attractive.

Nor is it obvious that Frissell would have found it important to hire a person of color to photograph Hampton. His function was fund-raising, which he did quite well. It was in 1900, when Johnston's photos were exhibited in Paris, that the Hampton endowment leaped. In 1899, Hampton's income barely equaled expenditures; the annual addition to the endowment was about $18,000. In 1900, the endowment increased by more than $163,000, in 1901 by $38,000, and in 1902 by $128,000.[27] Much of the money Frissell was raising came from northern Quakers and others who were not familiar with Hampton firsthand, but who could see in Johnston's photographs the kind of progress they wanted to support.

What sort of progress was worthy in the eyes of Frissell's potential donors? To begin with, it was clear that very little money was ever forthcoming from local legislators. A little money was appropriated to Hampton and its offshoot institutions by various state authorities, but these funds were so modest that they were hardly worth courting. The fact that securing Quaker backing was a major objective can be seen by the emphasis on John Greenleaf Whittier in many of Johnston's frames, where his portrait hangs on the wall and his verses are written on the blackboards.

Reporters at the Negro Exhibit of the Paris 1900 Exposition ranked Johnston's Hampton photographs second in importance only to W. E. B. Du Bois's exhibit on the status of the "negro population" of Georgia. Third

place was felt to go to a set of dioramas showing the upward progress of ex-slaves from emancipation to the present, furnished by Professor Hunster and the Washington public schools. Fourth in interest was said to be an exhibit of books by "negro authors," and fifth was an exhibit of the sort of products being made at Tuskegee.[28]

The Negro Exhibit, as it was termed, was hailed as an official success. It showed the world that the United States was making progress in handling its race situation. As the assistant commissioner B. D. Woodward put it, "I think this exhibition will show other nations that we know how to solve the negro problems upon intelligent, civilized lines. Some foreigners think we have nothing for the negro, but the bludgeon and revolver, we shall convince them otherwise."[29]

Thomas Calloway, who organized and installed the exhibition, received special commendations from Commissioner Peck for his services. People appreciated the variety of types of exhibits he organized, from data to dioramas, and the cleverness with which he filled a small space with a large quantity of material. Calloway himself devised the display cabinets at which visitors could leaf through the hundreds of photographs being shown, including Johnston's series.

The exhibition was also felt to be important for the African American community at large. W. E. B. Du Bois, in his discussion of the Paris show, singled out the Hampton photos for depicting African Americans "studying, examining, and thinking of their own progress and prospects." The exhibit as a whole, Du Bois emphasized, enabled African Americans to see and examine their own history, their own accomplishments.[30] Using Du Bois's comments as their cue, some modern researchers have understood the Negro Exhibit as an important site for the construction of the image of the "New Negro." While doing a measure of cultural work by educating the white world, it also spoke to the interests of nonwhite peoples in seeing themselves and their own accomplishments.[31]

That the people they saw were complex can be credited in part to Johnston's artistry: It was her choice to frame highly conflicted images. Bald eagles were juxtaposed against Native Americans in traditional clothing; students in starched dress uniforms deliberated South African politics. These and countless other disturbing elements in Johnston's frames destabilized any attempt at a single, unidimensional interpretation of the Hampton story.[32]

In addition to serving as an exhibit in the Paris Expo and as a fund-

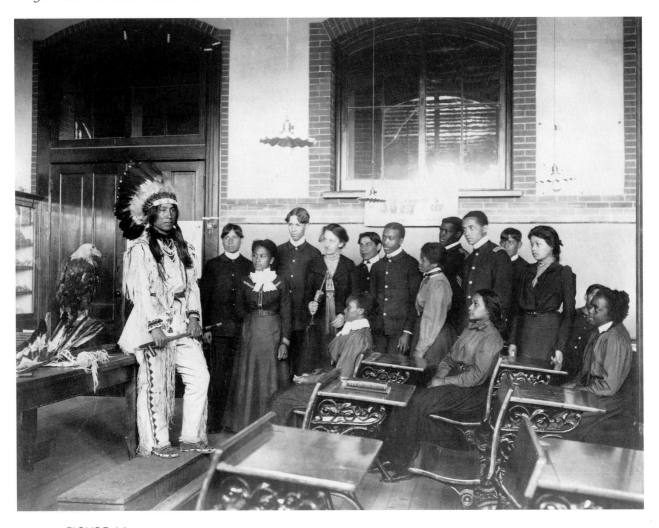

FIGURE 16

A lesson about Native Americans, Hampton, 1899. Widely reproduced, this tableau has received copious commentary, especially on the parallels between the nearly extinct eagle and the soon-to-be denatured Native Americans.

raising tool for the school, Johnston's photographic series was meant to help the school itself gain insight into its institutional goals. As Hampton Institute's *Southern Workman* commented in its account of the 1900 show: "It is part of the plan of the exhibit to contrast the new life among the Negroes and Indians with the old and then show how Hampton has helped to produce the change. . . . The value of such an exhibit lies not only in showing to others but in making clear to the school itself what it is doing."[33]

Unfortunately, when in 1966 John Szarkowski, the director of the photography department of New York's Museum of Modern Art (MOMA), selected a portion of the Hampton show to publish and exhibit under the name *The Hampton Album*, he chose a very particular subset of the original exhibit. Museum curators and catalog publishers make such decisions all

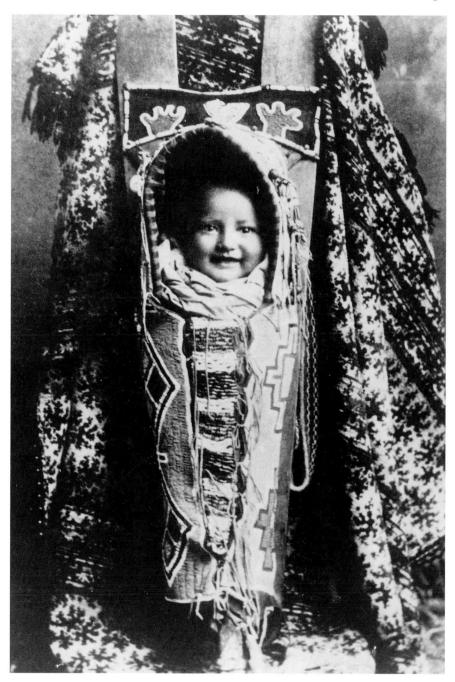

FIGURE 17
Baby, Hampton, 1899. This radiant Native American baby is posed in the traditional cradle-board. This photograph speaks to the vibrancy of traditional customs, not to their extinction.

the time, of course, usually on the basis of aesthetic and not political criteria. Still, by selecting certain views, by contrasting certain scenes, by captioning various photos as they saw fit, the staff of MOMA offered a lovely but entirely 1960s story of life at Hampton.[34] This is not necessarily a problem, except that it is MOMA's version of Johnston that many subse-

quent critics, such as Laura Wexler and James Guimond, relied upon for their analyses of her work.[35]

Any analysis of Johnston based solely on the MOMA exhibit is misleading. For one thing, although Wexler, in particular, bases much of her analysis on MOMA's captions, Johnston herself disliked captions, which she jokingly called the "gray matter" around a photo. To Johnston a photo spoke for itself; it did not need further explanation in words. Perhaps this attitude was a reaction to her earlier work as a magazine writer and illustrator, or maybe it was simply a statement of her belief in the artistic integrity of the photograph. Either way, she consistently resisted the use of the caption as commentary. At most, she scrawled a word or two on the back of a print to identify a subject or a location.

Little is known of the provenance of MOMA's set of Hampton photographs except the account of the ballet impresario and arts patron Lincoln Kirstein, that he discovered a set bound as an album in a Washington secondhand bookstore. Johnston's own set of Hampton prints, which she deposited with the Library of Congress, have some penciled notes on the reverse side, identifying the activity or group in the photo. Some have no notations at all, and none have actual captions. Therefore, it is a mistake to become too analytical about the MOMA edition's captions, except perhaps for a critique of MOMA's politics.

Apart from the issue of the captions, the selection of frames for the MOMA edition was not politically neutral. Against the MOMA-selected image of a class studying the nearly extinct Native American in figure 16, one can juxtapose an image MOMA rejected, like figure 17, with its radiant Native American baby bound in the traditional cradle-board. For every manual-labor or field-hand scene, there is another with a cluster of elegantly uniformed African American men learning horticulture or browsing tomes of poetry. For every African American woman dressed in servile chambermaid clothes, there is another in a work smock learning to use a hand drill, as in figure 18.

What is important here is to comprehend the sheer range of imagery Johnston offers us. If forty photos are enough to tell one tale, and looking at another forty can turn the story around, then the depth of Johnston's Hampton study can begin to be appreciated. Her apparent neutrality toward and outsider status regarding the debates within the African American community on the correct road for "negro progress" were probably an advantage in that they allowed Johnston to reveal the complexities of the

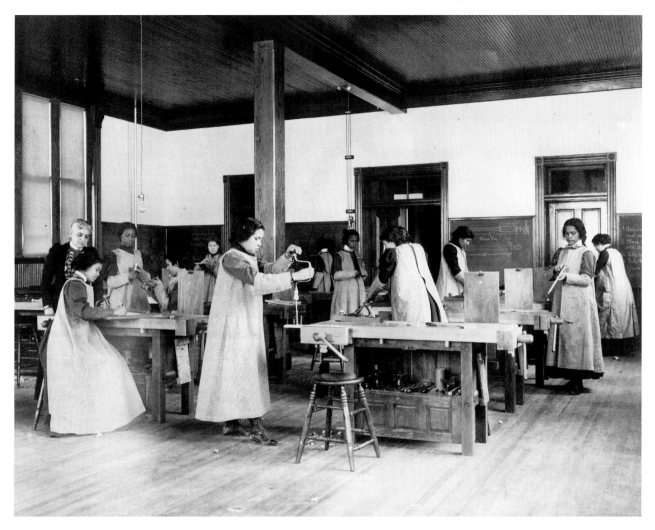

FIGURE 18

A class in "sloyd" (manual arts), Hampton, 1899. That women were being trained in such nontraditional work may seem surprising to those who assume that Hampton was a backward institution. True to the precepts of progressive education, the students wore protective clothing.

Hampton experiment, even as her progressive ideals kept her open to its promise.[36]

Apart from the recognition she received in Paris for the Hampton show, and the warm appreciation of Frissell as the school's chief fund-raiser, Johnston had the nonlucrative but satisfying support of the Hampton student body. Some wrote to ask for copies of various shots, and others appreciated that Johnston had brought to Hampton a selection from her own photo collection. One evening at the Domestic Science Building, Johnston showed a series of her own photographs along with some of the best of her contemporaries—F. Holland Day, Gertrude Kasebier, and Joseph Keiley.[37] That she took such pains shows the respect Johnston herself had for these students. They were not "objects" to her but "subjects";

not inferior people being palliated by a backward education, but hard-working students on the cutting edge of progressive education.

Johnston's impact was recognized a few years later by Day when he visited Hampton in 1905. Some of the students in the Hampton Camera Club (a.k.a. the Kiquotan Kamera Klub) remembered seeing Day's figure studies, especially his racially daring *Ebony and Ivory,* when Johnston showed her collections.[38] It could even be argued that Johnston's visit made it easier for Day to gain acceptance, for he was there to do his own very radical photography: headshots without context, intense meditations on the aesthetics of dark skin—material that was hardly suitable for a Victorian mantelpiece, much less a fund-raising appeal.[39] There was nothing crude about Day's photographs; they were just too "arty" for most people. That Day's visit at Hampton was a success says something about the open-mindedness of the student body.

Johnston tried to make the most of the success of her Hampton photos as soon as she returned to Washington. In December 1900, she wrote to the Bureau of Indian Affairs to offer to photograph the U.S. Indian Industrial School in Carlisle, Pennsylvania, for the upcoming world's fair in Buffalo, New York. The bureau declined for lack of funds, but by April of the following year she was photographing Carlisle with the blessing of Richard Henry Pratt, the school's founder.[40]

Pratt had established the Carlisle school in 1879 to train Native American children to enter white society. As he himself put it, addressing a Baptist convention, "In Indian civilization, I am a Baptist . . . because I believe in immersing the Indians in our civilization and when we get them under holding them there until they are thoroughly soaked."[41]

Having been a military man, Pratt's model for the white lifestyle was boot camp. The dormitories were bare, the schoolrooms austere, the discipline severe. During the summer months, favored students went on what was called the "Carlisle Outing," meaning that they were sent to work on the farms of white families in the area. Students at Carlisle were not orphans, but school policy was to act as if they were. It was hoped that after several years at Carlisle, children would be so estranged from their homes and families that they would not return to their reservations, thus (theoretically) hastening their integration into the American mainstream.

Johnston went to Carlisle in late March 1901. At first the weather was so overcast that she was dissatisfied with her work. Many of the images

had to be reshot for other reasons, as well, in some cases because her subjects were not aesthetically posed. As someone wrote to Johnston concerning a shot of a group of employees, "the upward gaze of a good many rather detracts from the good effect."[42]

The comparison of a Carlisle classroom with one at Hampton reveals remarkable contrasts. Carlisle has rough-paneled walls; Hampton is wainscoted to eye level. Carlisle students look down at their feet; Hampton students look at their work. Carlisle is ill-equipped, makeshift; Hampton is urbane, sophisticated. Some of these impressions come from the detail in Johnston's frames; Carlisle students dig in the ground with their hands, rather than using tools. They bend over their work, which is never made to look important, only menial.

Beyond the particulars, at Carlisle, Johnston's angle of vision seems to

FIGURE 19

Debate class, Carlisle Indian School, 1901. The question on the blackboard reads, "Resolved: —That the negroes of the south should not be denied the right of citizenship."

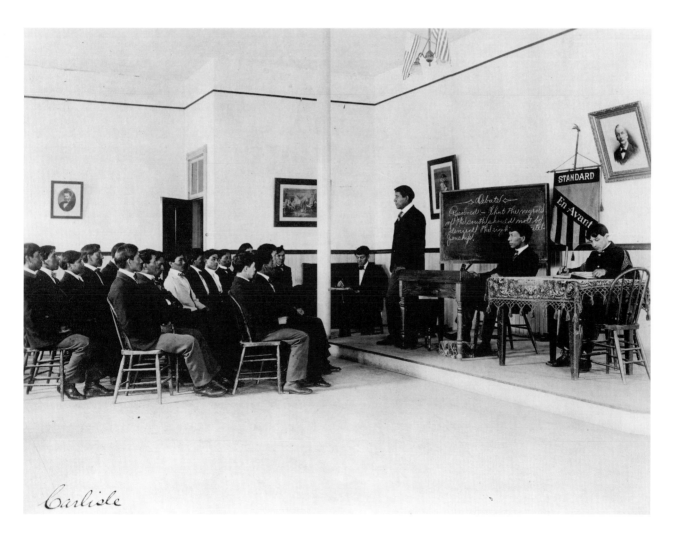

Carlisle

have shifted. No longer does she meet her subjects at eye level. Now her camera is farther back and angled somehow over the heads of the students. There are large stretches of wall and ceiling, tops and backs of heads. There is very little eye contact.

It may be that Carlisle was a very dreary place and her photos simply captured that fact. It may also be true that Johnston never felt as comfortable at Carlisle as she did at Hampton. Washington, where Johnston grew up, has always been an African American city. The civil service, a major Washington employer, was not actually segregated until early in the twentieth century. Native Americans, on the other hand, especially Pratt's deracinated ones, would have been a relatively unfamiliar cultural group to Johnston. One of Johnston's best friends, writing to her at Carlisle, resorts to such forced jokiness that her uneasiness becomes plain: "And there you are, a-going to waste at Carlisle, so to speak. But I guess the Indians know a good pussonable and Only Original American and will make it pleasant with a few war dances and powwows with other polite vaudeville accompaniments."[43]

What was Johnston supposed to be photographing at Carlisle? Since Pratt was paying, the photos presumably were to be used for fund-raising. But the whole series is so depressing that it cannot have been much of a success in that regard. The students rarely look at the camera; they are downcast, evasive. If any emotion at all was captured, it would have to be strain. The photographs suggest children being prepared for a cold, hard world. In figure 19, one of the rare Carlisle photos depicting students in formal dress, Johnston offers us a look at their debate class. The blackboard reveals the question they were debating—whether "negroes" had a right to citizenship.

The contrast between Johnston's dour Carlisle series and her friend Gertrude Kasebier's studio portraits of proud Native Americans could not be more striking. And yet the photos were taken in the same period, of some of the same people. Why are they so different?

For one thing, Kasebier was not working at Carlisle, but in her New York studio. For her Native American subjects, like Iron Tail and Zitkala-Sa, Kasebier left her studio open, her books available, and even served up plenty of frankfurters on unbuttered white bread, just the way her guests liked.[44] She let them pose in a variety of styles, in native attire or otherwise. None of this informality and mutual respect was characteristic of

Carlisle. Certainly native dress was anathema to Pratt, who was fond of saying that Iron Tail only wore it because Buffalo Bill paid him. All the same, Iron Tail's son was a student at Carlisle, and Zitkala-Sa, Kasebier's ineffable model, actually taught on the Carlisle faculty.[45]

The following year, Johnston had a request from Booker T. Washington to come to Alabama to photograph the Tuskegee Institute. Johnston asked for the same fee (plus travel expenses) that she had gotten at Hampton, offering this time to supply an extra set of prints, suitable for exhibition. She added that she would be happy to train some students while she worked.[46]

Johnston and her assistant came to Tuskegee in November 1902. Washington wanted a series of photographs to document the progress Tuskegee had made in its twenty-one years of existence. But its work was not to be demonstrated by contrast with the stagnation of the older generation, as Hampton's had been.[47] Tuskegee's special mission was to foster the development of offshoot institutions. Theoretically, students who graduated from Tuskegee would go back to their own communities to set up new schools. Some of these "little Tuskegees" were already up and running in Alabama, and Washington knew that showing the right photos to the right donors would make a big difference in the viability of these shoestring operations. So Johnston was not only supposed to photograph Tuskegee, but also its offshoot schools at Snow Hill, Mt. Meigs, and Ramer, Alabama.

What happened while Johnston was working at Ramer could have been the end of her career, or even her life. George Washington Carver called it "the most frightful experience of my life." Emphasizing that "it was a very serious question indeed as to whether I would return to Tuskegee alive or not," Carver tried to explain:[48]

It seems that Carver and Johnston had taken the train together from Tuskegee to Ramer. The train was late. When they finally arrived it was dark, and a crowd of local white people were waiting around on the platform to see what Miss Johnston was going to do. What they saw was Henry, the head of the Ramer school, with three of his colleagues, collecting both Carver and Johnston in his buggy and heading off into the woods, in the direction of his home. Around eleven at night, the postmaster Turnipseed's son and a couple of his friends were loitering in town when

they saw Henry heading back—with Johnston. Had she been dallying in the dark for several hours with five African American men?

Young Turnipseed and his friend Armes went from jeering to shooting in minutes. Johnston and Henry ran for their lives, and Johnston then crept back to the house; Carver smuggled her out the back door. They then went to the next station down the line, where she caught a train in the morning.

Back in Ramer, things did not end so neatly. Vigilante whites started searching for Henry, seen as the primary offender because: (a) he did not immediately take Johnston to a white hotel; (b) speculation was high as to what they were doing in the woods; and (c) the whites did not like him running a "colored" school in Ramer anyway, which they considered white turf.[49]

Unbeknownst to those patrolling his school in hopes of picking him up and lynching him, Henry had fled to Montgomery. Carver stayed alive by staying out of sight, eventually walking to another train station to return to Tuskegee.

Once Carver and Johnston were together in Tuskegee, they discussed what to do. Johnston's first instinct was to complain to someone in power—the governor or even her old friend Teddy Roosevelt, now president. Carver and Mrs. Washington were inclined to "say just as little as possible about it." In the end, they decided to let Booker T. Washington handle the situation as he thought best. Washington weighed the negative publicity Tuskegee would surely get against the potential benefits of pursuing the matter with authorities. Henry was finished with Ramer, wanting nothing more to do with the place; he already had a new job elsewhere. Ramer was not a choice location for rebuilding the school, so there was not a point to be made there, either. In what some would call his classic confrontation-avoidance mode, Washington opted for silence.

Carver called Johnston "the pluckiest woman I ever saw."[50] Johnston herself was equally admiring of Carver, as her portrait of him (figure 20) shows. Either out of respect for Washington's decision or from a new understanding of the ease with which a black man might be lynched, Johnston kept silent too. She never played up the Ramer incident for its publicity value, as she did some of her other scrapes.

The photographs that were made at Tuskegee might be judged worth all the trouble they cost: Johnston is clearly at the height of her expressive

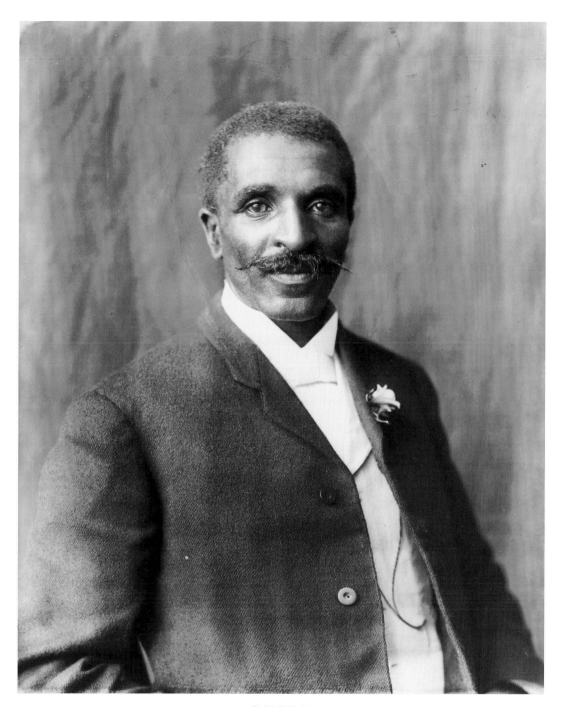

FIGURE 20

*George Washington Carver, Tuskegee, 1906. Following Johnston's aim to allow the subject's personality
to be revealed as fully as possible in portraits, Carver's trademark wildflower boutonniere was included here,
symbolic both of his interests and the idiosyncrasy of his mode of expression.*

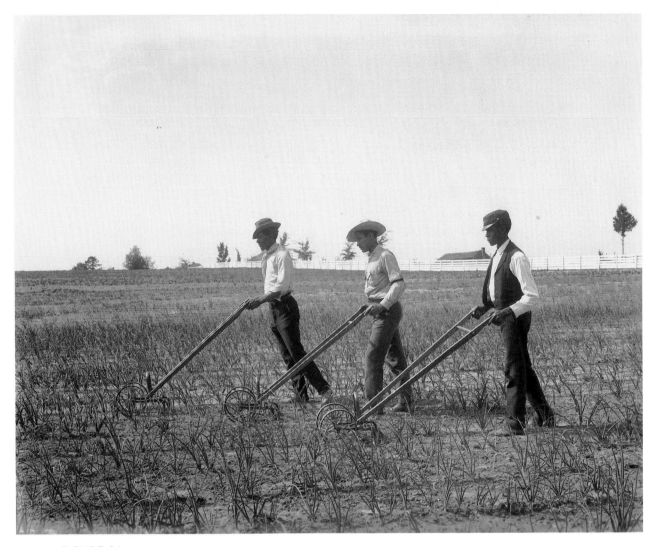

FIGURE 21

Cultivating onions, Tuskegee, 1902.

powers. Her frames are full of allusions, irony, wit, and complex intensity. Consider figure 21, with three farming students cultivating onions. Here Johnston makes reference to Jean-François Millet's *Gleaners*, a painting popular in the late nineteenth century. The gleaners live from what the harvesters have dropped, just as the Tuskegee toilers made their livings off the pittance that their richer neighbors left.

Figure 22, a hay-stacking scene, is so reminiscent of the haystacks of the French impressionists that it is hard to believe it is actually a photograph. From the graceful mounds of the haystacks to the nattily dressed Tuskegee farming students, the scene seems choreographed by some imaginative set designer dreaming of the French countryside. Johnston's visual

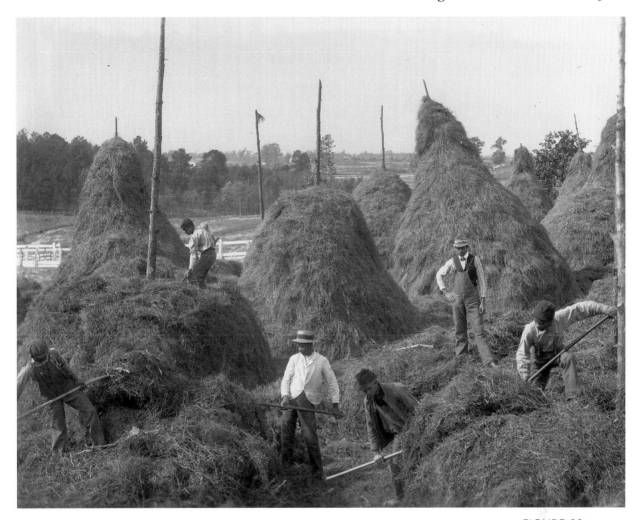

FIGURE 22

Stacking hay, Tuskegee, 1902. Johnston framed these Tuskegee agricultural students in a classic French peasant scene.

references make Tuskegee seem more classical, more aesthetically pleasing, than an agricultural school would ordinarily look.

In other shots, as in figure 23, Johnston juxtaposed black and white faces—white mannequin heads next to real African American heads in a Tuskegee millinery class—to raise questions about race. What does it mean, for a roomful of women of one color, to be bent over learning to adorn the heads of women of another color? In another shot, her Tuskegee students (again, all African American) wear slave-era homespun garments and toil over heaps of cotton, allegedly learning to make mattresses. On closer inspection, one woman is brandishing a hammer, another a hatchet. In another scene, also all female, the students wear frilly servant outfits and hover over pots of what could be grits or black-eyed peas. It is an

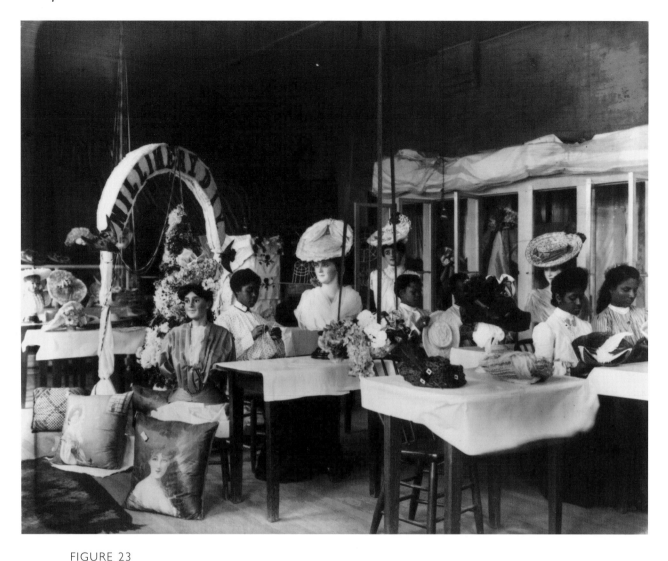

FIGURE 23

Millinery class, Tuskegee, 1902. As in the photograph of African-American students viewing a statue of George Washington (figure 13), the racial ironies are striking in this frame.

excruciating tableau to contemplate. From Washington's own writings, it is known that many female students at Tuskegee resented having to learn anything that smacked of slave-era labor.[51] Whether Johnston was aware of this issue is not known, but her photos suggest that the students may have had legitimate grounds for complaint.

Overall, there was much at Tuskegee that Johnston admired. Anything Carver did, from the agricultural program that he headed to the livestock anatomy class he conducted, was made to look fascinating. Far from finding all the new construction at Tuskegee either ugly or distracting, Johnston seemed to have considered it uplifting, even romantic. Her construction workers have the glow of the "brave builders of a dream." Her scene

of student brickmasons would warm the heart of any socialist-realist art critic. Her shots of students at the library, on the other hand, indicate that there was not much unstructured social time at this institution.

The series of portraits that Johnston did at Tuskegee—those of the teachers and Booker T. Washington's first family poses—helped define Tuskegee as an established institution, complete with a set of faces to remember. Unlike Hampton and Carlisle, both run largely by whites, Tuskegee and the "little Tuskegees" were run by and for African Americans. Johnston's photos were also used by Washington in most of his books and magazine articles to illustrate the content of his curriculum. No one looking at the full range of these photos would mistake Tuskegee for a backward, preindustrial backwater designed to pacify and deradicalize ex-slaves.

If the wave of the future was supposed to be workers tending big machines rather than toiling endlessly at manual labor, then this new worker was already being trained at Tuskegee. Johnston's photograph of the student oiling the milk separator (figure 24), with the worker dwarfed by the "round wheels of industry," prefigured Lewis Hine's 1932 Men at Work series.[52] And while the "little Tuskegees" like Mt. Meigs and Snow Hill look as rudimentary as they obviously were, they still signified the beginnings of communities based around a schoolhouse, rather than the "big house" of a plantation.

Four years later, in 1906, Tuskegee hired Johnston again, this time to do a series on its twenty-fifth anniversary celebrations. Apart from the obligatory dais shots and some scenes of outdoor barbecues, there was an important series documenting the work and interests of Tuskegee graduates out in the world on their own. The photos show an impressive range of achievements: inventors and artists, back-to-Africa advocates and Appalachian pioneers. Also chronicled were accomplishments of citizens from the writer Zora Neale Hurston's all–African American hometown, Eatonville, Florida. There are several portraits of the alumnus John Robinson, seen in figure 25, displaying his African artifacts or his agricultural output.

During this 1906 trip, Johnston departed from her usual documentary mode and started photographing anonymous African Americans, usually women, as in figure 26. Most were not identified on the back of the print, so they could not have been portraits she intended to sell to anyone. One

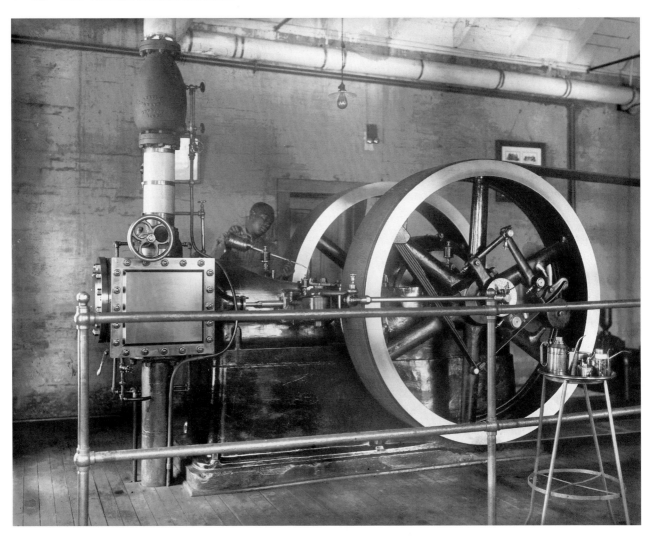

FIGURE 24

Oiling a milk separator, Tuskegee, 1902. Critics faulted Hampton and Tuskegee for industrial backwardness, yet Johnston's camera recorded this modern-looking worker tending an impressively complex machine.

frame, figure 27, depicts a large but informal grouping of Tuskegee women—again, unidentified—that speaks worlds of the sort of community they shared. At first glance, these women all seem simply genteel, but a longer look reveals their complexity. They are intelligent, strong, individual—and sisterly, too.

All four of these projects—the Washington schools, Hampton, Carlisle, and Tuskegee—took place within a few years of each other. As Johnston worked on each, she refined the techniques she had used on the previous job. She was self-confident enough to offer darkroom training to willing students. Surely it was her presence in 1902 and 1906 that reinforced the idea of having a photography division at Tuskegee. (Cornelius Battey headed the photography program at Tuskegee starting in 1916, and

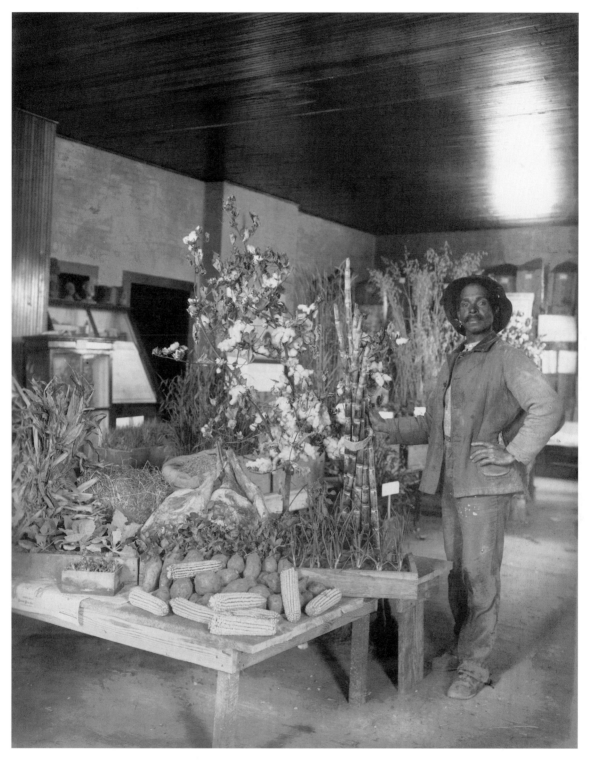

FIGURE 25

*John Robinson, Tuskegee, 1906. Tuskegee's twenty-fifth anniversary celebrations included a fair
to display the work of its alumni. John Robinson, Johnston recorded, "went to Africa to show natives in
[a] German colony how to raise cotton."*

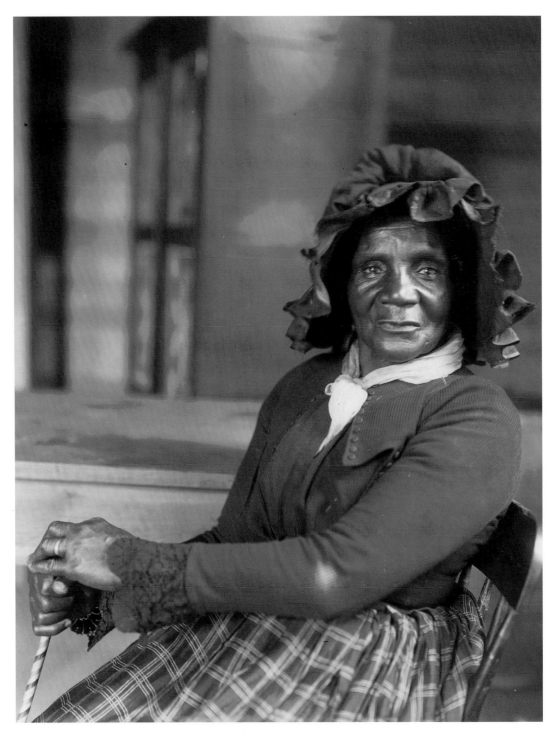

FIGURE 26

Woman at Tuskegee, 1906. Johnston did not identity this woman, whose face or demeanor must have caught her attention.

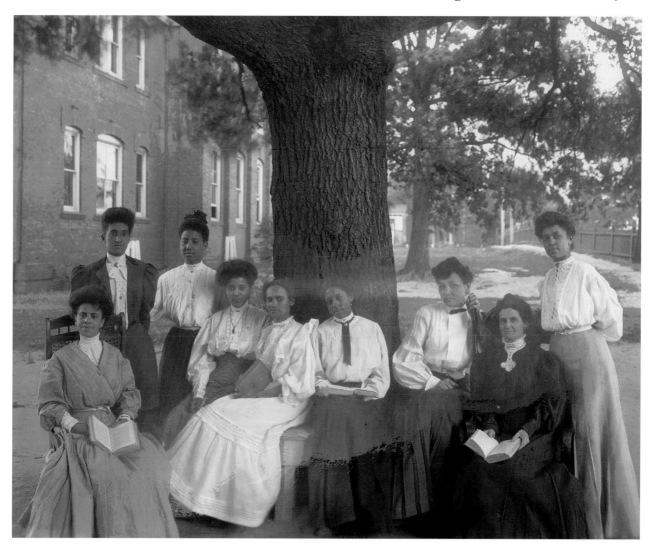

a great number of the South's working photographers—Ellis Weems, P. H. Polk, Elise Harleston—trained under him.[53]) It is true, in many ways, that Johnston was raising her own replacements when she went to Tuskegee, but she never begrudged any student a chance. Photography was a big field, and there was no telling what direction she herself would be taking in the next years.

FIGURE 27
Group of women, Tuskegee, 1906. Most were probably on the faculty at Tuskegee. They hold their books as if just interrupted in their reading and look at the camera with intelligent interest. A large but informal gathering, it suggests the style of intellectual culture at Tuskegee.

4

To New York and a New Partnership:
1900–1917

While working on her big turn-of-the-century projects, Johnston continued showing in other venues, even those more typical for artistic (i.e., not-for-hire) photographers. She exhibited two prints at the London Photographic Salon in 1896 and two more in the Royal Photographic Society exposition in 1897. The next year she exhibited at the Pennsylvania Academy of Fine Arts and had a one-woman show at the New York Camera Club. The year after that, 1899, she showed her Washington schools series at the Veerhoff Galleries in Washington. In 1901 she was invited to submit work to the *American Annual of Photography Almanac*. Stieglitz's *Camera Notes* printed two Johnston photographs in both 1898 and 1899.

The works she showed in art venues were generally in the dominant pictorial mode: exotically garbed women in dramatic poses. Their titles—*Geisha, Chrysanthemum Lady, Pepita, Mignon*—give clues to the sensibility behind them. Far more satisfying were her commissioned portraits of actual customers, where posture, decor, and costume all worked together to express a complete personality. These portraits were never cliché and often insightful.

They were also beneath contempt in the view of Alfred Stieglitz, who considered Johnston "merely" commercial. True artists kept themselves

above the mean considerations of the marketplace and did not stoop to trying to please customers. That some of Stieglitz's close (male) colleagues, among them Edward Steichen, did considerable commercial work at times was apparently acceptable. Furthermore, since the Photo-Secessionists were busy trying to prove that photography was an art form commensurate with paintings, they tried to make their photos look as much as possible like paintings.

Johnston, with her classical art background, naturally worked to compose a photograph in the most aesthetically pleasing manner possible. But there was a huge difference between balancing a composition and deliberately searching out hazy, atmospheric scenes to give a painterly effect.[1] Still, as long as Stieglitz was the most influential figure in American photography, it was prudent for anyone who wanted to be taken seriously to do at least some work in the pictorialist mode. So Johnston did, even paying her dues in 1904 to be an actual member of Stieglitz's Photo-Secession.

Nonpictorialist, documentary work remained her main focus, however. In 1901, the Pan-American Exposition was held in Buffalo, New York. Johnston's old Chicago friend C. D. Arnold was the official photographer for the fair; Johnston went primarily to cover the president's visit. Quite by chance, Johnston made the last snapshot of President McKinley before he was assassinated. Her whole sequence of McKinley photos suddenly became valuable, as newspapers and wire services vied for the right to reproduce these last images of the president. Johnston's mailbox filled with requests from common people for copies, some simply addressed to "Miss Johnston / Washington, D.C."[2] Apart from the McKinley photos, Johnston did, in the end, turn out some wonderful scenes of the Pan-American Exposition itself—informal, atmospheric shots of the crowds and the sideshows.[3]

While there is no telling how much money she made because of McKinley's death, there is considerable evidence of money she did not make—she was continually hounding unscrupulous newspapers to collect reprint fees or haggle over broken negatives.[4] In this, as with much of her turn-of-the-century business, George Grantham Bain acted as her agent.

Although most of Johnston's work with Bain was straightforward news coverage, the two overextended themselves from time to time. A case in point was their plan to introduce themselves to some wealthy patrons by offering to do their portraits for a special volume to be presented to the

"German Emperor." It was 1905 and yachting was the leisure activity of choice of the New York rich and famous. Bain more or less invented the "American Sub-Committee of the Imperial Yacht Club" and appointed Johnston the official photographer for an album they would print of American yachts and yachtsmen. This booklet would then be presented by the German ambassador, the Baron von Sternburg, to the German kaiser at the Kiel yacht races.

That Bain proposed to pay all the expenses of this venture himself gives some indication of its true purpose. He and Johnston mailed letters to a long list of prominent people on the East Coast, advising them to make an appointment for a sitting with Miss Johnston as soon as possible.

To be sure, many did schedule portraits. Others ignored the bait and sent back preexisting photos or turned down the proposition altogether. In the end, Bain and Johnston did put together an album, but it disappeared en route to Germany and was never properly presented to the kaiser.[5] To the extent that Bain opened a few strategic doors for himself and for Johnston, the enterprise was probably worthwhile.

They had other promotional concepts that went nowhere, such as designing stationery for Johnston featuring Roosevelt's scrawled introduction of Johnston to Dewey. Bain periodically tried to convince business leaders like Andrew Carnegie to sponsor albums of photos of themselves to distribute at the big world's fairs or other international events. Given that most American financiers were reticent about publicity, and that some people in America simply did not want their portrait handed about, such projects were not easy to sell. Perhaps it was this experience that taught Johnston to try other routes to the rich—such as, for example, their gardens.

Theodore Roosevelt was famous for keeping the media away from his White House, being especially concerned that his children not be spoiled by constant press coverage. He had known Johnston for years, however, so he gave her permission to visit and photograph. Johnston was amused by the Roosevelt children, noting, "They had a little fox terrier and a calico pony and a macaw, with a wicked-looking beak. The children used to pile on the back of the pony as thickly as they could sit, and he would trot along with them until he decided he had carried them far enough, and then he would sit down on his hind legs or rear up in front, and they would all go sliding down upon the ground."[6]

Johnston's friendship with Roosevelt went back to his Rough Riders

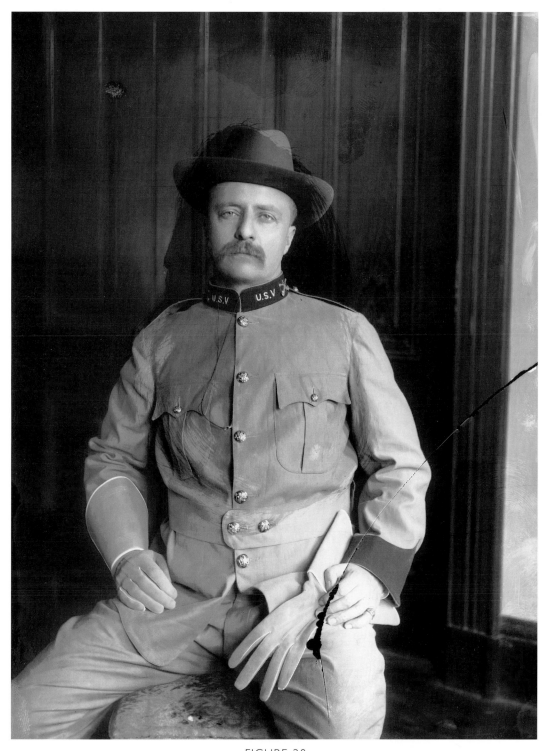

FIGURE 28

Theodore Roosevelt, 1898. Johnston captured Roosevelt in his new uniform only fifteen minutes after it was delivered.

days, when she was the first to photograph him in his new Brooks Brothers–made uniform. She had gone down to the Navy Department to photograph his successor but met Colonel Roosevelt there instead. Might she get a shot of him in his new uniform? "By jove, yes," he answered, provided she could come to his home early the next morning. She was there at eight in the morning—only fifteen minutes after the actual uniform had been delivered, by her account.[7] Figure 28, showing Roosevelt in his new Rough Rider uniform, is a curiously languorous depiction; the man seems almost glassy-eyed with pleasure at the cut of his cloth.

The most lucrative Roosevelt connection, however, was with the media darling Alice Roosevelt (later, Longworth), an exclusive Johnston would not have gotten had she not been the favorite of the president and his wife. Johnston's widely syndicated portraits of Alice, the "first daughter," from her debutante years (figure 29) to her elaborate wedding, all conveyed her unique presence.

Meanwhile, Johnston never let any world's fair business escape her. In 1904, she went to St. Louis to photograph the Louisiana Purchase Exposition, where she served on the International Jury of Awards. The French delegation, which included her mentor and friend from Paris Antoine "Papa" Lumière, spoke no English, so Johnston served as an impromptu translator for them. Not only did she receive awards from the exposition for her service, but there were commendations from the French government as well. This won her no favor with the Photo-Secessionists, however, who were boycotting the Louisiana Purchase Exposition for not categorizing photography as a fine art.

Happily, such disputes did not concern Frenchmen like Lumière, whose relationship with Johnston continued over the years. On her trips to France in 1905 and 1906, she, her mother, and her aunt became quite close with the Lumière family, who personally trained Johnston in the theory and technique of their new color process. Returning home to Washington, she wrote "Papa" Lumière long letters in French covering photography as well as personal matters. How much would it cost to send over some large quantities of cognac? Might she act as the agent for the property he wanted to sell? And yes, she was worried that her father was ill and might lose the job he'd had for some thirty-five years.[8] Johnston's father died some two years after that letter, in 1907.

Johnston was never shy about her ambitions vis-à-vis the Lumières. Whether or not she received any commissions from brokering their prop-

FIGURE 29

*Alice Roosevelt (later Longworth), 1902. While her torso suggests some tropical flower,
her eyes rest on the viewer with penetrating gravity.*

erty, the fact that they had trained her in their new color process was the real gold mine, and she knew it. Johnston's correspondents congratulated her for having the "inside track" on bringing the Lumière's process to the United States. In fact, the Lumières held themselves away from the American market until they could be more personally involved.

By 1912, the American papers were reporting that Johnston was making what was called "color photo-transparencies." These were a bit like large-format slides, meant to be individually framed and hung so the light could pass through them. Unlike her colored lantern slides, which were hand-tinted by artists, these new photo-transparencies were produced by sunlight falling on a light-sensitive negative. The precariousness of the process and the fact that no copies could be made meant it was extremely expensive: $50 a shot, a substantial amount in 1912. Johnston pitched it as an alternative to having a miniature portrait painted. Both were costly, she admitted, but the photo-transparency was more decorative. It was the sort of thing people with taste and means would want to indulge themselves with, even if she, the photographer, was loathe to let them buy the work. As Johnston explained in a newspaper article, "just when we get a particularly fine outdoor plate—one that we have worked over and petted and loved—along comes a patron and snatches it away. That's the cruel part of this work. I made some beautiful views of Miss Anne Morgan's gardens and some lovely ones of the Vanderlip country place that it was very hard to part with."[9] In case anyone missed the point, a fetching portrait of the socially prominent Vanderlips (in black and white, the limit of newspaper technology) illustrated the piece. Johnston became known as a pioneer practitioner of the color process, but color work was never her forte.

Johnston's relations with the Lumières were more intimate than those she shared with other European photographers, like Robert Demachy or Adolf de Meyer, but knowing such Europeans made her more cosmopolitan in outlook. Americans operating outside New York or San Francisco, particularly women, rarely felt worldly. Johnston, however, had lived in Paris as a student and had traveled Europe with her mother and her aunt.

Thus, when Gertrude Kasebier invited Johnston to "do" Europe with her in 1905, it was not an unreasonable proposition. Johnston's friendship with Kasebier dated back to 1899, when they were both on the jury for the Philadelphia Salon, and included the time when Johnston wanted to show Kasebier's work in Paris. A couple years after, Kasebier sent her an unusu-

ally candid note, "I've a great scheme in this head of mine. I want to do some Kings. Can you tell me how I can get some introductions. . . ."[10]

Some twelve years her senior, Kasebier was not an unworldly woman herself. She contacted Johnston with this particular idea because Johnston was known for her boldness when it came to getting access to people. Kasebier did not write often to Johnston, but when she did, she treated her as a colleague. "My dear Miss Johnston," Kasebier wrote in a 1903 note, "I have a cottage at Newport, just out of town. If you . . . come to me, you will be most heartily welcome. I can not but think that good would come if we were to see each other more. We two women with a common interest. Cordially yours. . . ."[11]

In the summer of 1905, the two women decided to go to Europe together—not to make money, but simply to enjoy themselves. Kasebier did at least one romantic portrait of Johnston at Bagna di Luca, and from the looks of some of their cafe shots, the two seem to have relaxed rather stylishly.[12] The elegant Baron Adolf de Meyer was their host in Venice, where they all continued to photograph one another. Then the two women split up for a short while, Johnston going to visit and study with the Lumières and Kasebier going to Paris to see Rodin. They met up again at the photographer Robert Demachy's estate in Trouville, France.[13] The British leg of the trip may have been a bit disappointing by contrast, since August was not party season in London. Still, they were given lab privileges at the Royal Photographic Society and everyone available tried to see them.[14]

Back in the States, Johnston never hesitated to try to develop a story from wherever she was wandering. What she had learned from the Lumières about wine-making she peddled as a magazine photo feature on traditional French viniculture. When she decided to travel in the southern states, she thought a feature on Joel Chandler Harris (a.k.a. "Uncle Remus") might be marketable. The only problem was that Harris was a notorious recluse.

Johnston was undeterred. Once in Atlanta, she hired a livery coach to take her out to Harris's Snap Bean Farm, where she proceeded to wear down his resistance. She put away her camera, sat out on the veranda with Harris, and let him talk about his garden. By and by, he naturally got up to show off his plantings. They then walked his garden for a while, and Johnston eventually took the photo (figure 30) that turned out to be his wife's

favorite. According to her, it captured the twinkle in his eye that she loved. At last, Harris chuckled, at last, he could see that twinkle himself! The U.S. postage stamp honoring Harris was based on the Johnston portrait, which is one of the few that convey his "grandfatherly" sparkle.[15]

In the summer of 1906, Johnston returned to Europe, this time with her mother and her Aunt Nin (Cornelia Hagan). In Paris the three women wandered into the morgue, quite by mistake, and ended up viewing a pair of suicides. They also went on the infamous tour of the Paris sewers, gondoliering along on that French version of the River Styx, and spent time with Monsieur Gaumont at his studio, studying his "cinematograph" (motion picture) machine.

However, the primary mission of this voyage, which was partly underwritten by the popular magazine the *Delineator,* was an audience with the English actress Ellen Terry. Johnston pursued Terry relentlessly until an insider at *McClure's* confided that they already had the exclusive on Terry's forthcoming autobiography. But the trip was not entirely wasted: Johnston tracked down Yeats in Ireland and Kipling in England and spent more time with Frances Hodgson Burnett, a friend since her Washington sittings.

This trip was marked by some elaborate socializing. Johnston gleefully reported how she developed the ruse of saying she had a cold, to have an excuse not to overeat in the earlier courses of grand meals.[16] Poor "Fader," as Johnston called her father, had to make do with letters from the travelers, since he stayed back in Washington at his job.

This was very much a women's trip, after all. The three Johnston women traveled like sisters, either looking after each other or leaving each other alone in a very natural and comfortable way. At some point Johnston typed up a table of contents for a hypothetical book called "Travelling on the Continong [*sic*] With Aunt Nin," complete with tributes to the "good old hot water bag," the "marvelous tuckaway umbrella," the "faithful and Protean Brief-Case," and "Aunt Nin's Cheerful, Chipper and Chatty Letters."[17]

Johnston also wrote a mock invocation for the 1906 trip, where she calls for the "peoples of the countries" they are visiting to "be picturesque" by wearing their own clothes; for servants to "accept no gratuities," and for the "unmarried men of all nations" to "Beware!!!!!!"[18]

Little evidence exists, however, that said unmarried men had great cause for alarm. By the summer of 1906, Johnston was forty-two years old. At the turn of the century, a single woman still unmarried by that age

FIGURE 30

Joel Chandler Harris ("Uncle Remus"), 1905. Johnston's portrait of the famously shy writer captured his avuncular charm.

would have been considered a confirmed spinster. Friends called Johnston a "bachelor girl," which had a somewhat more cheerful ring to it.[19] Apart from the labels and the joking, what kind of emotional terrain lay beneath? From the letters and photographs that Johnston saved, we can piece together a bit more of the picture.

Sometime in her late twenties or early thirties, Johnston came to know Mattie Edwards Hewitt of St. Louis, Missouri (figure 31). Married to the photographer Arthur Hewitt, Mattie ran their household and worked in their darkroom. The details of the marital arrangements are not known, nor the exact circumstances of Johnston and Hewitt's introduction to each other. Hewitt seems to have known Johnston in St. Louis but also to have traveled to Washington on several occasions. At some point, Mrs. Hewitt suffered a miscarriage, which may have resulted in an inability to bear children. After this episode, she was deeply upset. In 1909, she divorced Arthur Hewitt and moved to New York to live and work with Johnston, who had recently relocated to New York. They made their business partnership official in 1913, specializing in architectural photography, including stately homes and gardens. They dissolved their entire relationship in 1917.

Mrs. Hewitt continued working as a photographer based in New York with the photographer Jessie Tarbox Beals's daughter as her assistant, at least until the Great Depression squeezed the budgets of freelancers everywhere.[20] Even after this, Hewitt continued as a landscape and estate photographer. She died in Boston in 1956, leaving behind her photos and negatives but no personal papers.

Because the two women lived apart in the early years of their relationship, they wrote to each other, and since Johnston saved the correspondence she received, there is at least some record of Hewitt's feelings toward Johnston, as well as a few comments from Hewitt indicating what she thought Johnston felt.

The interpretation of these sentiments is hardly straightforward. Some scholars advise us to understand all the romantic outpourings between nineteenth-century women as expressions of female friendship, rather than sexual passion. Others are more inclined to see such writings as a clue to a greater, if submerged, lesbian subculture. Still others, like the photographic historian Jan Grover, remind us that same-sex love is as old

FIGURE 31

*Mattie Edwards Hewitt. From the set of her jaw to the angle of her elbows, Hewitt's stance
suggests a very determined woman.*

as history; that it is only recently that people have felt the need to label women as either heterosexual or lesbian.[21] With these caveats in mind, Hewitt's letters to Johnston can be examined—not to try to find a single category or label for them, but to understand the qualities of the women's relationship.

Many of the letters are undated, as is often the case with intimate notes; allowances must be made for possible errors in sequence. Fortunately, chronology is not always necessary to establish the flavor of a relationship. A few passages can say a great deal, as, for example, these excerpts from one letter of Hewitt's to Johnston:

> Mein Leibling—
>
> . . . Just reread your letter, *am* I all the nice things you say of me I wonder? Ever since you told me that I was indeed *worthwhile,* I have felt like another woman, and now if I have been able to make you truly care for me, well, I am *very* very happy over it. You do not know the wealth of tenderness there is in my heart for you, and shall I tell you why I have needed you so much and seemed so longing for love and affection? I have already told you of how little of the above I rec'd in my home.
>
> When I married the nice little man, I thought of course I should get all the love my heart had yearned for, but somehow he has always seemed too busy to stop long enough for such nonsense, as he calls it.
>
> Seven years ago, baby came and stayed just long enough to leave me with a hungry mother's heart. Since then I have never met with anyone that could fill this great big . . . until I met you in Buffalo and well, you know how I have tried to show you in every way possible that I loved you, loved you dearly.
>
> . . . I am not foolish enough to expect you to love *me* in this way only it was so sweet and meant so very much that I could not but tell it over and over.
>
> Your life is so full and your friends so many—that you have cared for me at all should make me satisfied.
>
> I am not going to weary you with a love letter every time I write, so don't worry dear. . . .
>
> . . . if I have been the help you say I am to you, then I am more than glad. I have been so afraid from the first that you

would think me a foolish sentimental woman and I was so happy
when you told me the other day that you understood—If I have
been proud of you and your work and put you on a pedestal, as
you say, please let me keep you there, as you deserve it surely and
that's my way of loving—

I wanted to at least tell you this once, especially about the lit-
tle baby girl. They think at home that I have forgotten, but you
know that a heart that has loved can never do that.

I wonder why I expect you to understand me better than
most people do—is it because I love you so?[22]

In another letter, Hewitt wrote:

. . . Ah I love you, love you better than ever you know. . . . Yes my
dear we will turn over a new leaf and stand *together* in time of
weakness or need of help and we must not ever again turn away
head or take hand away but when I need you or you need me—
must hold each other all the closer and with your hand in mine,
holding it tight, I will clear away all misunderstandings or
doubts—and the sun *will* shine again. . . .[23]

And then again, in another note:

I slept in your place and on your pillow—it was most as good as
the cigarette you lit and gave me all gooey—not quite, for we had
you and the sweet taste too—I am foolish about you I'll admit—
but it's no use trying to get you out of our system. . . . I am jeal-
ous of your friend CJ, not in the way you think though. I know
how thoroughly you appreciate and enjoy a woman of her caliber.
Poor Matey, what can she ever expect to mean to you? She is so
sadly lacking in the things you care for—but will go on giving
you the richest and best she had to give. . . . [24]

Hewitt's sentiments go the full range, from classic feminist solidarity
(let us support each other as we face the cruel world) to boldly sensual
allusions to shared cigarettes and pillows. Johnston is painted as the unat-
tainable beloved, while Hewitt casts herself as the worthless supplicant.
Often she addressed her letters to "Dear Ole Boss," referring to herself

with the nickname "Matey," a play on "Mattie" and "mate," meaning worker, and perhaps, partner?

In November and December of 1901, Hewitt wrote Johnston suggestive little letters about her husband's being out of town and what a "lonely widow" she was.[25] The following March, she scolded Johnston for not writing and speculated about her reasons. Was it the way she misspelled Francis with an "eye"? Or "was it because I closed my last letter with love!???"[26]

In November 1907, Hewitt wrote Johnston to ask whether she might be able to get Arthur a job with Lumière, who, she had heard, was planning to set up a company based in America. In 1907, Johnston was in some sort of business partnership with Philip F. Gerry, a Washingtonian. The Gerry-Johnston business in "Live Stories and Illustrations that Illustrate" was based in the V Street studio and marketed features to the media, like her wine-making piece, "With King Grape in the Midi."[27] What happened to this partnership is unknown. Gerry, who probably functioned as the press agent, was not mentioned in any of Johnston's correspondence.

Mattie Hewitt was no stranger, however. By January 1909, Hewitt was sending out invitations to the birthday party she had planned for Johnston at the V Street studio. The year 1909 is also when Hewitt divorced her husband, although details on the circumstances are unavailable. One undated letter from Hewitt mentions that "Mr. Hewitt" has to appeal before Friday or the fight is over, and how she has had a hard time remaining patient.[28]

However their relationship might be characterized, Johnston did move to New York first, and Hewitt moved in with her sometime after her divorce, probably during the summer of 1909. An undated valentine that Johnston saved seems to come from this period; this is the message scrawled on the back:

> this looks like some
> one was looking
> for their Mate.
> Will I do?
> I am still good
> for nothing but am
> hoping each day the
> Dr will say that I
> can move eastward—oh I will be so glad to get
> back to you all—Lovin—[unclear, E L?]

"Mate" is usually a reference to Hewitt. The closing letters seem to be the initials "E L," although they are not clear, and there is no other intimate correspondence from any "E. L." The handwriting is Hewitt's, as is the jocular tone. If she were recovering from a miscarriage or her divorce, she would have been eager to leave St. Louis and move in with Johnston in New York.

Another card Johnston saved showed pigs offering "best wishes." Scrawled on the back was:

> Pigs in Clover
> I hope that means us for 1911
> I have all the buful [beautiful] ones you sent where I can see
> em alle time,
> They means lots to your
>
> far away Matey[29]

In a letter dated 1910, Hewitt opened "Dear Pard of mine," and, complaining of Johnston's absence, wrote, "Is the chain good & secure, & will it hold longer than 7 days?" This is Hewitt's coy or bantering style; in her next paragraph she admitted she had a "special delivery" from Johnston the day before. In closing, Hewitt wrote that she has taken "a big dose of xxx's and ooo's" that have not done her any good, so "better get here and deliver the goods yourself young lady. . . . "[30]

Once the women were together in New York, the relationship fell into a certain pattern. Hewitt seemed to enjoy referring to herself as "the assistant," and to Johnston as "the Boss-Lady." Perhaps this was a psychological ploy to make Hewitt seem less in charge, even though she was older. Perhaps it simply reflected the reality of their work: Johnston was the photographer and Hewitt had been the darkroom assistant for both her husband and Johnston. It was not until their New York partnership that Hewitt started doing any serious shooting on her own.

Their first apartment together was at Irving Place, around Eighteenth Street, between Park and Third Avenues in lower Manhattan. The space constrictions of Manhattan real estate meant their daily life was cramped: They lived and worked in intimate proximity. Johnston's mother's letters to her daughter and Mattie in New York offer a clue to the state of their affairs. "Muddie," as Mrs. Johnston was called, wrote nearly daily. On hearing that the women had landed an impressive new customer, Muddie

wrote, "When two girls have faced the Babel of NY for two years, have conquered so many obstacles, and gotten so far on the road to success, I'm ready to back them against any odds. . . ."[31] In another letter, Muddie tells them they have succeeded because they have "braced" each other in hard times.[32] She considered her daughter and Hewitt both "her girls," rather than simply business partners.

For long stretches of time, Hewitt took on the "wifely" role of keeping in touch with her "mother-in-law," writing what she called "worry preventor" letters to Washington for Johnston, who was often too busy to stay in touch. Now and then, Hewitt even went to Washington to help out with Johnston family matters while Johnston stayed with the business in New York.

However their intimate moments were filled, the fact remains that Johnston and Hewitt lived and worked together for some eight years in New York City. Their heyday as a team was in 1913–1914, when they were featured in the *New York Times* and *Vanity Fair* as well as in several photo magazines.[33] They presented themselves as both fearless, willing to scale rooftops, and painstaking, willing to wait a half hour or more for just the right light. They name-dropped shamelessly, aware of the herd mentality among the society set. Once it was known that Mrs. Astor or Mrs. Whitney had commissioned Johnston-Hewitt to photograph her estate, all the others came calling too.

When the rage for the interpretive dancer Isadora Duncan swept Long Island society, Johnston and Hewitt were on hand to make the photos. Although Arnold Genthe is well known for his portraits of Duncan, Johnston's 1914 photographs of the performances of the "Isadorables" form a unique visual record of a very offbeat phase of American culture. Diaphanously draped, proto-Greek prepubescents or scantily clad urchins are all elaborately posed on the lawns of opulent Long Island estates, as if flown in directly from the Acropolis itself.[34]

The Johnston-Hewitt Studio was successful in part because it became known for a particular specialty.[35] Unlike their contemporary, Jessie Tarbox Beals, who often remarked that she never made a name for herself because she did not have a niche to be identified with, Johnston and Hewitt were known for photographing stately homes and gardens, as well as for documenting various structures for architects.

Johnston's original entrée to the New York scene was her 1909 contract to photograph the Carrère-designed New Theatre, one of New York's

most talked-about buildings. The challenge with this job, as with the caves she had photographed two decades earlier, was to illuminate the interiors sufficiently to reveal all the detail, without having the shiny surfaces (here, the gold decor) reflecting the flash-lighting. This time she used to good effect what she called "electric spotlighting." She and Hewitt were subsequently commissioned to photograph the interior of the immense Cathedral of St. John the Divine, the "New Library" of the New York Public Library at Forty-second Street, new buildings at West Point, the Manhattan Hotel at Madison and Forty-second, and a host of private homes.

When *Vanity Fair* asked, in a 1914 interview, what Mrs. Hewitt's role in the business was, Johnston was concise: "She develops and enlarges the pictures."[36] In their *New York Times* interview the previous year, Hewitt spoke for herself, making two rather strange points: that she got her start by photographing barnyard animals, and that she liked getting action in a frame, except she once got a little too involved with some lions. It was a bid for the daredevil image, perhaps, but it came across as oddly rustic next to the suave, cosmopolitan image Johnston built for herself in the next paragraphs. Hewitt was posing as the hayseed, while Johnston was commenting that she was just returning from a photo shoot at some Long Island mansion, and how marvelous her Parisian art training had been, and how wonderful Admiral Dewey had been to her.

Mattie Hewitt was certainly a very experienced woman in many ways. She had been through the grief of losing a child and had survived the difficulties of obtaining a divorce. In the context of New York and their business, however, Johnston was definitely in charge. She went out and got the business, and she did most of the actual photography. For unknown reasons (perhaps related to some Halloween revelries the night before), the two made an oral agreement to be partners on November 1, 1913. At this point they were living and working at 536 Fifth Avenue in New York, having moved from their 55 Irving Place townhouse.

The Johnston-Hewitt Studio also did a brisk business in hand-colored "lantern slide shows" of prominent people's gardens. It is a tribute to Johnston's aesthetic range (and her salesmanship) that she managed to interest so many people in seeing slides of gardens, a relatively limited sensual experience compared to visiting a real garden. Indeed, for the next few decades, Johnston made her living traveling the garden-club circuit, occasionally pausing for a protracted series of lectures.

When Johnston and Hewitt ended their partnership in March 1917,

Hewitt paid Johnston $500 to keep the studio and the business for herself. The only exceptions were the garden lectures and the related slides, which remained Johnston's exclusively. At the time their partnership dissolved, Johnston had no real plan for where to go. Their agreement stipulated that Hewitt would take care of Johnston's mail, store her belongings, and give her darkroom privileges at the 536 Fifth Avenue address until the following October.[37]

After they split up, Hewitt continued her photography business, specializing in on-location garden and estate work. In the winter months, she made her living photographing hotel events, selling snapshots to guests as souvenirs. [38]

The cause of the breakup is not known. Johnston seems to have been quite angry with Hewitt, since she went through many of their news clips from the partnership period and scratched out Hewitt's name from the credits and the text of some articles.[39] On the other hand, she did save Hewitt's romantic letters, and she clipped a newspaper interview with Hewitt that appeared some twenty years later.

Since neither woman left the relationship to go off with another partner, it may be safe to conclude that new attachments were not the problem. One comment Johnston made to an astrologer some years later may hint at what went wrong. Describing herself and how she lived, Johnston wrote: "I fear to make any combination with a second party, as I am used to living alone and independently."[40]

Johnston's unwillingness to compromise on lifestyle issues may have been one cause of the relationship's end. Significantly, she did not discuss herself in the usual language, of whether she wanted to marry or not, but chose a circumlocution, of making a "combination" with a "second party." Indeed, the lack of mention of marriage prospects is a glaring omission from that great stack of letters from her mother, especially as Frances was the sole surviving child in her family, the only continuation of their family line. Marriage never seems to have been expected of Johnston.

Perhaps most people she was close with, including her mother, understood that she was not particularly interested in men. Mattie Hewitt made no secret of how much she adored Johnston and how willing she was to offer wifely assistance to "the Boss." When Hewitt and Johnston looked around at their peers, they saw a number of other women of their age and occupation living together as couples. Among the photographers of the

time, Alice Austen, Laura Gilpin, and Clara Siprell all lived with female partners in long-term, committed relationships. By contrast, the photographers who tried, at some point, to partner with men—Beals, Hewitt, Kasebier—found it difficult.

Women artists throughout history have noted that the male spouse is less inclined to be supportive than the female spouse. The painter Anna Lea Merritt put it succinctly in a 1900 interview: "The chief obstacle to a woman's success is that she can never have a wife."[41] While Merritt was referring to the various enabling labors wives perform—care of sick relatives, in particular—she was making a broader point. Husbands, by and large, simply do not take care of all the distracting obligations of daily life for their wives. A woman partner very well might. The heterodoxy of this perspective, however, made it difficult to explore while living among family and old friends. In this light, Johnston's choice to move to New York—to the fringes of Greenwich Village, in fact—was significant.

In the first decades of the 1900s, Greenwich Village was a magnet for free thinkers of all types: sexual, literary, and political. Among the feminists of the Village, a good many were lesbian, attracted to a community well known for its open-mindedness and not as relentlessly family oriented as other places, an advantage for those not intending to have children. The Village was for socializing, and Johnston still loved to go out with friends . . . as a bit of doggerel from her files suggests:

> The flying trapeze,
> With a cry of Allez-oop!
> To jump the rails, kick over the traces,
> To go on the town and visit places,
> Sit ten at a table meant for two,
> And choke on smoke, as you used to do,
> To tread the floor with the dancing bears,
> They on your feet and you on theirs,
> To have flings at things
> that philosophers true shun,
> And undermine your constitu-shun.
> Home is heaven and orgies are vile,
> But you *NEED* an orgy once in a while![42]

Male-identified or female-identified, the Village menu of sexual possibilities was comprehensive. It included what have been called the "monotonists," who mated young and stayed together; the "varietists," who changed about; and the "resistants," the women who simply wanted to stay single.[43] Johnston may well have been in the last category, a woman who preferred being single, even chaste. On the other hand, she and Hewitt may have considered themselves married.

In Johnston's miscellaneous correspondence there are only a few letters alluding to male interest in her, specifically, unwanted overtures from a particular man. Her confidant, a certain Mr. Samuel Smith, told her directly that "her only fault" was in seeing the man the next day, if she knew what his "thoughts" were. He went on, "anyone who knows you . . . would at once acquit you of any possible folly or even of anything not based upon the most solid foundation of good sense and good taste."[44]

There are stray remarks in other letters concerning Johnston's behavior with her female friends, as in this joking note from Thomas Smillie to Johnston: "If you and Miss G. go on as you have been doing I shall just report it to the town council of A.C. and they will hold an inquest or something and shut you up." (A.C. refers to Atlantic City, a favorite vacation spot.)[45]

Unfortunately, no correspondence discusses the breakup with Hewitt. Did Johnston have no usable mailing address apart from Hewitt's? Or did Johnston shift to being more Washington-based again, obviating the need for correspondence with key intimates like her mother? One newspaper account she clipped said simply that she had "severed her connection with the New York studio, in order to give her entire time to showing these garden pictures, accompanying the exhibition with a brief talk on their history."[46]

In the summer of 1917, Johnston was again on the road, from Pasadena, California, to Newport, Rhode Island, with her slide-lectures on gardens. There is a gap in extant letters from her mother until 1918. Writing to "Fannie" alone, "Muddie" commiserates over what a hard year her daughter has had to endure, referring to, "the handicap of *appendicitis, shingle,* and other things that you had not only *to endure alone,* but to manage and decide—as no one could help you."[47] Johnston was fifty-four in 1918; her mother was not saying she was too young to have difficulties, just how hard it was to face things alone, without that partner who had been so capable.

5

"The Interpreter
of Gardens":
1918–1928

THE PERIOD FROM 1918 TO 1928 WAS DIFFICULT FOR
Johnston: A long and involved relationship had just ended. She
dealt with it, in part, by immersing herself in new projects, both
artistic and financial.

In 1918, she talked her mother and aunt into a joint real estate ven-
ture, to buy a house to rent out. Aunt Nin withdrew financial support at
the last minute, so the deal fell apart. Both Johnston and her mother were
highly disappointed, even as they tried to tell each other not to be. In any
case, Aunt Nin seems to have had a reputation for contrariness at this
point.[1]

That Johnston was toying with being a landlord—an idea she played
with throughout her adult life, in fact—may seem surprising to those who
assume all artists are left-wing or opposed to the idea of private property.
Johnston had no use for such assumptions: She lived as bohemian a
lifestyle as she desired but remained the consummate bourgeois in her
financial dealings. Her files are littered with her dunning notes to various
debtors, in tones ranging from polite to threatening. The dictum "buy
cheap, sell dear" governed a whole range of her speculative activities, from
buying and selling amber or paisley shawls to doing the same with parts of
houses.

In the miscellany section of her papers, one finds her typescript for a

very anticollectivist, anti–Russian Revolution barroom-type skit titled "Koolack." It is not certain that Johnston wrote the piece, although it has the ring of the "Push" crowd's humor.[2] By the standards of the day, Johnston was a "self-made" woman. Far from identifying with the poor or the working class, she focused on cultivating the upper class, whose commissions were her mainstay.

Although the portrait and the architectural markets were solid niches for upper-class patronage, they were not quite as underexploited as the newly emerging field of garden photography. The idea of landscape design as a major art form was relatively new in America in 1903, when Edith Wharton published her travelogue of Italian gardens, *Italian Villas and Their Gardens.*[3] While Maxfield Parrish's romantic illustrations marry nicely with Wharton's discussions of Italian villas and their grounds, the accompanying photos (unattributed, but probably Wharton's own) are uninspired.[4]

There are several reasons why garden photography was still in a rudimentary state. Gardening itself was a somewhat lost art in the building-oriented New World. There was a general feeling, too, that gardens demanded color treatment, and photography was still predominantly black-and-white. Johnston addressed both issues and in doing so made herself a place in the emerging field.

As if to announce her intentions, Johnston mounted a show, "Gardens, East and West," at New York's Touchstone Gallery in December 1917. Apart from giving her a credential in the field, the exhibition gave her exposure with the audience most likely to be hiring her services in the future.

To extend her market, Johnston developed a few garden lectures that she illustrated with hand-colored lantern slides.[5] Among the topics she addressed were: "Our American Gardens" (a round-the-country tour), "Gardens for City and Suburb" (how to use limited space), "Wild Flower Gardening" (a plea for their preservation and a plug for the national parks), "Birds and Berries" (a hat-tip to the bird-lovers), and "Garden Lore and Flower Legend" (the folklore behind the flowers).[6] The best material for slide shows, Johnston knew, was usually not a local garden, but one in a different clime. In New York, she showed Californian or European gardens, which were not only appealingly exotic but provoked no jealousy. Media reviewers came away impressed by the color of her slides and positively flabbergasted by all there was to learn about gardens. As far as many

American news reporters were concerned, there was not much of interest anyone could say about grass and trees and flowers—until Johnston taught them otherwise. The reporter Nancy Burncoat's reaction was typical: "The nearest I can come to telling you what she is, is to call her an interpreter of gardens—an interpreter of garden beauty and of the meaning of gardens. She has a way of taking gardens from all over the country and introducing them to each other in your presence, in a way that brings out the individuality of each."[7] Johnston herself considered Burncoat's interview one of her best ever; she liked thinking of herself as an "interpreter" of gardens.

Johnston was not trying to support herself by slide shows alone. Her usual strategy was to offer lecture packages to a garden club whenever someone in the area was hiring her to photograph his or her estate. Through the Garden Club of America, she advertised that she would photograph gardens for $10 per subject, with a guaranteed $100 minimum, plus travel expenses from New York.[8] Once in the area, she would give a lecture for some organization or club, which could charge whatever admission price it pleased. Johnston charged a flat fee for each lecture, usually about $125, a substantial amount in 1920.[9] In this way, she earned income from the privately commissioned shoot, generated slides for future shows, and sold the shows she had already prepared.

The garden-club lecture circuit was an efficient way of getting in touch with two often-overlapping sets of customers. Members who wanted their gardens preserved on film were also enthusiastic slide-show subscribers; conversely, seeing a show prompted some people to have their own efforts immortalized on film.

Some mainstay of the local gentry would usually invite Johnston to stay in her home, to claim the privilege of entertaining her. From the letters in her correspondence files, it seems that many hostesses found Johnston a stimulating guest, appreciating her blend of highbrow and bohemian tastes, and some remained in touch with her over the years. In big cities, Johnston often stayed at a club, which allowed her freer rein in organizing her time.

This gypsy lifestyle might not have appealed to her if she had still been in partnership with Mattie Hewitt, or even if her old Washington studio had been available. But in November 1916, Johnston and her mother had begun renting out the V Street studio to the Drama League Workshop to use as its headquarters and performance space.[10] By October 1918, John-

ston was receiving her mail in care of a Miss Talbot at Eighteenth and Eye Streets in Washington.[11] This may mean that her mother had sold the V Street home sometime between 1916 and 1918, a sale that would have provided the extra cash and impetus for purchasing some other piece of real estate.

In any case, Frances Antoinette Johnston died in July 1920. Her daughter felt the loss deeply. Six years later, when she was writing to console her friend Helen Fogg, who had just lost her own mother, Johnston poured out her feelings: "My mother and I had been inseparable chums, real understanding friends, ever since I could remember and my one deep ambition was to do for her as long as she had need of anything. In a sense, I have been lost ever since, my true occupation gone. I accepted the inevitable, even tried to prepare for it, but that does not really soften the blow."[12]

From 1920 on, Johnston's main family connection in Washington was Aunt Nin, who was not getting any pleasanter as the years passed. Aunt Nin did have a memorial stone carved for her sister's grave, for instance, but, in large letters on the front, gave herself full credit: ERECTED BY CORNELIA J. HAGAN. Johnston's files contain only one photo of Aunt Nin from this period, titled "Love among the Roses," showing the old woman posed on the porch of a house on the 2700 block of Thirty-sixth Street in Washington.[13] Johnston was not living with her. The Arts Club in Washington had become her regular D.C. base, although throughout the 1920s Johnston still called herself a New Yorker.

It might seem ironic that Johnston the gardening proselyte could identify herself with such a cement and concrete metropolis as New York City. But Johnston found aspects of urban gardening quite moving. Forced to make do with inadequate space or funds, the city gardener was a pioneer, a crusader. Tales of janitors growing flowers on fire-escape landings or schoolchildren tending tiny window boxes could be an inspiration to everyone.

Not that the New York garden-club meetings and events were organized or populated by tenement gardeners; the usual society figures were always in charge. Still, the appeal could be to something nobler; the gospel of gardening was more necessary in cramped New York City than suburban Washington or seaside Long Island. The countryside did not need human intervention to be inspirational, but Manhattan surely did.

Still, one can only wonder why Johnston became such a garden fanatic. Up until this point, she had been an extremely successful docu-

mentarist and portrait artist. These specialties introduced her to a lot of exciting people and causes, apart from bringing in large fees. Newspapers paid well for front-page photos of people, as she knew from her Dewey shots and her ongoing Alice Roosevelt Longworth portraits. She had also been doing a lot of commissions for architects—again, very well-paying work.

The argument could be made that her shift from portraits to gardens— with a human face rarely in the frame—was a sign that she was turning away from people at this stage in her life. Such a move could have resulted at least partially from a shift in midlife hormones, as Johnston turned fifty-four in 1918. It also might have been a result of residual feelings from the Mattie Hewitt breakup. Perhaps garden photography was simply more lucrative, and these frames were more pleasing without the human presence. Whatever the reasons, there are relatively few human subjects in Johnston's work after 1917. A similar lack of human presence has been noted in the garden photography of the French photographer Eugene Atget, whose melancholic "empty gardens" are seen as evidence of an "essentially solitary" person.[14]

Johnston may also have been feeling weary of the particular problems involved in working with human subjects. In her previous commercial work, "people" were customers that needed pleasing, not paid models like the "art" photographers used. Perhaps daily life had begun to seem like a constant struggle to "hustle" friends, to satisfy their various vanities. Nature presents its own challenges to the photographer, of course, but they are less personal.

In the 1910s and 1920s, gardening was one of the choicest passions an upper-class, artistic woman could indulge. Many of Europe's prominent bisexuals and lesbians of the period were avid gardeners or floriculturists. From Colette to Sackville-West, gardening was a passion both sensual and intellectual, a brain and body affair.

Despite her specialization in the garden, Johnston never had one of her own until she was in her eighties. In a way calculated to please other gardenless folks in her audiences, Johnston would argue that she "owned" hundreds of gardens every time she unpacked her box of slides. To have photos instead of actual gardens meant you could have many different sorts of gardens.

In modern parlance, Johnston was offering "virtual" gardening. (That this was preposterous does not seem to have occurred to the reporters who covered her talks—people without the leisure, themselves, for gardening.)

She was teaching gardening aesthetics, not soil chemistry. She liked to discuss more general questions, such as the relationship of the villa to the garden, or "landscaping." She introduced various theories about garden color, including the French idea of the all-green garden. Her lectures were based on her own slides, of course, but much of the ideology came straight from the writings of Edith Wharton, another self-appointed garden expert.

While similar in many tastes, Wharton differed from Johnston in key respects. Wharton was primarily a writer, not a visual artist. Her writings were often drawn from her travels, but she established elaborate households for her work phases. She was also quite wealthy, at least by 1925 when Johnston visited her in France. To own a villa near Paris and another in Provence, to sponsor extravagant cruises—all were well within her means.[15]

When Johnston did photograph Wharton's Pavillon Colombe (figure 32), she stressed the overall ambiance of the landscaping rather than focusing on particular gardening feats. Johnston lavishly praised Wharton's terrace, a rather plain patio with potted plants, which she pronounced an "out-door living room" conducive to "that lovely exchange of ideas and wit—the gentle art of which too often seems obsolete with us."[16]

Photographing Elsie de Wolfe's Villa Trianon (figure 33), Johnston decided to include a human figure at last: the *maitre jardinier* with his topiary of the "cock of France perched above the world." Even if Wharton or de Wolfe's gardens were of dubious horticultural value, photographs of such exclusive settings were popular in magazines like *Town and Country,* which bought many of Johnston's garden studies. Regardless of the plantings, Johnston was sympathetic to the idea of loving gardens in the abstract, simply for the atmosphere they might provide.

Indeed, the way Johnston described her own history as a garden enthusiast rings somewhat false. In a 1927 interview, she said her grandmother had had a beautiful flower garden in Rochester—but Johnston hardly ever visited Rochester.[17] She added that she studied flowers as a girl, but there is no evidence of a particular interest in flowers in her existing ephemera. The rose garden behind her childhood home in Washington was designed by Johns Burroughs, whose portrait she made on several occasions, but Frances Hodgson Burnett's "secret garden" was probably more central to Johnston's aesthetics.

Since the move from Washington to New York took Johnston ever farther from nature, her new focus became the "civilizing effect" of gardens.

FIGURE 32

Pavillon Colombe, Edith Wharton's villa, 1925. Johnston admired the way the garden terrace had become an outdoor "salon." The actual plantings were hardly notable, but the setting encouraged conversation and easy intimacy.

As early as 1922, Johnston was writing newspaper articles maintaining that city people needed gardens to reduce stress.[18] This idea became quite commonplace in the late twentieth century, but it was a consciousness breakthrough in the build-it-quick Roaring Twenties.

An early member of the New York City Gardens Club, Johnston was the prime mover behind the 1922 club-sponsored photo contest, with the theme of "civic improvement through gardening." The general public was invited to submit photographs of gardens that were helping to improve city life.[19] Johnston, who called herself the club's chair for "pictorial records," was inventing this field of hers as she went along—and was reasonably successful. Mrs. Andrew Carnegie and her friends were members of the City Gardens Club, which was enough to make it useful to a freelancer like Johnston. A good word from the right patron could mean new connections all across America and Europe.

Johnston used her personal contacts and the garden-club circuit to set

FIGURE 33

Elsie de Wolfe's Villa Trianon, France, 1925. Although Johnston usually avoided the human presence in her garden photography, here she immortalized the head gardener, creator of the topiary.

up a series of lecture tours. In the 1920s, the allure of Hollywood—for writers especially, but for other creative people as well—was hard to resist. It was rumored that the studios paid vast sums for anything anyone did, as long as it was somehow connected to the movie business. Johnston went to Southern California in 1923 to photograph a few wealthy people's gardens in this "land of limitless opportunity," as she called it, and then started talking about staying.

Johnston did not want it known to her friends back east that she was actually considering moving to Hollywood; she dismissed rumors with a blithe comment, "everybody is boomed as a possible new resident."[20] In fact, she had a Los Angeles address of her own, and she was proposing to go into business there with a woman by the name of Viroque Baker.

Johnston called her latest new project "Kinema-Kraft Prints." It was a scheme to sell movie stills to the American public as hang-it-on-your-

living-room-wall Art. She proposed to roam the sets of various "photo-plays" being shot and make a variety of stills that might have mass-market appeal. Stars were the idea. Gum-bichromate prints, having the look of an etching or mezzotint, would be made by Viroque Baker and sold in the arts or gifts departments of "leading Dry-goods stores." In other words, they would pitch this product to a store like Marshall Field's, not Woolworth's. The retail price for 8-by-10s would be up to $2 each; 11-by-14s would go for up to $5 each. (At the time, a new Victrola record cost about $1, so this price structure seems fairly reasonable.)

Johnston wanted a retainer from the commissioning studio of $1,500, plus $500 per week for twelve weeks to do product development. She needed complete freedom of access to studio sets and an on-premises darkroom. After that $7,500, she asked for 40 percent of the net profits on sales. Considering that she was trying to sell the studios an idea they did not really need—their big stars were already big, with or without extra publicity—she was asking a sizable amount of money. For most workers, $7,500 represented several years' wages, and 40 percent of the net profits did not leave much for anyone else.

It is not clear how she planned to divide these proceeds with Viroque Baker, although they had gone so far as to set down in writing what each would bring to the plan. Johnston stated that she supplied the concept of making such prints, the marketing ideas, and the "interest" of four studios—Pickford-Fairbanks, United Artists, Thomas Ince, and Goldwyn Studios. Baker would be contributing her workshop, her knowledge of the gum-bichromate printing technique, and her connections with Famous Players–Laskey and Universal Studios.[21]

In the end, the venture never materialized. The memo Johnston drew up for her astrologer around this time reveals her indecision: "Next season, in my work, apparently, I have two courses open, one lying west and the other east. Which course seems indicated as the most desirable to follow? . . . I have considered a new departure in business, in which I would be associated with a person I have only know [sic] for a short time. Does the arrangement promise well?"[22]

Whatever the astrologer's opinion, it was probably lack of interest by the studios that canceled the plan. In any case, Johnston seems to have become disenchanted with California and decided against staying. The greenery—both horticultural and financial—was lavish, but the culture of

Los Angeles was strange to a person accustomed to dealing with old money. The fact that California had no use for Europe, either, was probably alienating for Johnston, who had strong Old World sensibilities.

Her California stay was not unrewarding, however. In 1924, the Huntington Library of San Marino, California, paid Johnston $3,500 for twelve hundred photographs from her collection. They purchased her own set of autographed copies of portraits she had made along with the original plates and a catalog set of blueprints. Johnston also agreed to organize, date, and identify the material for their archives.[23]

Henry Edwards Huntington, who owned the archive, was a railroad magnate with an elaborate Southern California estate that Johnston had photographed in April 1923. The two must have gotten along well, since by the fall of 1923 Johnston was trying to sell him two manuscripts by her aunt Elizabeth Bryant Johnston. Huntington's librarian was not interested in the manuscripts but agreed to buy Johnston's portraits of eminent Washingtonians.

It took Johnston and her assistant, Georgiana Stebbins, some seven weeks to get the glass plates and prints ready to ship, but the results were impressive. Jennifer Watts, who studied this collection in depth, commented that it shows Johnston's uniquely painterly approach to photography.[24] The finished portraits reveal something of the personality and style of the sitter without calling attention to the process. Johnston did not retouch negatives, Watts found, but cropped images to focus attention on a particular face or to eliminate background.

To modern eyes, the differences in Johnston's depictions of male and female subjects are striking. Men are posed surrounded by their work, with books and papers at hand. Women are presented against studio backdrops, or in some undefined, neutral space. For men, the face is highlighted, with clothing often blending into a dark background. Women are softly lit, with the camera pulled back to feature both the face and the full length of the gown. Men look active, while women seem to be controlled by the socially prescribed order.[25]

To interpret these observations as a reflection of Johnston's conventionality—Watts suggests labeling her a rebel with a "small *r*"—may be to oversimplify. By and large, the men who paid to have their portraits made were powerful by virtue of the work they did. On the other hand, many of Johnston's women clients, particularly those portrayed in the Huntington collection, were society matrons. They had achieved prominence through

their ornamental qualities and by their affiliation with powerful men. Such women would want their gowns to be a salient feature of their portraits.

In keeping with this interpretation are the Johnston portraits of women who were important because of the work they did, like Ida Tarbell or Susan B. Anthony, which show them surrounded by their work at their desks, or in the waist-up pose that was standard for men. Johnston's blue-collar women workers, from places like the U.S. Mint and the Lynn, Massachusetts, shoe factories, were portrayed with their work tools in hand. Regardless of class or gender, Johnston tried to make the portrait convey the essential qualities of her subject.

Furthermore, as a commercial artist, Johnston had to make sure she pleased her customers. Portraiture is a two-sided proposition, combining both the aesthetic decisions of the artist and the expectations of the client.[26] By comparison, the self-portrait may be the more revealing mode, as it represents the artist's own statement, unfettered by the client's needs. Johnston's studies of herself were made mostly in the 1890s, in her Washington studio days. There is a series of her dressed as a man, and a series of "paradox" shots, where her clothes and her expression are at odds.[27] Her self-portraits show viewers there was more than one woman, more than one consciousness, behind the surface they saw.

The Huntington portrait purchase was a big boost to Johnston's finances as well as to her sense of artistic legitimacy. There was not a big gallery or museum market for photography in those days, so a sale to a library represented an especially important vote of confidence. Her payment of $3,500 was also a considerable sum, and she had to decide how to use it.

In 1925, Johnston would turn sixty. Now that she also had a significant sum of money, she decided to prepare her will. Once this first version was complete, she would amend it many times, adding and subtracting benefactors at whim. In this first version, after following the usual protocol of asking that her debtors be paid, she provided for the perpetual care of her parents' cemetery plots and her own. She left a couple of small ($100) gifts to relations and the rest of her estate to her friend and assistant Georgiana Stebbins. She left her lantern slides to the Towne Foundation of New York, provided they continued with plans for a Museum of the Peaceful Arts. Otherwise, the slides were to go to the Library of Congress.[28]

The bequest to the Towne Foundation is remarkable as a note of pacifist sentiment in a life not short on military themes. From her studies of

the military academies, to her USS *Olympia* scoop, to her lifetime closeness with the Roosevelts and the John Philip Sousa family, Johnston was very comfortable around uniforms. Perhaps she, like others, was reacting to the destructiveness of the recent world war. Whatever the reason, she had clipped for her files a 1924 news article covering the will of Henry Towne, who had left a large endowment for a Museum of the Peaceful Arts in New York City.[29]

At the same time, Johnston was contemplating a return to Europe, a trip that would pay for itself. Her usual tack as a garden lecturer—to arrange as many private garden shoots as possible—would not work in Europe; it would be difficult enough just to get an invitation for a visit, let alone permission to photograph. On the other hand, she could count on magazines like *Town and Country* to pay for photos of certain homes or gardens, which would cover her expenses.

She also decided to earn money en route by working the crowd at all the festive shipboard events. If she set up a darkroom on board, she could give customers relatively instant service. Wealthy passengers with nothing to do but go to parties and talk over the pictures later could be a gold mine. This urge to make the most of her European savoir faire soon led her into treacherous financial straits, however.

Johnston used her personal connections with a friend at the SS *Laconia* office, Mrs. Jane Hill, to negotiate the deal. The *Laconia* would provide a darkroom on board for her exclusive use and would allow her to sell her services to fellow passengers. Anticipating a large demand, and not wishing to bother with the darkroom work herself, Johnston hired an assistant, Bert Forse, for the length of the voyage.

How she came to engage young "Togo," as she called him, is unclear, but it cannot have been on the basis of his references. His background was as a lip-reader for the deaf in the Washington area. Her arrangement with Forse was typical of the deals she offered to her assistants: You pay your own expenses, and when I start to make profits, you'll make money, too. As she wrote to him later, "I definitely understood that you had some private income and would not expect any salary or cash advance until the business showed a profit over all expenses."[30]

Johnston shopped at the camera stores in New York before leaving, laying in a good stock of paper and developing supplies, as well as cameras and lenses. The *Laconia* was booked for a long cruise: from Spain to Algiers, Constantinople, Palestine, Egypt, Naples, Rome, Nice, Monte

Carlo, Paris, and with a final stop in England before returning home. With all that touring, Johnston anticipated a booming business.

It never quite materialized. To some extent, she blamed the captain for letting others use her darkroom, detracting from the exclusivity of her photos. Then, too, Forse did not work out particularly well. Far from living off his own means, he came on board with no money at all. Johnston was forced to lend him mounting sums just so he could leave the boat when they docked at various ports. As she wrote him, "I also paid for your laundry, you [*sic*] tips to the Laconia stewards and some small borrowings which I heard of indirectly. . . . It was not pleasant for me to learn from Mrs. Roundey (who is extremely fussy about money) that you had borrowed a dollar from her somewhere and forgotten to return it. . . ."[31]

Over a year later she was still trying to recover $100 from Forse for a 5-by-7 Graflex she had given him to return for a refund at Willoughby's in New York. Rather than following directions, he had traded it in for an enlarger, which he took with him to Hampton, Virginia, where he was working in the Langley Laboratories developing film. At first he claimed to have lent the Graflex to one of his friends who would not return it, which only increased Johnston's ire. Her attempts to explain to him what it meant to "take responsibility" failed completely. By November 1926, she was paying the Post Office to trace him, to no avail.

The relationship with Togo exemplifies Johnston's willingness to extend herself to people who charmed her with their irresponsible ways. Surely she had not completely believed his stories about his father's oil rigs or the $60,000 in stocks that his last landlady had stolen from him. Johnston must have realized there was a reason why the young man had no money to his name. He presented himself well, as someone who only cared that everyone enjoy themselves, and he could be quite likable. But just as she misread his geniality, he misinterpreted her generosity. Forse did not realize that Johnston cared very deeply about her money, as those who have earned all of it themselves often do. Only in her various wills did she ever give away anything; otherwise, she spent her money herself, whether on whiskey or trips to Europe. Thus, she hounded Forse for over a year to get either her camera or its value back, though surely it must have been obvious that he was never going to pay. Her letters indicate that she could never quite decide what to think of him; she berated him for his thievery in one paragraph, then in the next reminisced about the good old days in the cafés.

Apart from the camera theft and his social debts, Forse used little common sense and made expensive mistakes. Johnston had asked him to bring some purchases of hers into the United States, to take advantage of his duty-free allowance, but Forse simply mailed the items from the ship to their U.S. addressees, which meant Johnston had to pay duty on everything, in addition to the postage. A good many things she had asked him to mail never arrived, and he had not bothered to insure them. But even after running through a long list of grievances against him, she would end by asking him to go visit Aunt Nin and show her his scrapbook of the trip.

Everything looked a bit different from Togo's perspective, of course. As he told her, "you were 3/4ths of the time absorbed in your own thoughts and when I respectfully report that I had to chase around and borrow a dollar for flash light powder to take to the masons in Jerusalem . . . you'd say 'yes, yes' like you'd pacify a child that was screaming for a lolly pop. The only way I ever got your attention was to announce something violent like 'The waiter must be dead.'"[32]

Despite the cruise passengers' lack of interest in having the Johnston-Forse team produce their vacation photos, Johnston was able to spend a good deal of time in France and England photographing estates and gardens for her slide shows and for the newspaper and magazine market.[33] She thought of giving guided tours on her next trip, taking wealthy women to all the clever places that only the insiders knew about. She proposed to her friend Miriam Nesbitt that they start "our own little personal Tourist Bureau," but this partnership never materialized.[34]

In 1926, Johnston showed "In Old World Gardens" at New York's Ferargil Gallery on Fifty-seventh Street. The show was such a success that the Brooklyn Botanical Garden invited her to exhibit photos during one of its plant shows. These same photos were then recycled to the *Woman Citizen, Town and Country,* and the *International Studio* as well as the home and garden pages in the Sunday supplements of many major newspapers.

In January 1927, Aunt Nin broke her hip in one of the newly invented revolving doors. Immediately after the accident, Johnston moved to the Arts Club in Washington to coordinate her aunt's hospital care and keep the extended family informed of her progress. Johnston stayed on in this capacity for some three months . . . until Aunt Nin abruptly called her lawyer and revoked Johnston's power of attorney, in favor of a representative of her insurance company.

That Johnston felt betrayed is clear; for the following week or two,

there is a notable absence of letters to the extended family detailing her aunt's condition. In April 1927, Aunt Nin took a sudden turn for the worse and died. No reconciliation seems to have taken place. Johnston hardly appeared grief-stricken either, even though Aunt Nin was her mother's sister and had been a household fixture and traveling companion for much of Johnston's life.

True, Aunt Nin had not been particularly kind to her niece late in her lifetime, even though she left her a small trust fund in her will. Perhaps the old woman was offended that Johnston had complained to some relatives about what her hospital care was costing. (At the end of January 1927, Johnston had written to her cousin Fred Fishback, who was himself ailing, that Aunt Nin's expenses were "staggering"; that after the next week's bills were paid, her aunt would have exhausted her ready funds; and that therefore, she, Johnston, was going to see about liquidating some of Nin's "deeds of trust.")

It barely seems to have occurred to Johnston that a potential heir might find such news alarming. She went on to berate Fred for malingering over his own medical problems, warning him that "worry is not only useless, but may easily kill a man." Forget your troubles, she urged him, and "you'll be well in a week."[35]

Cousin Fred seems to have needed something other than a slap in the face, since he died some four months later in the very sanatorium where Johnston had been writing him. It was characteristic of Johnston to deal with other people's financial or health problems with a matter-of-factness that bordered on callousness. Only once did she ever write to anyone about having a medical problem herself, and even then she made several drafts of the letter in order to achieve a properly distanced tone. About money matters she was similarly bald, expecting others to do what was needed to survive, just as she did.

In rare instances, and usually on behalf of an elderly relation, Johnston did commit the occasional charitable act. A year before Aunt Nin's death, she had contacted the writer Harris Dickson to persuade him to interest a publisher in her cousin Molly's manuscript, a *Gone With the Wind*–type saga. There was no money in this for Johnston; helping out a decrepit, plantation-era lady just seemed a decent thing to do.[36]

Even with her small trust fund, Johnston's financial affairs continued to have a certain hand-to-mouth quality. She frequently bought and sold amber jewelry, Oriental prints and artifacts, and odd bits of exotica she

picked up on her travels. Most of these transactions consumed a tremendous amount of paperwork, since the items were usually consigned to dealers, where they had to be retrieved if unsold. Some items were sold and returned endlessly. Many were personal possessions that she did not want to keep anymore, but these transactions also suggest a clever woman-in-the-know who could pick up trinkets for a song and sell them for a tidy profit.

On the other hand, Johnston was sixty-three years old and had neither a regular paycheck nor a sizable trust fund. She did not even have a fixed residence. Instead, she drifted from one place to the next, drumming up business through friends. Some were well connected and generous. The architects Waddy Wood and Frederick Law Olmsted, for example, both gave her introductions to their clients as well as ideas to pitch to various magazines.[37]

Apart from the usual magazine and private commissions, Johnston constantly dreamed up new schemes. In January 1927, she proposed to her friend Helen Fogg that they share the cost of a 1928 European trip geared to producing a "Garden Guide to Europe." If Helen, who was just departing for Spain, could survey the prospects and perhaps find out what a small car might cost, Johnston thought she could afford the trip by the following year. And then, "what adventures wouldn't we two together scare up. . . . Who but us did Constantinople after dark, in the little German cafe, and acquired Ishmael of the white turban and Billy Joseph of the Chesterfieldian manner as our devoted slaves. Who but us had the imagination to motor from Gizeh to Memphis and Sakara in the desert twilight and explore the Sphinx by a rising moon? . . . I am rash enough to believe that we could work together and remain friends at least 2/3rds of the time. . . ."[38]

In July 1927, Johnston took off on a motor tour of the East Coast of America, a mixture of photography work and pleasure. She bought a car for this jaunt, and the car dealer arranged a driver for her, someone she would pay $100 per month, to cover his expenses.[39] Unfortunately, the driver provided was called up for the military, and another was substituted. The replacement demanded substantially more money and, on occasion, departed with the car without asking permission. Johnston complained at length to the dealer and eventually continued her trip with the original driver.[40]

From this point on, Johnston depended on a car and driver to fulfill

most of her photographic commissions. The driver looked after car maintenance and garaging and would assist her with equipment or luggage. She experimented at first with young white men supposedly working for pleasure and expenses but was better satisfied with underemployed African Americans, who found her per diem attractive compared to wages for other casual labor.

The trip in the summer of 1927 took Johnston to Delaware (to photograph the estate of the Du Ponts) and Philadelphia, and then south to Fredericksburg, Virginia. By September, Johnston was writing chatty little notes to the flamboyant dramatist Paul Kester in Virginia, full of intimacies about their visits with each other.[41] She stayed at beautiful country inns and took tea in the parlors of romantically crumbling family estates . . . and found a new calling.

From this point on, Johnston would be a southerner.

6

Johnston's Ante-Antebellum South: 1928–1944

MANY IMPORTANT PHOTOGRAPHERS IN AMERICA, like Dorothea Lange and Walker Evans, spent the Great Depression years working for government agencies, using their cameras to "put a human face on tragedy." Johnston, however, had not featured people in her frames for quite some time. Her specialty had become gardens and estates, the inanimate pleasures of the wealthy. After the stock market crash of 1929, however, the rich were not inclined to advertise their lavish lifestyles by retaining photographers. Many, like Johnston's former partner Mattie Hewitt, had to curtail their businesses sharply. Artists were, in many respects, a luxury.

Johnston's salvation turned out to be the Carnegie Corporation, which supported her with back-to-back grants throughout the 1930s. Her friends at the Library of Congress had recommended her highly to the Carnegie board, who in turn introduced her work to the American Council of Learned Societies (A.C.L.S.). The work Carnegie funded was Johnston's most original yet: to photograph the early American architecture of the southern states, in order to preserve as complete a record of these buildings as possible before they were, in many cases, demolished. After decades of working to please and flatter rich clients, Johnston was finally being paid to design an important, original research project.

The approximately 7,500 negatives that Johnston produced in the

1930s form a major archive now used, on microfiche, in scores of universities and libraries across the country. Even during her own lifetime, a great many of the structures she photographed were destroyed, particularly those designed for humbler uses. Old mansions and churches were more likely to find champions than old warehouses or cotton-press sheds. Both for the actual records and for the inspiration her methodology gave to others, Johnston's historic-preservation work is generally considered her most enduring photographic contribution.

The project started simply. In 1927, Johnston went to the Fredericksburg, Virginia, area to photograph Chatham, the estate of Mrs. Daniel Devore. At her hostess's urging, she roamed the nearby countryside, spotting a great number of decaying but marvelous buildings. With no particular plan in mind, she shot rolls and rolls of film. The results were of such high quality that she exhibited them in Fredericksburg in April 1929, causing quite a stir. People were used to admiring the great mansions of the county, but the simple old buildings—even the colonial churches—were not usually put on display. Still, in a relatively small town like Fredericksburg, everyone would go to a new show at the town hall, and Johnston's exhibition attracted more than its share of the schoolchildren as well.[1]

When the Fredericksburg show ended, Johnston returned to New York with a worrisome medical problem that she referred to as "a bloody discharge from the genital tract." Her doctor cured it when he "removed a growth" from her in his office.[2] It is not clear what might have been removed in an office procedure that would have stopped such bleeding, but Johnston said her doctor gave her a "clean bill of health" afterward.

The following month, September 1929, Johnston was feeling sprightly enough to return to the Washington real estate market and buy an old Georgetown row house. Designed as a two-family dwelling, the house needed extensive renovation. Her plan was to convert it to three studio apartments that she could rent out and live off the income. A month or two later, after the crash, the same property might have sold for a good deal less, but if Johnston had put the money in the stock market she probably would have lost most of it anyway.

Regardless of how astute an investment the Georgetown property was, Johnston was not entirely suited to the landlord role. She was constantly railing at late-paying tenants and complaining about bills for repairs, and she did not stay in Washington to oversee repairs or supervise the selec-

tion of tenants. From time to time, she tried to talk her friends into renting from her, but it never worked out. Still, in spite of her complaints, she made money on the houses she bought, sold, or rented—even if it was never as much as she would have wanted.

By November, she was back in Virginia socializing with the landed gentry. Before long, she made herself useful to them by writing press releases for the "Stratford Sport Day" they were planning to hold at the Foxcroft estate, an old manor in Middleburg, Virginia. As she described it, various hunting clans would meet for an "Invitation Hunt," to be followed by a "Hound and Dog Show," a "Hunter Trial," and a "Hunter Market," including "lively raffles" of such "famous Virginia products" as goats, puppies, and hams. More a fantasy of eighteenth-century English life than a realistic re-creation of an old-time Virginia fair, this was the South that Johnston liked to imagine. The "gentlemen sportsmen of Virginia" who were sponsoring Stratford Sport Day were dedicating it to the memory of General Robert E. Lee, whom they called "a true lover of all sport." The funds raised were to go toward restoring Stratford Hall, Lee's birthplace.[3]

How Johnston felt about this celebration of Lee—and thus of the Confederacy and its slave system—can only be inferred; she made no direct statements about racial issues in her writings. Twenty years back, when she was photographing Hampton and Tuskegee, she treated both students and staff as friends. Her portraits of them and their work are respectful and positive. She took the trouble to train students in the rudiments of photography and brought her own collection of photos to display. That she saw nothing questionable about going for a ride in the woods near Ramer at night with a carriage full of African American men says something about her personal indifference to—or ignorance of—the customs of bigotry. Obliviousness to the racism faced by others could have been a sort of blindness produced by her relatively privileged life, as some critics have noted.[4]

Her treatment of individuals was more straightforward. She was extremely loyal to Huntley Ruff, her main chauffeur and photographic assistant in the 1930s and 1940s, an African American from the Washington area. At one point, Huntley was arrested for vehicular homicide. Johnston arranged a lawyer for him so quickly that the case never came to trial and Huntley went free (she did, however, make Huntley's family pay every cent of the legal fees).[5] She also looked after Huntley's health, at one point delaying a work trip so that he could have his tonsils removed.[6] That

Huntley's job included more than just driving the car and hauling the equipment may be inferred from a remark by one of Johnston's correspondents, referring to "Huntley's admirable picture of Miss Johnston and her fine car," reproduced as figure 34.[7] (Whether Ruff composed the frame or merely snapped the shutter is not known.) She bequeathed Huntley both money and her car in various of her wills, and she clearly would not have dreamed of caricaturing Huntley's speech as she did her Atlanta driver's after her Uncle Remus interview. She treated Huntley as a learned person, which he was, judging from his various notes to her.

Occasionally, some of Johnston's correspondents made fairly racist remarks, but we have no evidence of Johnston's reactions.[8] After years of passing herself off as a New Yorker or even a pseudo-European, Johnston was now reinventing herself as a southerner. Indeed, a New Orleans news-

FIGURE 34

Johnston in North Carolina, 1938. Huntley Ruff, her driver and assistant, may have snapped the photo. Before the gas rationing of World War II put an end to her road work, Johnston, driven by Ruff, roamed the South, saving old buildings with her camera.

paper described her as such: "A Southerner, she went to Paris as a student."[9] Johnston had herself reinstated in the D.A.R., an important network for white women that she occasionally relied upon when covering unfamiliar territory in the South. She knew what was expected of her; she stayed in the right sort of homes and hotels and connected with garden-club women, the D.A.R., or chamber-of-commerce supporters wherever she could.

Such bourgeois connections were customary within the historic-preservation movement. Its early workings were fueled by the energies of ladies' clubs and focused primarily on stimulating patriotic pride. Antebellum women, for example, worked to buy George Washington's Virginia home and make it a shrine and an inspiration for the citizenry.[10] This patriotic tradition was perpetuated in the late nineteenth century by groups like the D.A.R., which made the notation of Revolutionary War sites into a ritual for members.

In the early twentieth century, a more broad-based preservation movement developed, one that looked away from the patriotic shrines and focused on more locally based projects. Small historical societies formed, studying anything with seventeenth- and eighteenth-century "associational value," from tools and old workshops to city halls.[11] By emphasizing the relatively distant past, the "colonial revival" movement was trying to find a more satisfying way of life. If modern urban America was unpleasant, one could search for an earlier, more idyllic era.[12]

In 1926, this locally based look-backward-to-Eden sensibility was in evidence when John D. Rockefeller Jr. announced plans to rebuild Williamsburg, Virginia, and Henry Ford decided to reconstruct Greenfield Village in Michigan. Although Rockefeller's romantic vision of early Virginia life has been criticized by later generations of scholars and visitors, it seemed quite plausible in its day. "Prettifying" Williamsburg to make it a more harmonious and unified-looking town than it ever was seemed entirely proper. Even if real colonial gardens were never as ornate as anything in Rockefeller's Williamsburg, such revisionism was seen as serving a higher cause.[13] The grand scale of Ford's and Rockefeller's ventures has been credited with stimulating the entry of a great number of professionals, from architects to landscape designers, into the preservation field.

In this light, Johnston's own move into preservation work makes perfect sense. The appeal to patriotic sentiments was part of her own forma-

tion. As a professional garden and estate photographer, she had the skills that large-scale enterprises like Williamsburg were now calling forth. She was part of a new coalition of professionals working to re-create the look of early America. By scouring the countryside and photographing all the relevant structures she could find, Johnston was giving the restoration architects the raw material they needed for their plans.

Beyond aiding the actual restoration planning, Johnston worked to increase public interest in preservation, encouraging people to rally behind saving a particular local building or designating a whole district as a preservation zone. Either way, tourism was bound to increase, bringing fresh income to financially struggling areas. This focus on designating preservation zones was later criticized for its elitism, but it was a radical notion in the early 1930s when Johnston and others were advancing it.[14]

Seeing herself as a missionary for the cause, Johnston made a case for historic preservation to all the various interest groups she could. She impressed socialites with her university backing. She impressed the scholarly community with her Carnegie backing. She impressed philanthropic organizations with her grassroots backing. What could be more irresistible than a photograph of a crowd of schoolchildren learning to identify the old buildings of their own hometowns?

In 1930, Johnston made two important moves. First, she donated all 144 of her Chatham photographs of early Virginia architecture to the Library of Congress. From time to time, Johnston had donated small items (frequently garden books) to the library.[15] This particular donation, however, became the nucleus of the Library of Congress's Pictorial Archives of Early American Architecture, under the direction of Dr. Leicester B. Holland, who headed the Fine Arts (now called Prints and Photographs) Division. From this point on, Johnston and Holland were close personal and professional friends. It was Holland who urged Frederick Keppel, president of the Carnegie Corporation, to fund Johnston's plans to photograph more Virginia sites. It was Holland, too, who jointly administered Johnston's grants, since her funders usually stipulated that her material would be deposited with his division at the Library of Congress when she was finished.

For her part, Johnston wrote Holland the warmest of letters and sent presents to his wife and children every Christmas. In the 1938 version of her will, she left Holland her Georgetown property with the kind proviso

that he should feel free to sell it to finance another archeological dig in Greece if he so desired. Her support continued through her various wills; she considered Holland a close friend for the rest of her life.

Johnston's second big move came in June 1930, when she accepted an offer from the architect and *New York Times* writer Henry Irving Brock to illustrate the book he was writing for the Dale Press, *Colonial Churches in Virginia.* All that summer, she traveled to Brock's sites to photograph churches. Her standards were quite exacting. For instance, she convinced the Williamsburg governing board to chop down some trees that were in the way of the shot she wanted of the Bruton churchyard.[16] The book went considerably over budget, but that was not her concern. Brock was a well-connected writer and critic in the early architecture field, a valuable ally. The photos she made for his volume were excellent and led to many opportunities for her.

Carnegie funding was already coming to Johnston through Dr. Holland by the summer of 1930. Meanwhile, she had located another interested party, the head of the University of Virginia's architecture department, Edward Campbell. As Johnston wrote to Campbell many years later, "I will never forget that the little acorn of the Carnegie Surveys was planted in fertile soil at your department at the University and fostered there grew into an oak of mighty proportions."[17] Campbell was a great proponent of Jeffersonian design, Johnston told Holland, and full of suggestions for local sites that needed photographic preservation. Of equal interest to Johnston was Isabella Burnet, librarian of the university's School of Fine Arts. Burnet was the first of many college employees upon whom Johnston relied to keep her larger surveys organized. Again and again, Burnet sent Johnston lists of sites already shot by others and sites needing further consideration.

Johnston photographed when the weather permitted, using the off-seasons to organize her paperwork. As busy as she was, she never neglected the necessary gracious gestures toward her funders. If Keppel asked her for a special photo of something, she sent it immediately with no bill attached; the Carnegie office had to write and ask to pay. From time to time, she sent Keppel the odd vase or curio to show that she considered him a man of taste. Careful not to impose herself, she still made a point of calling on him in New York on occasion. Johnston left both Keppel and Waldo Leland (the head of the A.C.L.S.) little keepsakes in her 1938 will.[18]

Johnston used Campbell, on the other hand, to legitimate her work

FIGURE 35

Pavilion II, University of Virginia. Johnston started her Carnegie-sponsored surveys at the University of Virginia.

and promote it to the University of Virginia. In early June 1932, she wrote to Campbell, urging him to buy some 350 to 500 of her Virginia prints to start a collection at the university. The series included some fine shots of the university itself, an acknowledged masterpiece of Jeffersonian design. Figure 35, for example, is a striking view of one of the Pavilions of Jefferson's Academical Village. Later that month she wrote Keppel, to suggest that the Carnegie Corporation buy $3,500 worth of her photos to donate to the university.[19] Then she tried variants of the scheme: What if Carnegie funded Johnston to make a series of negatives, so other libraries could subscribe and receive a set of prints in return?

In January 1933, Johnston received the $3,500 from Carnegie that she had requested to fund her work in Virginia, for which her contact was Burnet rather than Campbell. Burnet understood the work and was willing to do a great deal of tedious research on various locations. Campbell became more distant as work got under way, perhaps because he detested Holland.[20] Then too, Campbell could be annoyingly careless. He would send Johnston to photograph sites he considered crucial, like the Cabell house, and then leave those frames out of the final survey—quite by accident.[21] He did give her detailed advice, though, on whom to consult in various cities and counties and how seriously to take them.

Throughout the year, Johnston reported good progress to J. L. Newcomb, the new president of the University of Virginia, who conferred with Keppel over priorities. Was it better to spend the remaining funds by having Johnston photograph more locations, or to have her print the negatives she had already made? By the end of the year, Keppel was ready to provide a little more of both: Carnegie would pay Johnston $1,500 more for new negatives and an additional $1,000 to make a set of prints to show and keep at the University of Virginia.

As her fieldwork expanded, Johnston continued to establish regional contacts. Milton Grigg, a Charlottesville architect, was a great help, as was G. B. Lorraine, a Richmond real estate broker. Lorraine was also an amateur historian and thus was knowledgeable about the condition and ownership of old properties in his vicinity. Charles Peterson, of the Department of the Interior, sent her lists of buildings in various counties for what she called her "dope sheet."[22] This sort of information was important to Johnston as she mapped out her shooting schedule.

Once she located promising sites, her architectural self-education guided her focus. She devoted great care to interior detail, as can be seen in her view of the staircase at Mirador, home of the Langhorne family, in

Albemarle County, Virginia (figure 36). If a building was occupied, she usually asked the residents to leave so she could remove all distracting clutter from the interiors.[23] Not only did this give a clearer view of the underlying structure, but it changed the mood of the frame. A good example is her view of the fireplace wall at Mt. Custis (figure 37), which in its bare state conveys a chaste serenity.

It has been said that museum exhibits and preservation sites stimulate the "dream spaces" of the viewer; that by addressing memory, they allow viewers to explore their personal feelings about the past.[24] Perhaps this is what Johnston did as she stripped down those old homes. Removing the owner's knickknacks and personal furnishings, she cleared the clutter and focused on her own personal vision of the past. In the many staircases and fireplaces she photographed in this series, she may have felt echoes of both the magnificent hearth in her Washington studio and that staircase photo that crowned her Hampton series.

Photographing the exteriors of structures meant calculating the best time of day for each view and including all appended structures, however dilapidated. If earlier generations of historic preservationists can be criticized for celebrating only the grand homes of the national leaders, Johnston cannot. She took great pains to search out the humbler buildings—the slave quarters of plantations, the sheds covering the cotton presses, the old city water fountains, the warehouses. She even located a surprising number of large and elaborate dovecotes, as in figure 38. No building was too insignificant for her attention; the most "minor" were often the most endangered.

As confident as she was of the project's value, it was also pioneering work, so the market was not yet large or obvious. While Johnston pursued foundation and university support, friends like Lorraine tried promoting her work in various entrepreneurial directions. In 1935, Lorraine, on Johnston's behalf, offered the Metropolitan Museum in New York a whole archive of her photos. He made the same offer to several wealthy individuals. A set of two thousand prints would sell for $1.50 each, $3,000 altogether. There were, apparently, no buyers.

Johnston kept her prices deliberately high, aimed at the upper end of the market. She was explicit: "I hear constant echoes of my high prices for my photographic work, but no criticism of the value and quality of my services. It is always a surprise to find so many people who still expect to buy grade A cream for the price of skimmed milk."[25]

It should be remembered that Johnston was seventy-one years old in

FIGURE 36

Staircase at Mirador, home of the Langhorne family, Albemarle County, Virginia, 1926.
Johnston was often praised for her aesthetic approach to architectural documentation. Here, an
assortment of curves and rectangles flanks a vast negative space, the true center of the frame. The
staircase is grounded by the compass, suggesting earth, and ascends to the infinite.

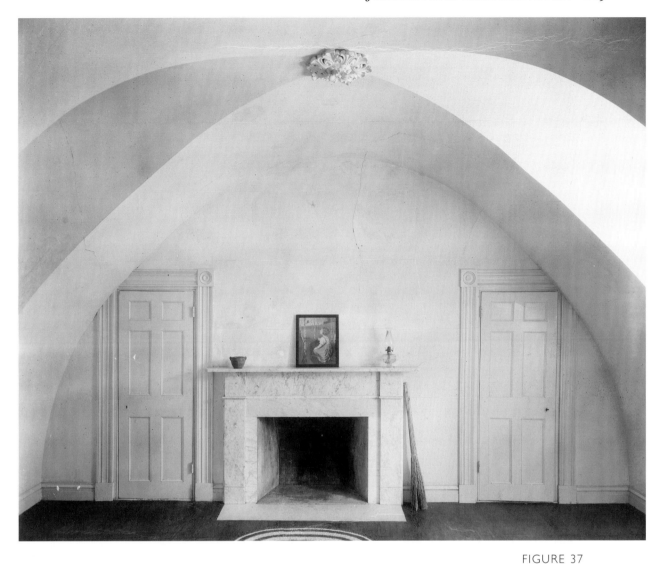

FIGURE 37

Fireplace wall, Mt. Custis, Accomack County, Virginia, early 1930s. Johnston commonly recorded fireplaces. Although the corners of the doors are cut off and the fireplace is off-center, the overall effect is harmonious. The arches give the wall a gothic framing, emphasizing the tranquility of the space.

1935 and hoping to make some investments to provide for her old age. By July of that year, she was at work on another of her real estate schemes. There was a building in downtown Washington, D.C., that she could buy and renovate—if she were able to convince some friends to move in and prepay a few years' rent. One of her close friends, "Eliz-Pete" Willis, wanted in on the deal, but she had to get the money from her father, and he would not lend her anything until she divorced her husband. Although Eliz-Pete was in Reno a month later for her divorce and remained a life-long friend of Johnston's, the real estate plan never came to anything.

Another sideline of Johnston's was buying and selling architectural details. She would salvage the wainscoting, bricks, or some other feature of a building that she knew had value and then consign the material to

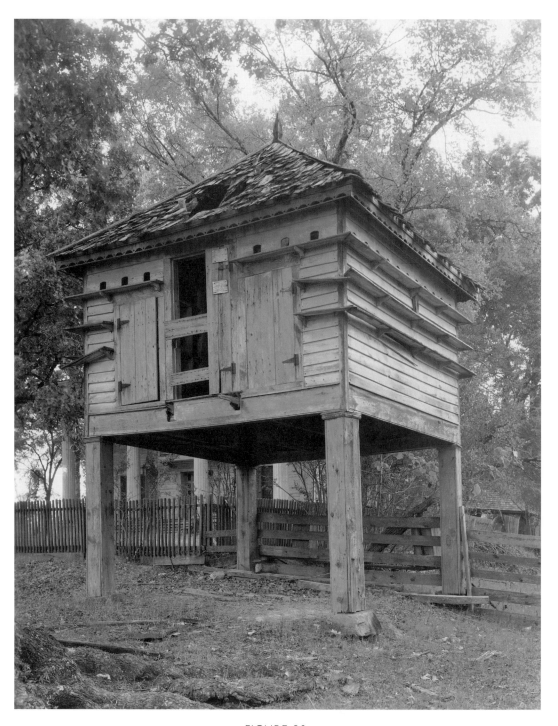

FIGURE 38

Dovecote, Hill Plantation, Wilkes County, Georgia, c. 1938. Dovecotes were among the most rustic outbuildings of old southern plantations. The elaborate arrangement of roosts and hidey-holes lends appealing complexity to an otherwise rudimentary structure.

dealers or pass the word among interested parties herself.[26] She called her-self "Blackbeard," she said, because she resorted "occasionally to piracy."[27]

Such activities were quite energy-consuming, but it was not until 1935 that Johnston first made reference to her advancing age. In a letter to Lor-raine, she urged him not to mention her age when offering her Virginia survey prints to buyers. Stressing age, she said, was "so baldly inadvisable now. Might react as disability aginst [*sic*] future grants by raising immedi-ate question as to physical fitness of threescore and ten for field work. . . ."[28] It was age discrimination she was worried about rather than her ability to work.

If her letters can be believed, she was still flirting with any number of her old chums well into her eighties. From 1936 onward, she maintained a lively flirtation with Ernest Coe, a Florida landscape architect significantly involved with establishing the Everglades as a national park. Coe's corre-spondence refers to several "lovely" dinner parties and suggests they "trip the light fantastic" some night at the Everglades Hotel.[29] There was also a "special boyfriend" whose letter Johnston's assistant, Dorothy Bowman, apologized for opening.[30] Then too, in her late seventies, Johnston wrote to a friend that she was staying the night at an "attractive bachelor's apart-ment," someone she called her "very best Baltimore swain." As she put it, "sounds real devilish, doesn't it?"[31]

Such talk was a fine way to flirt, and Johnston counted a number of great flirters in her circles. Over the years, letters from Johnston's friend Jo Hubbard Chamberlain contained some of the most flirtatious blather in her files, even his note announcing his marriage. Zelda Branch addressed her as "Darling Madame Queen," and Frances Dean (a.k.a. "Darlee") closed with cozy little endearments like "yours undetachedly."

Even strangers, including interviewers meeting Johnston for the first time, came away with the impression of a larger-than-life personality. There is hardly an interview that does not make sly reference to her fond-ness for bourbon, or cocktails, or "living it up." It is as if that portrait she made of herself some forty years earlier, with cigarette lit, tankard and skirts raised (the frontispiece), was still the image she had of herself.

In 1936, she received the good news that the A.C.L.S. was giving her $3,500 to photograph the early architecture of North Carolina. As part of the project, Waldo Leland arranged three southern mentors for her: A. R. Newsome and Howard Odum of the state university at Chapel Hill, and William Boyd of Duke University, in Durham. Newsome and William Hamilton of Durham ended up being her chief advisers for this project.

After some years as an amateur historian, Johnston seemed to enjoy this chance to give her work depth. There was no well-defined group of historic structures that she had to be sure to include in her photos, just a countryside replete with patched-over and cobbled-together buildings that might contain early American elements. Therefore, the more she knew, the better she could spot the kind of structures that architectural historians would find interesting. She studied early American regulations concerning minimum house size and other landholding laws, making note, for instance, that a colonial-era settler who was given a five-hundred–acre plot had to build a house of a certain minimum size, usually 48'-by-16'. She followed the history of various architectural features, like chimneys and "water tables"—ledges for roof runoff.[32] Such features were often a good indication of the vintage of a structure.

In late 1936, the Carnegie Institution of Washington awarded Johnston a small grant: $500 to spend for a month photographing St. Augustine, Florida. The results were to be used in a campaign headed by Verne Chatelain, director of the St. Augustine Historical Survey, to gain support from local businesses and citizens for the restoration of the city. The proposed restoration would be an expensive undertaking, but if people could be made to see their city as something unique and special, they might support it. High-quality photographs of key attractions might also remind chamber-of-commerce leaders that increased tourism would lead to greater revenues.

Johnston made her St. Augustine series in January 1937. She seems to have enjoyed the project, although there are references in her correspondence to a large cost overrun: "there was an emergency to be met, and I did what I could."[33] She also had a problem with her friend Liz-Pete Willis, for whom Johnston had arranged work with the larger project, the St. Augustine Historical Survey. Their personal relationship subsequently was strained when Willis borrowed money from Johnston and then discharged other debts (like bills from her dressmaker) before repaying her friend. For the most part, however, Johnston had a warmly sociable sojourn. Not only did she correspond with several people she met in St. Augustine after working there, but she considered buying a home there for a winter retreat.

Her St. Augustine photographs were considered superb. There were her usual gardens, courtyards, and elaborate facades—and then one quite haunting image of a bone-lined shed, an ossuary. Apparently John Mer-

riam, at Carnegie, had asked her to photograph a particular Seminole graveyard if she could.[34] She obliged—and then tried to talk Carnegie into funding another series of St. Augustine photographs. No such commitment was forthcoming.

Johnston had a major show at the Smithsonian in February 1937. In April, she arranged to be invited to exhibit at the American Association of Museums' annual meeting, to be held that May in New Orleans. These exhibits strengthened her connections with the museum community, which included a goodly number of architects, among others, who were very enthusiastic about her work.

Through such meetings, she also came to know a number of people working for the Historic American Buildings Survey (H.A.B.S.), which was started in 1933 to do work modeled after Johnston's own Virginia survey. As a joint venture of the Library of Congress, the American Institute of Architects, and the Department of the Interior, the H.A.B.S. sent out teams of photographers and architects to measure and to record endangered buildings. Johnston ended up working closely with many H.A.B.S. people, among them E. Walter Burckhardt, who wanted to collaborate on a book of the architecture of the river valleys of Georgia, Alabama, and Mississippi; F. D. Nichols, who eventually wrote a book on the architecture of Georgia using Johnston's photos; Edward Jones, with whom she had discussed various possible book projects; and Thomas Waterman, with whom she collaborated on several works.[35]

There were two main reasons why the leading architects wanted to work with Johnston: She was not afraid to do the legwork involved in locating historic structures, and she knew how to photograph a building in a way that both historians and artists would appreciate. She focused on the right kind of detail. As Holland put it, "In one picture she accurately presents the elevation, size, shape, and distinguishing characteristics of a structure."[36] She herself would often boast that a bricklayer could figure out the pattern he needed by checking the detail in one of her 8-by-10s.

Johnston's most unique advantage, however, was her relationship with the general public. When Johnston came to town, she generated that mixture of sensation and seriousness that meant local papers had something to report. She gave talks and held press conferences, and her message was always addressed directly to the people in front of her. She firmly believed that it would take grassroots enthusiasm to save the old buildings of anonymous places. If the local folk would rather put up a dress shop or a

grocery store than save an old cotton warehouse, the historic-preservation movement would dwindle to a handful of socialites saving each other's family estates for posterity. The lure of tourist dollars might appeal to a local constituency, she thought, provided the area had adequate resources. As Johnston wrote in response to an article in the *Washington Post,* "many a village father, casting an envious eye on the gold mine for the tourist trade developed so magnificently at Williamsburg, is regarding with new respect . . . the fine old houses, the gabled farmhouses, inns, the mills and cabins of his neighborhood."[37] Historic preservation required trying every way possible to creatively bring this heritage to the attention of as many people as possible.

The November 1937 exhibition of Johnston's work in Charleston, South Carolina, is a case in point. Johnston mounted twenty-five Charleston photos—unidentified—at the Gibbs Art Gallery and had the *Charleston Evening Post* and the art association sponsor a contest. School-children—the old standby—were brought to the gallery and asked to identify as many photos as they could. The contest brought nearly a thousand children to the show and generated a couple of useful newspaper photos as well as a lively story detailing some of the amusing responses offered by the students. The Citadel had been confused with the jail, the College of Charleston had been mixed up with "The Playground," and the "Declaration of Independence" was said to have been signed at the house of the "Liberty Tree."[38]

In 1938, Carnegie dispatched Johnston again, this time to New Orleans. One local reporter was so taken by her methods that he described them in great detail:

> Daily now she is going about downtown New Orleans, checking records, then selecting and studying houses and courts and intersections. She had drawn a map of buildings, showing which will photograph best in the morning, which in the afternoon . . . she is planting herself at corners, in courts, on balconies, to fight it out with the clouds and the sun.
>
> Sometimes . . . she sits for hours in her car. Then she may give up for the day because conditions aren't right. . . . She calls on the police to help her in many places, to stop traffic and push cars aside.[39]

The French Quarter was a nightmare for photographers. As Johnston put it, "Your traffic—it makes photography often impossible. . . . Cars whiz through your old section . . . hell-bent-for-leather. And the parking! It's out of the question to do any work for long stretches."[40] She followed this lighthearted jabbing with some generous hyperbole about the uniqueness and sophistication of New Orleans, just the sort of flattery to endear her to these very cosmopolitan southerners. Yet her comments were serious; her comparison of the Big Easy with Paris foreshadowed her decision a decade later to move to New Orleans.

But before she settled down, she still had more of the South to cover. In 1938, she photographed the hundred-year-old Uncle Sam plantation in Louisiana—a timely move, since it was demolished in 1940 to make changes in the nearby river levee. At the time of Johnston's visit, Uncle Sam was considered one of the most complete plantations still standing, even though it had been unoccupied for years. The eight views Johnston made, ranging from the "big house" to the pigeon tower, remain a valuable resource for students of plantation design.[41]

Johnston, ever the savvy freelancer, knew that it was better to have two patrons footing the bill for a trip than one. By the same token, any time she could use a trip to work in a marketable shoot or even a useful connection, she did. *Town and Country* frequently bought her garden and estate shots, and the *Magazine of Art* bought a number of Charleston scenes to illustrate a piece by DuBose Heyward on the Dock Street Theatre.[42] Johnston seems to have taken great pains to visit the writer Ellen Glasgow in Richmond to show her a selection of photographs, even giving her several, never a common Johnston gesture.[43] It may have been that Glasgow's publisher paid for this expedition, for a new frontispiece for one of her books, or that the American Academy of Arts and Letters was paying, since they did acknowledge receipt of eight Glasgow photos.[44] Regardless of who sponsored the trip, Glasgow was definitely the sort of figure Johnston liked to cultivate; she would have enjoyed making Glasgow a gift.

Margaret Mitchell (Marsh), the author of *Gone with the Wind,* was another southern figure Johnston tried to befriend. Johnston had asked Lorraine in 1937 to try to interest Mitchell in backing an architectural survey of Georgia, an offer that Mitchell parried, albeit with great flattery. By the time of Lorraine's next solicitation, in 1939, Mitchell had been inun-

dated with *Gone with the Wind*–related business; she offered a few thoughtful suggestions but did not intend to get involved herself.[45]

Johnston was planning to do a substantial amount of fieldwork in the spring of 1939—covering Mississippi, Alabama, and Georgia. In addition to A.C.L.S. funding, some of her travels were cosponsored by the Southern Pine Association of Biloxi. She had sold them on photos of early American buildings that were still standing because they were made of that superior material: wood. Her plans were upset, however, by a season of record-breaking rains. By late June, she was complaining that they had had "forty days of rain in Alabama since the beginning of May."[46] More than just weather may have been bothering her in Alabama, judging from the headline she got in the Birmingham paper: "Carnegie Woman to Take Dixie Pictures." The accompanying story made note that her car had "Shanghai" license plates, which she was quoted as saying her "Negro chauffeur" had bought at Sears.[47]

In October 1939, Johnston arranged a series of projects in Savannah, Georgia. *House and Garden* had given her a list of Savannah sites they wanted photographed, and she had a few new public-relations ideas to promote as well. Before long, Mayor Thomas Gamble was a Johnston convert, writing a friend at Georgia Railway to sing her praises. Johnston, he proclaimed, photographed "spots of beauty that you and I would callously pass up of no significance. Miss Johnston has been carried away by the beauty of the arches of the Central of Georgia Railway Depot and the approaches, and she will show them to you. I feel sure that neither you nor Mr. Pollard have ever appreciated the charms of these arches, but now that they are brought to our attention we will do our best to preserve them."[48]

Subsequently, Johnston proposed a major public-relations campaign to the Savannah Chamber of Commerce, for which she would do a series comprised of about seventy scenes of "picturesque Savannah." These photos would be mounted as a major exhibition at the Telfair Academy, with selections to be reprinted for the collection of the Savannah Landmarks Commission. As a final touch, she would pick out her most popular shots for the chamber of commerce to use in its publicity for tourism and advertising. She priced the whole project at $1,000. The chamber of commerce countered by suggesting a per-shot price, but this was not how Johnston wanted to work; her travel costs and other overhead had to be amortized over a fairly sizable total project.[49] Nothing came of the scheme in the end, but since most of the photos were already shot, they were eventually recy-

cled into the book *The Early Architecture of Georgia,* by Frederick Doveton Nichols, which appeared posthumously in 1957.

Thanks to the magazines that were featuring her work, news of Johnston filtered back to some of her old acquaintances. Johnston's Chicago friend Clara Laughlin was writing another of her breezy guidebooks, this time entitled *So You're Going South.* Could they use some of Johnston's southern photos for illustrations? Johnston was enthusiastic, but she did expect to be paid, she warned Clara. Laughlin's budget was flexible enough to accommodate these charges, so the photographs were included. Roger Scaife, Laughlin's editor at Little, Brown, found Johnston intriguing and wrote to her proposing to do a book of her reminiscences, but nothing came of the project.[50]

Around this time, Johnston began letting people know that she was finally interested in buying a house for herself. Her first thought was to purchase one of the elegant but unrestored homes of old St. Augustine. Some of them must be cheap, she speculated. It is impressive that a seventy-six year old woman was imagining herself renovating a crumbling mansion with no indoor plumbing.[51]

In any case, World War II was starting to impinge on Johnston's work, as peripheral to the war effort as she was. She could no longer depend on her trusty driver-mechanic-assistant, Huntley Ruff: He wrote from Fort Meade, Florida, where he had been stationed, worried about what might happen to her car. Gas rationing was a constant worry, since she was entitled to no special allowance for doing work "in the national interest." Eventually, between gas rationing and dwindling supplies of photographic materials, she had to abandon fieldwork.

After endless wrangling with the University of North Carolina Press, however, her North Carolina book with Thomas Waterman, *The Early Architecture of North Carolina,* finally came out. It was dedicated to two women who had been organizing her North Carolina work: Kate Arrington and Elizabeth Cotten. A special first edition was printed for the Colonial Dames and sold by advance subscription, helping to finance a volume that had grown increasingly expensive throughout its production.

But publication did not mark the end of troubles with this particular book. One reviewer had questioned whether this work was really so "pioneering." Had not Waterman borrowed a great deal from Louise Hall and other contributors to the 1939 *Federal Writer's Guide*? It was Waterman who was responsible for the text and thus his honor at stake, but Johnston

jumped into the fray all the same, writing him a long memo to use in rebuttal. Back in 1935, when she was just finishing the Virginia survey, no one knew of more than a handful of pre-Revolutionary homes in North Carolina, she maintained. The secretary of the North Carolina historical commission could think of perhaps three. A historian for the state added a few more. By uncovering so many valuable historic sites—between six and seven hundred sites in forty counties of North Carolina—she and Waterman really were pioneers, she argued. As for their relationship with the staff of the *Federal Writer's Guide,* Johnston freely acknowledged that she and Louise Hall "became excellent friends and I gave her full access to all my material."[52] The editor of the *Guide,* Edwin Bjorkman, had actually wanted to use some of Johnston's photos, only his Washington office would not authorize payment, so she had to refuse. In other words, she was a source rather than an imitator. She also pointed out that Waterman's text was already under review when the *Guide* came out, in the summer of 1941, so Waterman would have had to have been "clairvoyant" to have stolen anything from it.

Johnston's argument was persuasive. After those first few years in Virginia, Johnston had developed a particular methodology. She had a network of advisers to give her leads and a mapping system for laying out her work, and Waterman seems to have worked well with Johnston and her system. If anything, the authors of the *Federal Writer's Guide* learned from Johnston and Waterman, rather than the reverse.

In any case, by the time the summer of 1942 rolled around, Johnston was thinking about a different kind of book, one that would let her celebrate her own "southern" roots. Now it was Johnston's father's great-grandfather, the Reverend Lewis Craig, who would serve as the foundation of Johnston's identity, just as earlier, her mother's Revolutionary-era ancestors had supplied her with a D.A.R.-suitable lineage.

Johnston wrote to her friend Ola Coleman that she intended to make a "pilgrimage" retracing the "hegira" of her "pioneer forebears" of Craig's Church, as they traveled from Virginia to Kentucky in September of 1781. If Ola was willing to pay her share (which she estimated at $3 to $3.50 per day) she was welcome to come.[53] Ola accepted, and Johnston made arrangements.

First she contacted her usual connections—her D.A.R. network and her friend Zelda Branch's contacts in the Works Progress Administration

(W.P.A.) and the Department of the Interior. She also wrote to relevant clergymen and distant relatives, trying to pinpoint the exact locations of her ancestors' graves and to locate any material on the history of Craig's Church. She let people know that she intended to put together a book on this "amazing pilgrimage" of some six hundred souls in the years just before the end of the American Revolution.

In a letter describing this personal research project to Thomas Waterman, she related her hope that some new material on Craig's Church might have surfaced during the recent indexing of old church and court records by W.P.A. workers. She added, "*OF COURSE*, I'll do a book, illustrated by a well-known lady photog. if I can come on the material I think must be there. I've caught your bug, see?"[54]

Johnston and Coleman did make the trip, although no book resulted. According to a newspaper account and a small note in a railroad magazine, Johnston, Coleman, and their chauffeur, one Johnnie Washington of Winchester, Virginia, had been taken before the police for questioning. Apparently Johnston had been photographing a shallow ford that Reverend Craig's flock probably had crossed back in 1781. A small boy reported these activities to the police, since a Norfolk and Western railway bridge spanned the stream and bridges were considered "enemy targets." The police grilled the chauffeur first, although they do not seem to have believed much of what he said—to the extent of even doubting his name. As for Johnston and Coleman, they were reported as speaking with "either a foreign or a northern accent."[55]

Even if there were no tangible results from this pilgrimage, however, the mission still had great symbolic value for Johnston. These were roots she was attempting to claim; this was the South she had been trying, all along, to resurrect. Johnston's South was not a landscape of Hamptons and Tuskegees, full of ex-slaves making their way in Booker T. Washington's footsteps. Nor was it some populist vision of a "New South," as was emerging from the sociology departments of some universities, notably the University of North Carolina. Even less was it the moonlight-and-magnolias southern fantasy of convention. The South Johnston sought was ante-Antebellum. The story that interested her was that of her Scots-Irish-Moravian pioneer forebears. In her mind this was a South before slavery, before the plantation system—however ahistorical she knew that to be. The Reverend Craig, she knew, had gone to jail rather than let the govern-

ment tax or license his right to preach. It was this religious freedom struggle, not the next century's abolition struggle, which she chose to make her own. That she herself had no particular religious affiliation did not strike her as ironic in the least; the way she interpreted it, this history was about freedom.

Having defined her roots to her own satisfaction, Johnston returned to other projects and the question of a home and a garden. Washington, D.C., might have seemed the logical place for her to alight, since her personal history was lived there. Indeed, in the year following her Craig's Church pilgrimage, Johnston returned to Washington to work on a new project.

The publisher Walter Frese, of Hastings House, wanted a series of Washington photos for his "Washington Sketchbook" and calendar. What should have been a simple job for an old Washingtonian like Johnston, however, was greatly complicated by wartime regulations. Johnston and her assistant needed security clearances and identification badges merely to stand and photograph half the scenes Frese wanted. When she finished this work, she realized that she was finished with Washington, too. She went south in the summer of 1944 with two jobs in mind. The Delta Steamship Line wanted a "picture book" of New Orleans for an advertising campaign, and her Savannah associate Edward Jones had asked her to do some architectural photos in Georgia.[56]

The trip was awful, as she explained to Jones. She reached Athens, Georgia, in September, only to have her car stolen by her new chauffeur, who drove back to Washington with it. Even though she eventually was able to retrieve the car, her gas rations had been used up. In addition, she was out of film. She warned Jones that if he came looking, he would probably find her in some "old ladies home" soon, although she allowed as how she would prefer an "old gent's home."[57]

Hardly two months later, she was writing upbeat notes to her friend Zelda Branch about what a fine time she was having in New Orleans. Zelda had given her introductions to some of her newspaper friends, which meant Johnston had some lively drinking companions as well as plenty of interviews in the press. There was even a nice young man with a darkroom she could share. What more did she need?

A year later, Johnston was packing up the trappings of her Washington life and heading back to New Orleans—for good.

7

The "Octo-Geranium"
Puts Down Roots:
New Orleans,
1945–1952

Most people in their eighties would not choose to move themselves to a new city and an old house in need of extensive renovation. If Johnston had had a supply of relatives in town to help her, her decision to relocate to New Orleans might have seemed more reasonable, but she had no one she could call on. But this does not seem to have bothered her; like most other women in her immediate circle, she was used to taking care of herself. Indeed, she was so accustomed to denying that her advancing years were any impediment to her plans that she probably convinced herself it was true.

During this period, there is only one point at which she mentions a need to slow down and relax: in 1948, when she went for a "rest stay" at a friend's guesthouse in Winchester, Virginia.[1] For the most part, Johnston handled everything herself until two or three years before her death. At that point the combination of a couple of serious falls and some nonspecific ailments made her realize that she needed help. Fortunately, she had come to New Orleans when she was still able to get around and meet people, still energetic enough to direct the renovation of a house. By the time the inevitable decline set in, Johnston did have a system in place for her own care.

Johnston had photographed New Orleans back in 1938 and found the city aesthetically pleasing: It was old, bohemian, and French. It was also

still relatively affordable, and the people she met were congenial. There had been an active arts community in New Orleans throughout the early part of the twentieth century, and it was a particularly favored destination for photographers. Lewis Hine, Edward Weston, Robert Tibbs, Paul Strand, Arnold Genthe, and Doris Ulmann all did important work in New Orleans. By the last years of World War II, however, much of this artistic activity had come to a halt. Most photographers could not get film, paper, or developing chemicals unless they were working for the government in some capacity.

In spite of the shortages, and in spite of her age, Johnston busied herself trying to organize a darkroom. She was not feeling a sudden passion for the developing process per se but was simply frustrated with her Washington processor, Mr. Scott, whom she suspected of misplacing her film. Ever on the lookout for personable young men, she located David C. Arnold, a photographer and returning war veteran eager to set up shop with Johnston. Arnold was buying a townhouse that he planned to renovate to include a ground-floor apartment for Johnston and a darkroom for their mutual use. Johnston, who had moved from 812 Dauphine Street in March 1945 to 929 Dumaine Street, was enthusiastic about the plan. Unfortunately, Johnston's pleas to get Arnold a ration of photo supplies failed, and Arnold could not get rid of the tenants he inherited, so the idea of a partnership gradually faded, and Johnston returned to her search for something suitable.

When she saw the house at 1132 Bourbon Street, "I signed the contract to purchase, within an hour after I had first seen it."[2] Johnston closed on the property for $4,600 and in August 1945, moved in. That she was buying it from a building-and-loan society probably meant that it was a foreclosure, which would explain the low price. The house needed work, of course, but it was just the type of place Johnston had been looking for in St. Augustine years earlier—an old house with character, priced to sell. Not only was it in walking distance of a variety of amusements, but it was an old building—one hundred years old, by Johnston's estimate—with plenty of New Orleans character.

She named it Arkady, her version of Arcadia. As she described it to her friend Emma Ward when inviting her to visit, 1132 Bourbon Street was "in walking distance of the best spots of the Vieux Carre, two blocks from the French Market and the Morning Call, where you can get coffee and doughnuts at 4 am." Best of all, Johnston concluded, "we could settle

down to making plans for cashing in all the outlets I have started on my way down."[3] To another correspondent, Johnston wrote, "they tell me if you start eleven blocks over—at Canal and Bourbon—and hope to drink your way with a stop-over at every life-saving station on the way, you won't get to 1132 Bourbon for about six months."[4]

When she bought the house, the entire front facade was decked with old-fashioned, wrought-iron balconies, but the downstairs rooms in the back faced a junk-strewn courtyard. Behind that were the former slave quarters, which did not even have electricity. After having the courtyard cleared, Johnston had a pond installed and surrounded it with suitable vegetation—tall grasses, papyrus, and water lilies. When the inevitable mosquitoes arrived, she bought several dollars' worth of goldfish to eat the insects. The slave quarters, after being renovated and electrified, were rented out—on one occasion, to the Mardi Gras queen Valenteena Harris.

Johnston subdivided the main house into three apartments—the ground floor, including a darkroom, for herself, and the two other floors for renters. The second-floor flat had four rooms and a bath and rented for $75 or $100 per month.[5] From time to time, she would find a particularly responsible tenant—a family connected with one of the nearby hospitals, for example, who always paid the rent—but most were students, drifters, or other impecunious souls.

For her personal quarters, Johnston unpacked her accumulated chinoiserie, which included some large furniture as well as various urns and scrolls. In the past, she had decorated in the Arts and Crafts mode, a relatively soothing style that did not distract her customers. For the home of her mature years, however, she wanted to exhibit all the exotica she had spent a lifetime collecting. In New York or Washington such decor might have created a pretentious, museumlike effect, but in New Orleans it seemed chic, very much in keeping with the orientalist mode of the New Orleans author Lafcadio Hearn. Johnston loved the idea of making her Bourbon Street entrance in such style and photographed the results with obvious satisfaction.

Ever since she left her parents' Washington home, Johnston had lived in rented apartments, hotels, semiprivate lodgings at her club, and other people's homes. Now she finally had a home and garden of her own. Once she was settled, she took to keeping cats, including Herman, Vermin, and Mr. Purrcy Purrkins, who were very entertained by the goldfish. An undated postcard urging her to return home sent love from her ten cats,

although the tone was tongue-in-cheek, so perhaps that figure was an exaggeration. Johnston herself sent written regards to what she called her "catagory" at home. At one point, she wrote the editor of the *Atlanta Constitution* inquiring about plans for a State Cat Week, closing by calling herself a "cat collector, mostly of the Mehitable [*sic*] variety."[6] Despite her new home and feline companions, however, she spent the next five years shuttling between Washington, Atlanta, and New Orleans, supervising shows, organizing her negatives, and promoting her work.

She stayed in touch with a core group of old friends by mail: Zelda Branch, Emma Ward, Leicester Holland, Jo Hubbard Chamberlin, and Thomas Waterman. For the most part, she used Ward to gain access to negatives stored at the Library of Congress or to any of her personal belongings still at the Washington Arts Club. On one occasion, she asked Branch to straighten out a bad mix-up with her Washington files, but Branch made it clear that she could not because her husband had become an invalid and needed her at home. Even when there was not work to be done, Branch and Ward were her main Washington connections; she relied on them to keep her on the Washington grapevine. Her other Washington connection, her longtime assistant Georgiana Stebbins, may have died sometime after 1944, since she no longer figured in Johnston's wills or correspondence after that point.

Holland usually wrote chatty, intimate letters, as did Chamberlin, but one lived in Pennsylvania and the other in New York, and neither could actually visit her. The people she spent the most time with were probably her chauffeurs and the various tenants of her Bourbon Street house.

In an interview with the *Atlanta Constitution,* Johnston explained that she was traveling "with her Negro woman chauffeur, whom she hired one night in the driving rain in Washington when she took refuge in her cab."[7] The woman's name was Lessie Lee, and she not only drove the car but had moved to New Orleans to become Johnston's cook, personal maid, and general assistant. In June 1948, Lee had to return to Washington to help her (juvenile) son out of legal troubles, but she returned to work for Johnston until September, when she found herself out of a job. Johnston blamed her for letting some of her cats get away and for letting her cocker spaniel die. When Lessie Lee told her she "wasn't hired to take care of dogs and cats" and became abusive besides, Johnston fired her on the spot.[8]

Kathaleen (Kay) Mills also worked for Johnston in various capacities, mostly at 1132 Bourbon Street. Mills entered the picture sometime before

March 1946, when she wrote Johnston to say she was going to Chicago and had borrowed Johnston's 5-by-7 camera. Mills had had a clerical job with a New Orleans newspaper, but she left that because she felt it was beneath her. Unemployed, she lived off the rents she collected from the tenants of 1132 Bourbon Street when Johnston traveled to Washington. Kay was good at writing plaintive letters, always closing with effusive professions of devotion—which did not prevent her from simply departing New Orleans one day, leaving the household bills and the pets unattended. She also took with her most of Johnston's valuables, a theft she later tried to pass off as a protective measure: he was "saving" Johnston's belongings from being stolen by others.

From California, Mills wrote Johnston earnest letters about going to night school, even promising to take French lessons, as Johnston had suggested. It was not until 1951 that Johnston told her lawyers to threaten Mills with prosecution unless she returned her belongings: a camera and lenses, garments, maps, rare posters, and books. Even then, Johnston told her lawyers that she did not believe the girl had thought she was stealing; it was more that she had annexed Johnston's belongings. A stern threat to prosecute would suffice, she advised. A month after the lawyer's letter, Mills shipped a thirty-nine–pound package to New Orleans . . . so perhaps Johnston knew Mills better than it might have otherwise seemed.[9]

By this point, Johnston had become an expert at drafting threatening letters. She was eighty-six when she sent this note to her delinquent tenant, Mr. Grames:

> If you are planning to leave New Orleans without making good your promise . . . to pay the $25.00 arrears of your long overdue rent for my Quarters apartment, which you occupied for two months, I think it might be well to consider the unpleasant consequences certain to follow the breaking of all your lying promises and your cheap chiselling.
>
> Pay me now, sending $25.00 by Johnny Lewis, as promised. You will have to pay eventually. I mean business and this is not a threat but a promise.[10]

This Johnny Lewis was one of Johnston's assistants; he was briefly (for one day) in one of her wills, slated to receive $500, the same amount she usually settled on for Huntley Ruff.[11]

Because she had renters at 1132, she needed help getting bills paid and rents collected in her absence, not to mention keeping up with repairs. When Mills deserted, Johnston had some tenants, the Robertses, take over, despite the fact that they had warned her in advance that they were not interested in caretaking. Although she was in California, Mills wrote to Johnston to complain about the Robertses—and to vindicate herself. Then Martha Roberts would write to Johnston, detailing all the bills Mills had never paid. Her "caretakers" had one thing in common, it seems: red ink on the balance sheet.

The situation improved when Johnston's neighbors started looking after 1132 when she was away: Edna Miremont at first, and then Mrs. Tom Sawyer, both of whom were left money in Johnston's last will. Miremont was a devoted correspondent, although noticeably more Christian than any of Johnston's other friends. After a bad heart attack, though, she did not think she could keep looking after the bills, repairs, and tenants of 1132, so Mrs. Sawyer, of 828 Bourbon Street, took over. It was her husband who notified friends that Johnston's health had taken a bad turn in March 1952, just months before she died.

In addition to the small circle of people who were working for her in various caretaking capacities, Johnston was close with some of the old bohemians of the Vieux Carré. The one she was most intimate with, judging from the photographs of the two together, was the photographer Joseph Woodsen Whitesell, known as "Pops."[12]

A portrait photographer, Whitesell had local and national celebrities among his clients: Sherwood Anderson, Sinclair Lewis, Lyle Saxon, and decades of Mardi Gras queens. Whitesell was famously eccentric. He and Johnston enjoyed drinking and trading stories and talking about mutual acquaintances; they were quite comfortable lounging on her patio in their kimonos, as seen in figure 39.

The thriving bohemian culture of New Orleans, rich in art and drink and deviance, must have made the city quite congenial for an old nonconformist like Johnston. Apart from the lush Mardi Gras underworld, there were the writers like Lafcadio Hearn, who had created an elaborate mythology around Creole culture and its superstitions. For visual artists, the old city provided boundless color, with its organ-grinders on the sidewalks, flower-sellers on the street corners, morning mists on city courtyards, and Spanish moss draping the bayous. Some photographers, like Doris Ulmann, were taken by the look of the common people of the city,

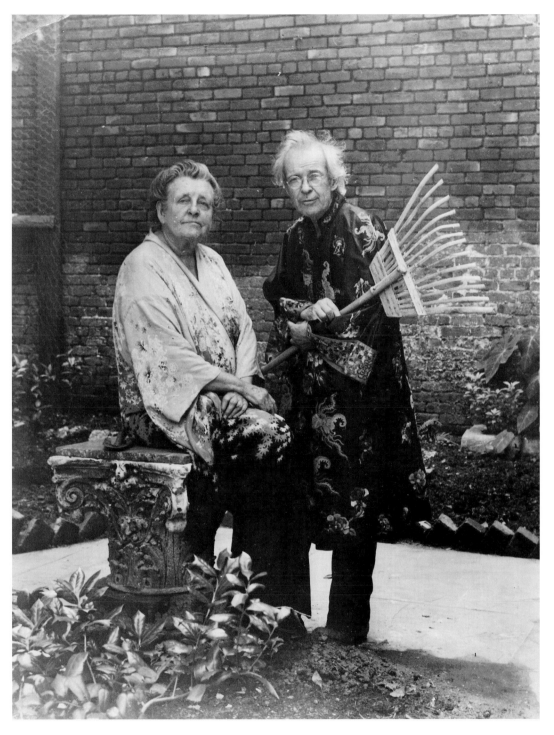

FIGURE 39

Johnston with Joseph "Pops" Whitesell, New Orleans, c. 1950. The two old bohemians lounge in their
kimonos in the garden of Johnston's Bourbon Street townhouse.

with their creased skin and bent bodies. Others, like Johnston, avoided faces, concentrating instead on the crumbling facades and byways of the city's old quarters.

Johnston's relatively few photographs from her last years in New Orleans primarily document her renovations of 1132 Bourbon Street. But still, she was far from retired. In tribute to her contribution to the field of architecture, the American Institute of Architects made her an honorary member in a ceremony on the November 5, 1945, in her new hometown, New Orleans. In November 1947, she had a show at the Smithsonian; in photos of her at the reception she looks like the grand old lady of photography that she had become. She also, as ever, had numerous other projects up her sleeve.

She wanted to do a book on the early architecture of Georgia, for example, but it had not gotten beyond the planning stage. In 1944, she had mapped it out with the Atlanta architect Edward Jones and thought they were going forward with the project. Johnston had already finished much of the photography and considered Jones a close friend, after all. She even left her negatives with Jones while she traveled, with the understanding that he would look for a publisher or perhaps a wealthy customer for a set of prints. Two years later, she was desperate for her Georgia negatives. Why did Jones not answer her letters or cables? Her paranoia was palpable.

Jones was probably innocent of any sinister intentions. As mutual friends reminded Johnston, he was a working architect and was away from Atlanta for long stretches of time. He had not even seen her pleading letters. As far as her negatives were concerned, it seemed that Scott, her Washington photo processor, was the one who had misplaced a large batch of them. And even if Jones had not secured a book contract, he had gotten himself a position on the board of the Telfair Academy of Arts in Savannah just so he could get them to buy a set of her prints—by his account, anyway. Johnston forgave Jones periodically, but she never had the close working relationship with him that she had had with Henry Brock in Virginia or Thomas Waterman in North Carolina.

Waterman published two more architectural volumes with Johnston's photos: *The Mansions of Virginia* in 1946, and *Dwellings of Colonial America* in 1950, both with the University of North Carolina Press. Johnston and Waterman remained close, but he was in failing health—he died in January of 1951—and could not work with her on a Georgia book. Lam-

bert Davis at Chapel Hill was actively looking for a collaborator for Johnston, but it was not until 1957—years after her death—that the University of North Carolina Press finally published her Georgia photos, in a volume by Frederick Doveton Nichols.

In the years from 1947 to 1949, Johnston spent much of her energy supervising the cataloging of her donations to the Library of Congress. In 1948, the Library of Congress asked the Carnegie Corporation for funds to catalog her bequests, but Carnegie turned down the request. By their reckoning they had already spent $23,000 on Johnston's work by May 1948, which they felt was enough. Instead, they forwarded the proposal, with their endorsement, to the Bollingen Foundation. Eventually the work was supported with $5,000 from the Old Dominion Foundation.

Johnston delegated most of the hands-on work, which was primarily clerical, to Emma Ward. Ward was usually paid for her services, but from time to time Johnston failed to offer compensation, and Ward was offended. Sometimes, Johnston suggested to Ward that she take some unpaid leave. Once, in a thinly disguised attempt to get more work out of Ward, Johnston tried talking her into a "vacation" in New Orleans in the heat of summer.

Johnston was more successful at manipulating Jo Hubbard Chamberlin, who wrote her flirtatious letters and even placed an article or two about Johnston in popular magazines. Zelda Branch and Emma Ward had both gotten her more publicity than Chamberlin ever had, but Johnston felt they "owed" her that. Perhaps this was a sort of sexism on Johnston's part: Certainly Jo Chamberlin, who had settled in New York with his brand-new postwar family, was not expected to drop everything and come to New Orleans whenever she asked.

Considering her age and the obscurity into which many other women photographers had fallen, Johnston enjoyed surprisingly good press coverage. She had had a great time meeting Ray and Sue Thompson, who wrote for the *Times Picayune New Orleans States* and gave her stunning headlines like "Camera Crusader: The Old South Will Be Preserved Because One Woman Persevered."[13]

Maud Ronstrom's "Sixty Years with a Shadow-Box" was another long article full of great quotes. In it, Johnston called herself an "octo-geranium" and remarked on how nice it was to "settle down and gather one's articles of bigotry and virtue around one"—by which, she explained, she meant her brass collection, her cats, and her "Four Roses hat" (her bour-

bon). When questioned about her photographic aesthetics, she explained, "I leave the trick angles to Margaret Bourke-White and the surrealism to Salvador Dali." The highest compliment she could be offered, she added, was if a bricklayer or a contractor actually used her photographs to figure out how to restore a wall or building.[14]

Doris Lockerman of the *Atlanta Constitution* also promoted Johnston's work in her column, praising her for her "artistry of light and shadow." She described Johnston's "delicate compositions, without artifice or elegance, showing windows out, doors agape, tin signs still nailed to neglected walls." Johnston, "bobbing the lavender taffeta bow on her hat in a flurry of impatience" blustered, "I've done thousands of these . . . literally thousands! Hundreds of them in Georgia alone! And with every camera known to man! I use one until it wears out."[15]

Johnston's biggest press coup was probably the article Emma Ward sold to *Life* magazine, which ran in April 1949: "Speaking Of Pictures . . . These Are by a U.S. 'Court Photographer.'" While leading with a description of Johnston's impressive access to official Washington, the *Life* reporter added, "Now 85 and still photographing, Miss Johnston is a heavy cigaret [*sic*] smoker and has a fondness for sidecar cocktails." It was also said that she enjoyed a highball "seasoned with enough bourbon to color the ice." Johnston liked giving the impression that she was an instinctive photographer who ignored technical details: "I wore out one camera after another, but I always took pains to have only the finest German lenses. Nowadays when camera clubs ask me to speak to them, the members always want to know what light meter I used, and how much exposure I gave my pictures. I didn't have a light meter or any other gadgets and I judged the exposure by guess."[16]

Although the technology of cameras and the developing process had advanced considerably by the late 1940s, Johnston was not particularly interested in the hardware of the business, and even less so in the chemistry of papers and developers.[17] To her, if the sun was at a good angle and the weather was cooperating, she could get the picture she wanted, no matter what camera she used.

All this publicity probably boosted Johnston's ego more than her income, but she did make a significant sale in her last years. In June 1949, the University of North Carolina purchased a set of Johnston's North Carolina prints for $1,500 and sent along a young photographer to help her with the printing.[18]

In the summer of 1949, Johnston's personal situation began to deteriorate perceptibly. Her longtime financial manager, L. Russell Alden, died at the end of June. This was emotionally distressing and financially disastrous, as it was Alden who had always forwarded to her most of her steady income, the trust fund dividends from Aunt Nin's Kodak stock. It took quite some time after Alden's death for a new executor to be appointed; in the meantime, Johnston had to do without this income.

Physical problems compounded financial ones. As Johnston wrote Emma Ward, "I have gone through a very unfortunate period of a checkup in a hospital—clean report, but a bill for $500.00, and a condition that was very near a complete nervous breakdown. . . . I have become very lame and find it difficult to climb stairs. . . . I am not physically able to get out in the morning and go to a cafeteria to get breakfast or other meals."[19] Although distressed by her condition, she praised the "very personable young physician" who had treated her and felt pleased to have made "a firm friend of my delightful doctor."[20]

Barely a year later, Johnston was writing to Dr. Maurice St. Martin informing him that she had named him the executor of her will, giving him full access to all her papers and belongings. Shortly after, St. Martin suggested some codicils to her will, but Johnston's lawyer advised against them, so they were dropped.

In the wills she wrote for St. Martin, one of which is the last in her papers, he was to be given $3,000 free and clear. He would then pay out a few other small bequests and give himself the rest of her estate as her "residuary legatee."[21] Indeed, her last two wills in 1950 are strikingly different from her previous ones. Neither Maurice St. Martin, Edna Miremont, Mrs. Tom Sawyer, or John Lewis had ever been mentioned in any of her previous wills; she did not know any of these people even a few years earlier. Her oldest friends, Emma Ward and Zelda Branch, were cut out of her final will completely. She was mad at Zelda for not visiting New Orleans at her request, and Emma had declined the last job Johnston had asked her to do, as she had been hired by the Brookings Institution. So in spite of all the years and all the devotion, Johnston wrote her lawyer and told him to cross off Zelda's $1,000 and Emma's $1,500 and the rights to her literary estate.[22] There is one indication that the historian and Library of Congress administrator John C. L. Andreassen may have been named the residuary legatee in Johnston's ultimate will, since he is described as such in Nichols's 1957 book on the early architecture of Georgia.[23] The last

will in her papers, however, left most of her estate to the people caretaking her or her property.

Johnston was eighty-six when she was writing these final versions of her intentions. She had been raised as an only child; she had no children herself. She had no known relatives who were still alive. Most of her friends were as old as she was or already gone. Leaving money to her care-takers may have given Johnston the feeling of having a measure of control over them. To leave them the money in her will, rather than to overpay them in day-to-day life would have satisfied her sense of correctness.

Her estate was not large by modern standards, but the exact size is hard to determine from her records. As with many people, when she was reporting to the I.R.S., she tended to undervalue assets; when she was applying to banks for loans to improve her properties, she inflated the value of everything. She seemed to have had about $12,000 in stocks and bonds in addition to owning 1132 Bourbon Street, which she had bought with the proceeds from the sale of her Washington property.[24] It is not clear whether she also owned a second New Orleans property, at 1438 Euterpe Street, which she had bought in October 1950 for $8,000. Edna Miremont expressed worry in June 1951 that the bank was foreclosing because Johnston had not kept up with the payments. Even if she had owned both houses, however, her assets only totaled about $25,000 . . . apart from her photographic archives at the Library of Congress, her most valuable legacy.

Compared to some of her peers, Johnston was reasonably successful from a financial point of view. Jessie Tarbox Beals had died in 1942 in the charity ward of Bellevue Hospital in New York. Alice Austen died the same year as Johnston, having spent her last years in the Staten Island poor-house. Not only was Johnston solvent, but the decade before her death she had the resources to hire people to put her photographic output in order. And thanks to her lifelong commitment to the Library of Congress, she had a capable institution to which she could entrust her legacy.

Nevertheless, her death—March 16, 1952—was barely noticed in the press. Her obituary in the *New Orleans Times Picayune* gave an incorrect date of death and noted that she was graduated from "Notre Dame university" rather than the convent school of Notre Dame of Govanston, Maryland.[25] Otherwise, little was said. Her body was cremated and buried in Rock Creek Cemetery in Washington, D.C., as she had wished.

Concluding
Thoughts

EVEN IF WE HAD FULL ACCESS TO THE COMPLETE LIFE story of Frances Benjamin Johnston, in its most minute detail, the question of how to interpret that life would remain a problem. With only a keyhole view, such a global evaluation seems impossible. As soon as we think we know something about the meaning of Johnston's life—whom she has been working with, what she was interested in—a shadow falls. Everything is suddenly obscure. We do not know why some project stopped, why a particular relationship ended. It is as if someone in the room were standing in front of the door, blocking the view. As historical biographers, our voyeurism is comparatively genteel; we cannot elbow in like modern-day paparazzi, or set up electronic surveillance like the F.B.I. Historians are, at best, mere gleaners, and like Millet's gleaners, we may come away from our labors only half-satisfied. Still, with a life as rich as Johnston's, we have ample food for thought.

To conclude this look at her life, some questions raised in the introduction can be revisited. The issue of the repression of women in the Victorian era can be straightforwardly addressed, at least with respect to Johnston's career. While turn-of-the-century women in general led lives circumscribed by serious limitations on their choices, Johnston resisted—or ignored—such stifling. Throughout her life, she surrounded herself with other women who chose to be independent: the women of her family

first, then the women of her clubs and her professional contacts. Only once did Johnston ever acknowledge facing any discrimination, and that was when she worried that her advancing age might raise questions about her fitness for fieldwork. She never considered her gender an impediment to her professional life.

How did she come to assume such liberty? Early upbringing may have been crucial; Johnston's was uniquely enabling. She was raised as an only child, with no male (or female) sibling in competition for privileges and resources. Johnston's father was an unassuming, undemanding man. There is no evidence that he ever minded the long European trips of his wife and daughter or his wife's long, public career. Johnston's mother was in charge of the household, and she strongly believed women ought to have the same opportunities as men. And just as Johnston's mother was herself a working journalist all her life, so did she expect her daughter to use her education to make something of herself in the world.

Raised in a fairly egalitarian if not matriarchal household, Johnston chose to embrace these values in several important ways. Most important, perhaps, was her decision to chose a career and to acquire training for it when she was still relatively young, just eighteen years old. Finding other single, determined women to ally herself with on her return to Washington—her club and Arts League friends—was another important choice. Rather than minimize her differences to make herself more respectable in the eyes of others, she flaunted all of them she could. In this sense the image reproduced as this book's frontispiece, her 1896 self-portrait, was her statement to the world of exactly how she wished to be seen. Her hiked-up skirts, cigarette, and liquor were meant to convey her identity as an independent, freethinking woman.

Johnston maintained these "vices" for the rest of her life. She spent some seventy years of her life—from age eighteen to eighty-eight—drinking a variety of alcoholic beverages. She never failed to mention to interviewers her taste for cocktails, such as sidecars and mint juleps, or bourbon. The age at which she started smoking is hard to pinpoint, but it was probably sometime in her twenties, when "Luckies" appear in her household budgets and hotel bills. And as for "showing ankle," there is no indication that Johnston did anything but flirt with any and all people she admired, including the doctor who treated her final illnesses.

Those liberties she flaunted may seem tame by modern standards, but

they served to mark her as separate from the American cultural main-stream. This may have made it easier for her to claim that greater freedom: the right to design a fulfilling, creative life for herself, on her own terms. She did not call herself a feminist—she did not see herself as the sort of woman who chained herself to a ballot box or started hunger strikes for women's suffrage. For Johnston, as for her mother and for many other women of their time, liberation was defined in different terms: To be liberated meant taking responsibility for one's life. If this entailed some unconventional activities—riding around at night with a group of African American men in the backwoods of Alabama, for example—so be it.

Whether her rebellion against convention included her sexual choices cannot be said. All that is known for a fact is that she very firmly closed her bedroom door to future generations of researchers. In all the many boxes of materials she entrusted to the Library of Congress, she left no explicit statement of her sexual orientation.[1] Still, sifting through her letters and her legal documents and her clippings, a picture emerges.

Johnston's was a life spent mostly in the company of strong, creative women, women who shared their work with each other, who supported each others' successes. These were women who looked to each other for emotional density as well. As scholars have noted, the Victorian era was a time when women were (re)discovering female friendship.[2] This was certainly true of Johnston, for whom there were relatively few men who offered professional support, much less emotional depth. With her female friends, her attachments were involved, complex.

With one particular woman, however, the intimacy was colored by decidedly sensual feelings. From the closeness of their working life together, from the tone of their letters, from the emotional storm of their breakup, it would seem that Mattie Edwards Hewitt was Johnston's lover. Most likely, this was Johnston's only love affair. There were flirtations before and after Hewitt, but none that suggested the depth of commitment that the partnership with Hewitt entailed, nor the anger and pain that raged when it ended.

For reasons we can never know—be they personal preference, or the conventions of her family's social circles—Johnston never identified herself with any of the openly lesbian circles of her day. Her New York partnership with Mattie Hewitt was probably the closest she came to publicly acknowledging her commitment to another woman. After Hewitt, she

kept up her bantering with a few safely married men and worked closely with a handful of her oldest female friends. Everyone else she kept at arm's length.

To understand Johnston as woman-identified, however, is to view her in a slightly different context than the usual accounts of the history of photography suggest. By shifting the focus away from the patriarchs of photography—Stieglitz, Steichen, and their cohort—another, more gyno-centric universe emerges. Not only were there many great women photographers around the turn of the century, but many had steady female partners for most of their careers. Laura Gilpin's partner was Elizabeth Forster. Clara Sipprell spent her first years with Jessica Beers, and the rest of her life with the writer Phyllis Fenner. Alice Austen shared her home and her life with Gertrude Tate for some fifty years.[3] Little is known of Mattie Hewitt's intimacies after her breakup with Johnston, since she destroyed her personal papers before she died in 1956, but there are indications that she was close with the photographer Jessie Tarbox Beals.[4]

For many of these women, New York was where they crafted their emancipation, even if they later went elsewhere. In the first decades of the twentieth century, the city was a mecca for creative women in all the arts— sculpture, painting, literature, music. The parallels with Shari Benstock's Left Bank of Paris, where lesbian leadership was so remarkable, are suggestive. Whether based in Paris or New York, by leaving home and choosing an unconventional lifestyle, these women spared themselves the limitations that a heterosexual marriage would have imposed. Their creativity was not blocked by ego-threatened or propriety-obsessed husbands. Alice Austen could photograph her girlfriends in drag, if these were the images she chose to make. Johnston could spend a month on a battleship with a few hundred male sailors, if that was her choice. Most of these women photographers traveled widely, in fact, either on commission or freelance. It would be hard to overestimate the sense of freedom, of worldliness, such wandering could encourage.

While the new woman was often defined by her rebellions against convention, such rebellion required a measure of financial independence. For Natalie Barney and other Left Bank women, family inheritances provided the financial resources. Others, like Johnston, supported themselves through their work and therefore had a personal interest in the advancement of the professional status of women. Johnston, for example, was determined that photography be as female-friendly as possible. Her arti-

cles in *Ladies Home Journal,* her show of American women photographers in Paris, and her supportive correspondence with women in the field all stand as evidence of Johnston's commitment to the advancement of women in professional photography.

While the patriarchs of photography were unwilling to allow women access to the leading sector of the field, they were only mirroring the opposition to women of the fine-arts community at large. The early twentieth-century art world has been described as being in the grips of a "virility thrust," with the male artist in control and the female as his sexual object.[5] Women were supposed to be the model for the artist, not the artist proper. Undeterred, Johnston and others stayed in the field and kept working. It was Johnston's cohort of professionals who paved the way for the next generation of women—Berenice Abbott, Margaret Bourke-White, Dorothea Lange, and Helen Levitt—who in turn made possible the careers of modern photographers like Cindy Sherman and Annie Leibowitz. Had there not been women like Johnston in the early years—training other women, showing their work, offering patronage—this history might look very different.

While avoiding the repressive forces in the dominant art establishment, Johnston maintained her own aesthetic values. Many dated back to her early classical training. Symmetry and clarity were important. The composition of a frame had to be visually satisfying. As her career matured, however, a photograph had to go beyond "aesthetically pleasing." In Johnston's last decades, a photograph had become a record, a historic document. The work of making these records and leaving them in a usable form for historians and architects was the last legacy of this long and creative career.

A simple interpretation of Johnston's life and work could end here, as a new woman who found the ways and means to make a creative, unconventional career for herself. Only this would not account for the more conventional side of Johnston, a woman who joined and rejoined the D.A.R. and who made money by very traditional means, like investing in the stock market, owning a small business, and evicting impecunious tenants from her properties.

Both her petty-capitalist proclivities and her embrace of more leftist ideas, like the "new education," could fit together under the general rubric of turn-of-the-century progressivism. Johnston did identify herself with many progressivist leaders, like Theodore Roosevelt. She believed in

education as a means of social uplift. She thought utopian communities, like Elbert Hubbard's Roycrofters, should be taken seriously. She considered world's fairs to be forward-thinking, internationalist events. She believed in the Rough Riders and in Admiral Dewey's victory in Manila Bay.

Although the progressive label goes far to reconcile many of Johnston's apparent contradictions, it does not speak to her particular aesthetic inclinations, which managed to embrace both Arts and Crafts and early American styles. There is a thread joining these apparently disparate tastes, however, a movement historians have termed "colonial revival." Facing the dislocations and disappointments of the modern industrial era, many late nineteenth-century thinkers were inspired by the early American period as a model of dignity and purpose. The homespun aesthetic was celebrated by restoring early American houses, by buying colonial antiques, by championing the "honest artisan" aesthetics of the Arts and Crafts movement, and by tracing genealogies to early American roots.[6]

In this light, Johnston's Mission-furnished studio, with its spinning wheel by the hearth, makes sense. Her interest in her family tree and her membership in the D.A.R. also make sense. That her career culminated in the replacement of portrait work—with its ephemeral values—with the recording of thousands of sites of early American architecture also makes sense. Johnston had settled, finally, on something of value.

No one label—be it new woman, progressive, or colonial revivalist—can possibly cover or explain all Johnston's complexities. Here was a Jim Crow–era young white woman who traveled the South on her own, to show the world how great the new black colleges really were. Here was a convent-educated daughter of a bourgeois household who decided to live with her woman partner on the fringes of Greenwich Village. Here was an old lady in her eighties who loved calling herself an "octo-geranium" and kept planning more and more work for herself.

While her choices were never conventional, they were not perverse; there was deliberation, self-definition behind most of her moves. Few women have the means to write so many choices into their life-scripts. Few people, men or women, would opt for such a self-reliant life. But Johnston had great confidence in both her work and her personal strength. She made her decisions and went on with her life. If it seems strange that Johnston figured out so much about how to live as a self-determining woman without attaching herself to the first or second waves of feminism,

it can perhaps be seen as one more proof that the personal is political, whether there is a movement or not.

Apart from the radicalism of the choices Johnston made about how to live her life, there is also the question of her art to consider. Has her work stood up over time? What rank would Johnston occupy, were there ever a Photography Hall of Fame?

Given the many different genres Johnston worked in, her success in each must be considered individually. Selections from Johnston's portrait work have been mounted as a gallery show and featured in a richly detailed catalog.[7] In garden and estate work, she is still notable, as is her old partner, Mattie Edwards Hewitt. Johnston's architectural studies remain important reference tools for students of early American architecture. She is one of the few photographers in history ever to receive acclaim from both architects and historians. A selection from her archives of architectural photos is carried on microfiche at major libraries around the world.

It is Johnston's work as a documentarist—the Washington, Hampton, Tuskegee, and Carlisle school studies—that has provoked the most controversy. Was she, like her contemporaries Jacob Riis and Lewis Hine, invading other peoples' lives to perform a sort of social surveillance?[8] Or was she genuinely giving her subjects a means of seeing themselves, a mirror to reveal their accomplishments, their aspirations? Such questions can never be answered in a definitive fashion, but they raise important considerations.

First, it must be underscored that all photographers impose their own tastes on their depictions of their subjects. A human holds the camera, not a machine. The nature of this imposition may vary, and its interpretation can be debated, but it is always true that the act of observation changes what is being observed. Johnston was very deliberate in the framing and composing of her photographs. She arranged her subjects in a particular order around a particular focal object or person. At times, she gave her images closure by having the people at either end pose an arm or hand in an embracing fashion. She controlled the viewer's intimacy with her subjects by shifting her subjects' distance from her camera. She cropped images quite freely. So, of course it can be said that she editorialized.

Whether her editorializing violated the intentions of her subjects in any way is another issue. She probably had little control over facial expres-

sions; given the slowness of the photographic technology she used and her reliance on natural light, her subjects often had to hold their poses for up to twenty seconds.[9] Such long poses might even imply a certain complicity or authenticity on the part of her subjects. That many of her subjects wrote and asked to buy copies of the shots they were in suggests a degree of individual approval for her depictions. The institutions who hired her for her major projects were certainly satisfied. They paid gladly and used her photos with great success in exactly the way they had planned—in most cases, for fund-raising campaigns. Of course, the subjects and the clients might have been satisfied and still have been "exploited" in some way.

This suggests a further consideration: Who did Johnston see herself serving? In the case of her historic-preservation work, she was explicit. Her client was the Carnegie Corporation, but her "people" were the stone-masons and bricklayers and contractors who might use the detail in her photos to guide them in their work. If anyone could lay a pavement or build a fence by examining one of her photos, she was satisfied.

To Johnston, there was no great gap between her own aesthetics and the needs of her clients. Yes, she "constructed" her images to please herself, but as a commercial artist, she worked to please her clients as well. Did she respect her subjects? Did she try to present her subjects as they wished the world to see them? Did she try to convey her subjects' sensibilities and personalities?

That the answer to all these questions is basically affirmative is indicative of the type of photographer Johnston saw herself to be. She did not photograph anyone she considered to have less dignity than she herself. Indeed, Johnston's lack of interest in most W.P.A. photography projects, which were largely devoted to documenting the impoverishment of share-croppers and the growth of migrancy and breadlines, gives some clue to her feelings. Johnston never produced any of those images of the down-trodden, even though she traveled the South at the same time as Dorothea Lange, Walker Evans, and the other depression photographers.[10]

Johnston's indifference to their "New South" imagery may have masked a more fundamental hostility to "new" anything. The South Johnston was trying to preserve was not the Old South, but what came before it, the colonial South. Early American life was what she was resurrecting, real "from the mountains, to the prairies" imagery—an ideal, preindustrial, rustic America with no debates over slavery and all the important

personal freedoms still intact. To her mind, the modern South was like the modern North or modern anywhere: not good for much. She never grumbled aloud about Walker Evans or Dorothea Lange or any other patho-photographers, but it is clear she had no use for them.

To a great extent, the New South movement was a product of sociologists that emerged just as Johnston was discovering herself as a historian. When she did her first historical digging and realized how much of early American life could be inferred from its architecture, she was convinced. Everything she read about land grants, plot acreage, and the shape of chimneys helped her photographic work. The more she learned, the easier it was to discover the right buildings to document, the right details to feature.

Here was a career that started with cabinet wives and ended with slave cabins. Frances Benjamin Johnston worked in most major genres of modern photography—portrait, documentary, garden, and architectural—and made a name for herself in each. That she continued to feel so experimental about her craft throughout her long lifetime says something about the very real freedom she lived.

Who, today, could claim such liberties?

Notes

A Note on Sources

Before her death, Johnston deposited most of her papers and photographs with the Library of Congress. These are the main sources I used for researching this book. Her papers alone occupy some twenty-one linear feet of shelf space and include letters, clippings, copies of her articles, ephemera she saved on her travels, working notebooks, and diaries. Fortunately, the materials have been organized by categories with a finding aid, and, best of all, the whole collection was microfilmed, not only saving the original documents from overhandling but enabling researchers worldwide to have access to the primary source material, even if interlibrary loan of thirty-seven reels of film can be cumbersome. Some libraries, like the excellent New York Public Library, have purchased their own copies of these films. For this reason I have included reel numbers in my endnotes.

To examine Johnston's photographs and to read any inscriptions or marginalia, it is best to visit the Library of Congress's Prints and Photographs Division, although some of its collection can be seen on-line at its Website. In New York, an alternate edition of the Hampton photographs can be seen by appointment at the Museum of Modern Art library. In addition, some fine-arts libraries, like the Avery Library at Columbia University, own a set of microfiche of Johnston's southern architecture surveys (see Gwaltney, ed., *The Carnegie Survey of the Architecture of the South, 1927–1943*).

Abbreviations

BTW Papers	Harlan, Louis R., et al., eds. *The Booker T. Washington Papers.*
	Urbana: Univ. of Illinois Press, 1972–79.
FBJ	Frances Benjamin Johnston
PP/LC	Library of Congress's Prints and Photographs Division

Introduction

1. For an example of the pitfalls of postmodernist analysis as applied to Johnston's work, see Wexler's "Black and White and Color." For a more nuanced postmodern treatment of Johnston's work, see Davidov's *Women's Camera Work*, chap. 4.

2. See Rosenblum, *A History of Women Photographers*, chap. 1; Vestal, *The Craft of Photography*, pp. ix–xix; and Davidson and Lytle, *After the Fact,* pp. 208–13.

3. See Fryer, "Women's Camera Work," pp. 96–97.

4. Even advocates for women's role in photography, like Johnston, made their argument in terms of the appropriateness of this work for women's fine motor skills and delicate sensibilities.

5. As Smith reminds us in *The Gender of History,* there is no such thing as an ungendered historical truth.

6. See Christy, *The American Girl.* For an analysis of the impact of the Christy girl, see Banta, *Imaging American Women.*

1. The Birth of a Bohemian: 1864–1885

1. To claim Pocahontas as an ancestor may not be an index of racial openness, as Prof. Prettyman of Barnard College has pointed out, referring us to the 1924 Virginia Racial Purity Act. By this definition,

one could include a minor amount of Native American ancestry—enough to descend from Pocahontas—and still be considered "white."

2. Reel 25 is the source for all the genealogical material quoted here.

3. According to one of Johnston's sources, Margaret Keith's mother's maiden name was Mary Bowling, "of the Bowling branch of the Family of John Rolfe, who married Queen Pocahontas, and was the fifth in descent from her" (from a biographical note on Reverend Johnstone in reel 25).

4. See the family photos in lot 11734-2 at PP/LC.

5. See reel 36 for this passage and previous schooling information.

6. Reel 21, from her speech to the D.C. Quota Club, 20 Feb. 1936.

7. FBJ's exam books from Notre Dame are on reels 26 and 27.

8. Reel 27 has FBJ's mother's clippings.

9. Weinberg, *The Lure of Paris*.

10. In Kashey and Kashey's volume, *The Julian Academy* (with essays by Fehrer for an exhibition at the Shepherd Gallery, 1989), Johnston is listed as attending from 1883 to 1885.

11. Beaux, *Background with Figures*, pp. 122, 127.

2. A Studio of Her Own: Washington, D.C., 1885–1900

1. See Cosentino and Glassie, *Capital Image*.

2. See Milligan, "Society of Washington Artists."

3. See reel 29.

4. Rosenblum, *A History of Women Photographers*, p. 59.

5. See clips in reel 29, especially *New Haven Journal and Courier*, 23 Apr. 1892.

6. Letter from Eastman to Johnston, 26 May 1891, discusses some technical problems with customers' cameras. Johnston proposed, among other projects, the story "Women Who Use Kodaks," to which Eastman did not agree (July 1891), although he wanted some travel pieces; reel 3.

7. All the articles can be found on reel 33.

8. Demorest to Johnston, June 1891; reel 3.

9. The *Washington Evening Star*, 28 May 1892, has the best account, although the *Washington Post*, 29 May 1892, has a few extra tidbits. All from reel 29.

10. Reel 36 has one of her albums, which consists of postcards, visitors' brochures, and clippings pasted over old school notes.

11. 7 Apr. 1889; reel 7.

12. See Via and Searl, eds., *Head, Heart and Hand,* for several Johnston photos from this visit. Lot 11744, PP/LC, has thirty-nine prints, but they are said to date from 1900.

13. Rosenblum, in *A History of Women Photographers*, refers to this as Johnston's "objectivity," a term to be understood in contrast to the lack of objectivity of, say, Lewis Hine.

14. See reel 32.

15. See a clip on reel 29.

16. Demorest to Johnston, 18 July 1893; reel 4.

17. Tarbell wanted the Bible pages to lay flat without the props showing. See Tarbell to Johnston, 3 Jan. 1896; reel 4.

18. "Frances Benjamin Johnston," *Woman's Tribune*, 2 Apr. 1892; reel 29.

19. See clips on reel 29.

20. Nell Ray Clarke, "First to Shoot the 'Big Game,'" *Washington, D.C., Sunday Star*, 2 Feb. 1930; reel 29.

21. Reel 33.

22. Cosentino and Glassie's *Capital Image* has many Johnston studio photos.

23. For the estimated cost, see reel 4, letter of 7 Aug. 1894. The comparison figure was gleaned from classified ads in Washington newspapers.

24. The studio descriptions are from Julia Magruder's manuscript "The Frame for the Camera," in Johnston's papers, and Susan Hunter's "The Art of Photography: A Visit to the Studio of Miss Frances Benjamin Johnston" (c. 1895); both on reel 24.

25. "Over the Tea Cups," *Capital*, 30 Mar. 1895; reel 29.

26. From Johnston's Sept. 1897 article in the *Ladies Home Journal*, "What a Woman Can Do with a Camera," quoted in Glenn and Rice, *Frances Benjamin Johnston*.

27. See reel 29 for original news clips on these events.

28. The D.A.R. was formed in 1890, with eleven paid members (see Lockwood, *Yesterdays in Washing-*

ton). It is not clear when Johnston first joined, although she did let her membership lapse in the 1940s and had to reinstate herself.

29. Jerald Maddox, "Essay on a Tintype."

30. See Van Nimmen, "F. Holland Day and a New Art," p. 368.

31. Stieglitz to Day, 31 Mar. 1899, quoted in Jussim, *Slave to Beauty,* p. 137.

32. Reel 4 has an invitation to the Art Students' League's Christmas party of Dec. 1896 that advised invitees to "Forget your troubles [and your wife]."

33. The album can be found in PP/LC as lot 2763. There is also a photo dated Washington, D.C., 12 Aug. 1888, inscribed "To Darling Boo with Pinky's dear love" in lot 11734-1.

34. This account can be found in "Alice Berry Was Taken En Deshabille," *New York Morning Telegraph,* 5 Feb. 1898; reel 29. Searches of the *Washington Post* and the *New York Times* for that week turned up no other accounts of the story.

35. The term "personal photos" is used to refer to the more informal shots Johnston took for her own pleasure, while at leisure with her friends. Her "formal photos" featured a range of other subjects who were paying her.

36. For a sample of Thompson's clowning around, see the photos reproduced in Daniels and Smock, *A Talent for Detail,* pp. 22–25. For the Phister shots, see PP/LC, lot 11734-3. Frank in the altogether is dated 16 June 1895. He may be the model in some other risqué poses as well.

37. The "Miss Fanny" line is from Arnold's 10 Feb. 1892 letter. The "second violin" comment is from 5 June 1892. Reel 3.

38. For details on some of the debates, see Greenhalgh, *Ephemeral Vistas.*

39. For details here, see Hales, *Silver Cities.*

40. Once again, Johnston and Stieglitz were on opposing sides. She was seen as an Arnold-protégée, while Stieglitz was busy organizing a boycott of Arnold's dictates.

41. See Waller, *Women Artists in the Modern Era,* p. 251.

42. See reel 3.

43. See Knight, *History of the Work of Connecticut Women at the World Columbian Exposition.*

44. See ibid., pp. 10, 11.

45. Brown's "Recovering Representations," is the source for most of the information given here on the Smillie-Johnston-Harris team.

46. Brown, "Recovering Representations," p. 225. Brown describes the platinum printing process as consisting of two stages, where first the iron salts are reduced to a ferrous state by the exposure, then the platinum is reduced to its metallic state by the developing.

47. Ibid., p. 225.

48. Brown, *Contesting Images,* p. 89. See pp. 68 and 82–92 for other details and for reproductions of their prints.

49. See A. Doherty's "Frances Benjamin Johnston," p. 103. She points out that Johnston was also under contract to the *World* and to Charles Culver Johnson for Dewey photos.

50. See reel 24 for a copy of the card.

51. The fake enlistment record and certificate can be found on reel 24.

3. Showing America to the World: Paris, 1900

1. See Mandell, *Paris 1900,* which argues that 1900 was the last really big world's fair.

2. For detail on Johnston's work assembling the show, see Toby Quitsland, "Her Feminine Colleagues: Photographs and Letters Collected by Frances Benjamin Johnston in 1900," in Withers, *Women Artists in Washington Collections.*

3. See reel 5 for both letters.

4. Quoted in Moore, "Women Experts in Photography," p. 586.

5. Henrotin's 25 May 1900 letter is on reel 5.

6. Reel 20 has the material sent by the women who got in touch with Johnston.

7. Abel to Johnston, 27 June 1900; reel 5.

8. Stieglitz to Johnston, 8 June 1900; reel 5. Stieglitz used the excuse of poor health quite creatively over the course of his long life. For examples, see Whelan, *Alfred Stieglitz.*

9. To understand the categories, consult *Catalogue general officiel Exposition Internationale Universelle de 1900.* Group 3, class 12 is photography. Johnston showed in this class but is not in the catalog of exhibitors, probably because she entered late. For Stieglitz's boycott of the Paris fair, see Whelan, *Alfred Stieglitz,* p. 164.

10. See Quitsland, "Her Feminine Colleagues," p. 107.

11. See Michaels, *Gertrude Kasebier,* p. 63.

12. Details of Johnston's congress experience from Pector, *Congrès International de Photographie,* p. 44.

13. The categories and locations for the D.C. series are based on the *1900 Paris-Hachette guide practique du visiteur de Paris et de l'Exposition.* The omission of Johnston the guidebook seems to be due to her late entry. The Hampton exhibit location comes from her clippings file on reel 30, in the article entitled "Work of the Black Race," by Captain A. H. Mattox, source unknown.

14. The Washington schools were segregated by what was understood as "race." Although this author feels that categorizing people as "white" or "non-white" is a meaningless division, the terms will appear here without quotation marks.

15. Weisberger and Time-Life, eds., *District of Columbia,* p. 73.

16. See the group of monographs, Butler, *Education in the United States,* which the state of New York contributed to the U.S. education exhibit at the Paris 1900 Expo. Nicholas Butler wrote the introduction, defining progressive education, and Booker T. Washington wrote about Tuskegee.

17. Letter, B. W. Mark or Murch of the Franklin School to Johnston, 5 May 1900; reel 5.

18. B. F. Johnson to FBJ, 30 June 1900; reel 5.

19. A. Shaw, "Learning by Doing at Hampton," p. 426.

20. Ibid., p. 419.

21. As Hampton's newsletter, *Southern Workman,* reported in Dec. 1899, p. 498, "the arithmetic in the classroom shall bear directly upon the problems in the shops, and experiments in the laboratory prepare the way for practical work in the trade school."

22. See Anderson, *Education of Blacks in the South,* chap. 2, for details of this critique. Anderson reprints a number of Johnston's photos but selected only the more menial scenes.

23. See Moutessamy-Ashe, *Viewfinders,* p. 21.

24. The Shepherd incident was reported by the *Seattle Republican,* 6 Mar. 1900, p. 1, col. 4. It was cited by Willis-Thomas in her excellent *Black Photographers, 1840–1940,* p. 11.

25. See Pieterse, *White on Black.*

26. Julian and Arthur Dimock's photographs may be seen at the library of the American Museum of Natural History in New York City.

27. For data on funds, see Peabody, *Education for Life,* p. 363.

28. Captain A. H. Mattox, "Work of the Black Race," *New York Times,* n.d.; reel 30.

29. Quoted in ibid.

30. Du Bois, "American Negro at Paris," p. 577.

31. See Przyblyski, "American Visions at the Paris Exposition," p. 67.

32. See ibid. (the entire article) for an excellent treatment of this point.

33. "The Paris Exhibit," *Southern Workman and Hampton School Record,* 29 Jan. 1900, pp. 8, 9, quoted in Guimond, *American Photography and the American Dream,* p. 21.

34. West's *1900* is a good example of 1960s revisionism on Hampton-at-Paris. In this view, the Negro Exhibit was a whitewash of the race problem in America that Johnston's photos only reinforced.

35. See Wexler, "Black and White and Color," which has many problems apart from not having consulted the original oeuvre; and Guimond, *American Photography and the American Dream.*

36. It is regrettable that Johnston never wrote explicitly about her attitudes toward people of color. We only have the results—her photographs. From these and the manner in which she undertook various southern projects, we can infer her open-mindedness, at least. Even if she had simply been eager for a few lucrative commissions, she did not necessarily have to celebrate her subjects' varied accomplishments so extensively.

37. See *Southern Workman* 29 (Jan. 1900), p. 49.

38. Modern critics have debated the racism of Day's depictions.

39. See Michaels, "New Light on F. Holland Day's Photography of African Americans," p. 334.

40. The correspondence concerning Carlisle is found on reel 6, Apr.–June 1901.

41. Pratt, *Battlefield and Classroom,* p. 335.

42. Jessie Cook to Johnston, 10 June 1901; reel 6.

43. Alice Pugh to Johnston, 5 Apr. 1901; reel 6.

44. W. Homer, *A Pictorial Heritage,* p. 31.

45. Michaels, *Gertrude Kasebier,* pp. 32, 33.

46. Johnston to Booker T. Washington, 11 Aug. 1902, *BTW Papers,* vol. 6, pp. 501–2.

47. I'm indebted, for this insight and so much more, to Daniels and Smock, *A Talent for Detail,* p. 116.

48. Quotes and detail from letter, Carver to Washington, 28 Nov. 1902, found in Booker T. Washington papers, Library of Congress.

49. Letter from Robert Bedford to Washington, 8 Dec. 1902, *BTW Papers,* vol. 6, p. 609. Bedford even suggests relocating the school onto "colored" land, rather than dealing with Ramer any further.

50. This quote and the former from p. 3 of Carver to Washington, 28 Nov. 1902.

51. See Washington, *Working with the Hands.* Apparently the Tuskegee girls did not want to learn "domestic science" and said they were fed up with housework.

52. Hine, *Men at Work.* In particular, note the penultimate image, *Making a Great Transformer.* Even if Hine's photos feature more brawn, the relative scale of large machine versus small worker tells the same story as Johnston did some thirty years earlier.

53. See Willis-Thomas, *Black Photographers,* pp. 13, 19, 20, 22. The Battey photos of Tuskegee are very much like Johnston's.

4. To New York and a New Partnership: 1900–1917

1. As the critic Julia Ballerini reminds us, Stieglitz did not actually manipulate his negatives, adding in the gauzy haze or the etching-like scratches, as did many of his close colleagues. His famous *The Steerage* (1907) is very much in focus. By and large, however, Stieglitz did search out the moody setting and pose his models suggestively.

2. See reel 6, summer 1901.

3. The Johnston shot that Daniels and Smock, *A Talent for Detail,* reproduce on p. 75 seems almost Parisian: elegantly garbed fair-goers reflected in rain puddles.

4. Eventually, Johnston turned over her McKinley photos to the committee organizing his monument, although at one point she toyed with selling the images as postcards.

5. Reel 8 has samples of the yachting album letters and responses.

6. Nell Clarke, "First to Shoot the Big Game," *Sunday Star,* 2 Feb. 1930; reel 29.

7. Ibid.

8. Johnston to Lumière, 21 Oct. 1905, a draft of her letter to him in French; reel 8.

9. "Newest Portraits Are Color-Photo Transparencies," *Evening Sun,* 23 Oct. 1912; reel 29.

10. Kasebier to Johnston, 6 June 1901; reel 6.

11. Same to same, 6 July 1903; reel 7.

12. See picture group 11734-1A at PP/LC.

13. Michaels, *Gertrude Kasebier,* pp. 98–110.

14. See Johnston's letters from Aug. 1905; reel 8.

15. Johnston's story of the visit appeared in *Uncle Remus's Home Magazine,* June 1911; reel 34. Reel 33 has a typewritten postscript to the story, concerning the liveryman, Jehu. Johnston says Jehu offered to take her on a tour of the sights of Atlanta. Like what? she asked. "Well, Mistis', dey's de Ceme'tery, de INsane Asylum and de PENITEN-TIARY!!!!!!"

16. The 1906 trip diary and notes are c. Aug. 1906 and on reel 2.

17. This is typewritten, on reel 29.

18. Reel 2.

19. "Bachelor girl artist" is a term used by Agnes Schulenberg in an undated letter on reel 19.

20. See Alland, *Jessie Tarbox Beals.* He also notes the St. Louis connection of Beals and Hewitt. They may all have been Greenwich Village women, too.

21. See Grover, "Dykes in Context."

22. Reel 18. In general, look for the worst handwriting possible and you'll spot Hewitt's letters.

23. Ibid.

24. Ibid. CJ might have been CL, or Clara Laughlin, a woman close to Johnston over the years.

25. Hewitt to Johnston, 2 Dec. 1901; reel 6.

26. Same to same, 11 Mar. 1902; reel 6.

27. A handbill for this feature is on reel 33.

28. Both letters are on reel 8.

29. Postcard and valentine, reel 26. The translation of Matey's language is mine.

30. Hewitt to Johnston, n.d., but identified as 1910 by the cataloger; reel 8.

31. Mrs. Johnston to FBJ and Hewitt, 26 July 1911; reel 3.

32. Same to same, 13 Mar. 1910; reel 3.

33. "Matters of Interest to Women: The Camera Has Opened a New Profession for Women—Some of Those Who Have Made Good," *New York Times,* 20

Apr. 1913 (reel 29), is a long article on women in photography with a suggestive portrait of Hewitt and Johnston looking very much a couple. *Vanity Fair,* c. 1914 (reel 34), has a piece on Johnston-Hewitt titled "They Photograph the Smart Set." Reel 34 also has a piece by Eva Vom Baur, titled "Frances Benjamin Johnston, Mattie Edwards Hewitt," written for *Wilson's Photographic Magazine.*

34. See the clips from *Town and Country,* 1913, and *Literary Digest,* 1915, on Duncan; reel 35.

35. The firm's name sometimes appears hyphenated, sometimes not. For consistency, I will use the hyphenated form in this work.

36. The clip is on reel 34.

37. The legal agreement can be found on reel 22.

38. See Close, *Portrait of an Era in Landscape Architecture.*

39. See the clips on reel 34.

40. See reel 9, memo to her astrologer, probably c. 1925.

41. Quoted in Waller, *Women Artists in the Modern Era,* p. 261.

42. This is in typescript, two times, in what looks to be Johnston's typeface; reel 33.

43. See Schwartz, *Radical Feminists of Heterodoxy,* p. 75.

44. See the letter from Smith, dated St. Paul, 3 Oct., but no year; reel 19.

45. Smillie to Johnston, n.d.; reel 18.

46. The clip is from the *Post-Star,* 1917; reel 29.

47. Mrs. Johnston to FBJ, 3 Oct. 1918; reel 3.

5. "The Interpreter of Gardens": 1918–1928

1. See letters c. 13 Oct. 1918; reel 3.

2. This gem (and another, "A New Girl") can be found on reel 33.

3. See Dwight, *Edith Wharton.* The text gives a good sense of Wharton's garden interests and contains two Johnston photos of Pavillon Colombe.

4. See Wharton, *Italian Villas and Their Gardens.* Dwight's biography mentions Wharton snapping photos of Mount Athos, so it's possible that she took her own garden photos as well.

5. Johnston did not color the slides herself, however.

6. Full brochures describing the lecture series found on reel 33.

7. Worcester *Sunday Telegram,* 28 Jan. 1923; reel 29.

8. See reel 21 for examples of her fees.

9. In 1923, a white-collar woman worker might earn $20 a week as a bookkeeper or $30 per week as a stenographer.

10. See reel 29, 29 Nov. 1916.

11. Reel 3, Oct. 1918 letters.

12. Johnston to Fogg, 13 Jan. 1927; reel 10.

13. See LC/PP, lot 11734-2 for a photo of Johnston's mom's tombstone and for Nin among the roses.

14. Adams, *Atget's Gardens,* p. 15. Adams does not speculate about Atget's midlife hormone shifts, even though the desolateness of his garden frames was only characteristic of Atget's late-life work.

15. Benstock's *No Gifts from Chance* describes the 1925 Aegean cruise Wharton sponsored for $100,000 (p. 390 ff.). On p. 383 she notes that F. Scott Fitzgerald visited Pavillon Colombe in July 1925, around the same time as Johnston's visit, although there is no indication that they met.

16. See Johnston's comments attached to photos, PP/LC, lot 11731-17.

17. *Boston Evening Transcript,* 17 Dec. 1927; reel 37.

18. See "Gardens in City Environment," *New York Sun,* 19 Dec. 1922; reel 29.

19. See clips on reel 33, around the fall of 1922.

20. See "Pioneer Camera Expert Selects Residence Here," *Hollywood Daily Citizen,* 9 June 1923; reel 29.

21. See memos, c. July 1923; reel 9.

22. This memo can be found on reel 9. It is undated, but mention of the "east-west" choice and the "new partner" anxiety point to the Kinema-Kraft Prints project. The astrologer was probably Miss Herne, who warned Johnston in Sept. 1925 about a "loss in business" and disappointments over money. Johnston wrote herself a note to have "nothing to do with partnership." The year 1926 was supposed to be "splendid" however. Plus, a "gentleman comes into your life." For this later memo, see reel 24.

23. See correspondence for early 1924; reel 9. She dealt with Leslie Bliss at the Huntington.

24. Watts, "Frances Benjamin Johnston."

25. See ibid., p. 259.

26. Henkes, in his *Portraits of Famous American Women*, takes a strong position on the client-artist relationship: "Any portrait, whether commissioned or not, should be an artistic experience for its creator and an aesthetic experience for its subject. If not, the portrait has failed to achieve the goal of all real art, which is communication between human beings" (p. 3).

27. For an example of a paradoxical self-portrait, see the image on p. 30 of Daniels and Smock, *A Talent for Detail*. To see more self-portraits, including the ones in male clothing, see lot 11734-1A, PP/LC.

28. This will seems to have been her first. Reel 37 has them all.

29. This is in her clippings file; reel 30.

30. Johnston to Forse, 6 May 1925; reel 9.

31. Ibid.

32. Forse to Johnston, 1925; reel 9.

33. Johnston did not always realize she was supposed to give people like Elsie de Wolfe copies of the photos of her villa, but the editor of *Town and Country* did. See the letter to Johnston, 2 Apr. 1927, where her editor advises: "I feel, however, that it is best both for you and for us to please them [de Wolfe and Miss Morgan] in so far as we are able"; reel 10.

34. Johnston to Nesbitt, 30 Mar. 1926; reel 9. Nesbitt did run such an agency herself in later years, and she periodically wrote to Johnston to notify her of upcoming trips.

35. Johnston to Fishback, 31 Jan. 1927; reel 2.

36. Johnston to Dickson, 17 Jan. 1926; reel 9.

37. See Wood to Johnston, 5 Jan. 1927, and Olmsted to Johnston, 11 Jan. 1927; both reel 10. Waddy Wood said he'd worked with her for twenty years, which takes it back to when Wood was designing the Masonic Temple that was to become the National Museum for Women in the Arts. Olmsted thought she should pitch a piece to the *National Geographic*.

38. Johnston to Fogg, 13 Jan. 1927; reel 10.

39. Many of her drivers were arranged through her car dealership. How common this was—and how many people were buying cars without knowing how/wanting to drive them—is unclear. Johnston took a few lessons and gave it up.

40. Johnston to Stanford, 16 July 1927; reel 10. It took several letters before the problem was resolved. Since the substitute on one occasion passed himself off as Johnston's son, we can presume he looked white.

41. It is at this point that she began dabbling with the racist locutions of the good old boys. She writes Kester (5 Sept. 1927; reel 10): "where are you at (as the darkies say) where at is Mr. Paul Wilstack?" Fortunately, she did not use such language often.

6. Johnston's Ante Antebellum South: 1928–1944

1. For lists of visitors to the show, see reel 28.

2. Typescript, 15 Aug. 1929; reel 11.

3. For Johnston's efforts, see the press release dated 9 Nov. 1929, on reel 11. The Stratford Hall restoration was an undertaking of the Confederate Ladies. By 1932 they had raised all the funds they needed to buy and restore the old Lee plantation. Fiske Kimball, an architectural scholar and Johnston correspondent, consulted on the Stratford project. See Charles Hosmer, "The Colonial Revival in the Public Eye: Williamsburg and Early Garden Restoration," in Axelrod, *Colonial Revival in America*, p. 63.

4. This insight was contributed by Prof. Prettyman of Barnard College.

5. See Johnston to Eb Hoyt, 17 Oct. 1937; reel 13. The bill was $250, no small amount. After this matter was settled, Johnston arranged to get his driver's license restored.

6. See Johnston to Ralston Lattimore, 23 Oct. 1939; reel 14.

7. Brock to Johnston, 27 May 1940; reel 14.

8. A letter from W. S. Rankin ends with this postscript: "From the enclosure with your letter, I am convinced that you have lived long enough in the South to have acquired a southerner's understanding and appreciation of our nigger friends" (5 Nov. 1938; reel 13). Doctor Rankin was a trustee of the Duke Endowment and a pioneer in the public health field in South Carolina, but not a man known for his humility (see the interview with his colleague, Dr. W. C. Davison, in the Columbia University Oral History archives). It is unclear why Johnston was corresponding with him.

9. See "New Orleans Architecture Is Being Saved in Pictures," *New Orleans Sunday Item-Tribune*, 22 May 1938; reel 29. The image she seems to want is

reminiscent of the film *Driving Miss Daisy:* the eccentric white lady being driven around the South by her intense black chauffeur.

10. See Marling, *George Washington Slept Here,* p. 78.

11. See Hosmer, "Broadening View," pp. 121–39.

12. See Green, "Looking Backward to the Future."

13. The landscaping example comes from Hosmer's intriguing essay, "The Colonial Revival in the Public Eye."

14. For critiques, see essays by Elizabeth Cromley and Pierce Lewis in Blatti, *Past Meets Present.* Cromley criticizes the preservation movement as a form of storytelling that favors the wealthy. In her view, it offers the wealthy an idyllic version of their roots plus the opportunity to make money from the restoration/preservation process. Lewis argues that teaching people to see history all around them, instead of just in roped-off areas, would be more constructive.

Since Johnston never confined herself to the architecture of the wealthy, she would not have felt vulnerable to Cromley's critique. To Lewis, she might have said, "Fine, that's what I'm doing!"

15. As the scholar Elena Davis commented in a personal discussion, such donations could be a useful tactic for a rootless person like Johnston. While she used her Arts Club room in Washington for storage purposes, the Library of Congress was a good solution for items she did not need anymore, and such donations brought her goodwill.

16. See Shurtleff to Johnston, 29 July 1930; reel 11.

17. Johnston to Campbell, 1 May 1943; reel 15.

18. She might have been amused to be leaving bequests to the heads of two of the largest philanthropic institutions in the world. For details, see reel 37.

19. Johnston to Campbell, 5 June 1932, and Johnston to Keppel, 24 June 1932; both reel 11.

20. See Campbell to Johnston, 6 Mar. 1933; reel 11.

21. See the correspondence between Burnet and Johnston, Apr. 1934; reel 11. Johnston had gone out to the Cabell home several times, since in midsummer 1933 it was "blanketed with trees," and later

because she could not do the interiors when residents were home (see 31 Oct. 1933; reel 11).

22. Johnston had a network of friends at the U.S. Parks Service and the Department of the Interior. On Peterson, see Peterson to Johnston, 16 Mar. 1934; reel 11.

23. By all accounts, she was meticulous about reassembling owners' belongings.

24. Kavanaugh, *Making Histories in Museums.* The term "dream space" is from Sheldon Annis's article.

25. Johnston to Dombrower, 6 June 1935; reel 12.

26. See her "Memo. of *GOODS ON CONSIGNMENT,*" reel 28, for a typical list of items and an idea of her markup.

27. See Arthur Grey to Johnston, 25 Sept. 1935; reel 12. She had sent him some pre-Revolutionary bricks that she had liberated.

28. See Johnston to Lorraine, 16 Dec. 1935; reel 12.

29. Coe to Johnston, 10 Aug. 1935; reel 12.

30. Bowman to Johnston, 9 June 1939; reel 14. "I opened all the mail, and unfortunately, a personal letter to you from your special boyfriend—which *I did not read*—realizing in a flash what I had done."

31. See Johnston to Frances Dean ("Francie"), 5 Dec. 1941; reel 15.

32. See notes on reel 37.

33. She refers to the cost overrun (50 percent) in her letter of 7 Feb. 1937 to Dr. Leland; reel 12. The problem may have been Ruff's arrest for vehicular homicide, which would have meant she needed to hire another driver.

34. Merriam to Chatelain, 14 Jan. 1937; reel 12. The burial-ground photo, a surreal landscape of strewn bones, is LC J7 Fla-1075.

35. Re Burckhardt, see correspondence c. May 1939; reel 14.

36. Holland quoted in Harry Haller, "A Magic Shadow Box in Maryland," *Baltimore Sun,* 8 Aug. 1932; reel 37.

37. See Johnston's letter (n.d.) to Miss Ford, who had written in the *Washington Post* concerning H.A.B.S.; reel 19.

38. See "School Children Give Some Amusing Answers in Contest," *Charleston Evening Post,* 19 Nov. 1937; reel 29.

39. Harnett Kane, "New Orleans Architecture Is Being Saved in Pictures," *New Orleans Sunday Item-Tribune,* 22 May 1938; reel 29.

40. Quoted in ibid.

41. Andreassen, "Frances Benjamin Johnston and Uncle Sam," reprints some of Johnston's photos.

42. See Heyward, "Dock Street Theatre," pp. 11–15; reel 35.

43. See Glasgow to Johnston, 19 Apr. 1936; reel 13.

44. See Academy to Johnston, 16 Sept. 1936; reel 12.

45. See Marsh to Lorraine, 18 Mar. 1937 and 21 Feb. 1939; both Reel 13.

46. Johnston to Scott, 24 June 1939; reel 14.

47. *Birmingham Post,* 9 May 1939; reel 37.

48. Gamble to McCartney, 16 Dec. 1939; reel 14.

49. See Johnston to Dearing, 6 Jan. 1940, and Cobb to Johnston, 25 Jan. 1940; both reel 14.

50. See Laughlin to Johnston, 6 Sept., and Scaife to Johnston, 27 Sept. 1940; reel 14.

51. Johnston to Pellicer, 1 Dec. 1940; reel 14. She considered some romantic wrecks before she abandoned the idea. Given the upcoming war shortages, it would have been a bad time to buy anything that needed repair.

52. Johnston's memo to Waterman, June 1942; reel 15.

53. See Johnston to Coleman, 22 July 1942; reel 15.

54. Johnston to Waterman ("T. W."), 15 Aug. 1942; reel 15.

55. See the unidentified newspaper fragment, "Take Pictures of N. and W. Installations" (incorrectly identified by cataloger as c. 1930s); reel 29; see also a note in "The Cupola," *Norfolk and Western Magazine,* Sept. 1942; reel 34.

56. Johnston to Internal Revenue Service, 12 Jan. 1945; reel 15. She was explaining her big contracts in 1944.

57. See letters from Johnston to Jones, 4 Sept. 1944 and following; reel 15.

7. The "Octo-Geranium" Puts Down Roots: New Orleans, 1945–1952

1. See Johnston to Miss Carrie of Gray Gables, n.d. (c. 1948); reel 16.

2. Johnston to Edna Gordon, 3 Jan. 1946; reel 16.

3. Johnston to Ward, n.d.; reel 19 (the miscellany files).

4. Johnston to "Milby," 20 May 1950; reel 16.

5. She cited various rents, depending on whom she was describing it to.

6. See Johnston to Jones, 14 Aug. 1947; reel 16. It's full of typos and ends with this postscript: "P.S. I think I ought to fire my typist, but I cant unless I get irrutated enough to commit auto da fe." For the reference to the "catagory," see Johnston's letter of 24 Dec. 1946; reel 16.

7. Doris Lockerman, "Save Architecture, Photographer Pleads," *Atlanta Constitution,* 4 May 1948; reel 29.

8. Johnston to "Miss Wise Penny," 8 Sept. 1948; reel 16. The allegation of abusiveness is Johnston's.

9. The lawyers notified Mills on 4 Jan. 1951, and the package was received in New Orleans by 3 Feb. 1951. See reel 16.

10. Johnston to Grames, 27 Jan. 1950; reel 16.

11. Compare the will dated 16 Aug. 1950 with the revised one dated 17 Aug. 1950; reel 37.

12. For background on Whitesell, see Anne Peterson, "Louisiana Photography: An Historical Overview 1880–1940," in Mhire, *A Century of Vision.*

13. *Times Picayune New Orleans States,* 3 Sept. 1949; reel 29.

14. *Times Picayune New Orleans States Magazine,* 2 Nov. 1947; reel 37.

15. Lockerman, "Save Architecture, Photographer Pleads," *Atlanta Constitution,* 4 May 1948; reel 29.

16. *Life,* 25 Apr. 1949, and research for the article; reel 16.

17. A clipping in Johnston's papers quotes Mattie Hewitt as having very similar views. Of the early days of photography, Hewitt says, "We didn't have an endless variety of screens, filters and paraphernalia when I started out. We had the simplest sort of equipment. . . ." Modern day "hobby cameraphiles," she went on, sometimes had whole studios full of tools and appliances but did very little actual picture-taking. Hewitt added that she did not even bother to look through the camera lens sometimes. She just directed her assistant once she knew the scene was composed as she wanted. (Margaret

Warren Foote, "Famous Faces and Places Clicked by Camera Expert," *Christian Science Monitor,* n.d.; reel 30.)

18. The University of North Carolina has maintained its interest in Johnston's work. Its Visual Arts Center has available a traveling exhibition of architectural photographs by Bayard Wooten and Frances Benjamin Johnston, titled, "I Won't Take a Picture unless the Moon Is Right."

19. Johnston to Ward, 18 Aug. 1950, titled "Off the Record—Absolutely Confidential"; reel 16. While Johnston's 1950 correspondence often refers to the hospital event as a recent one, it actually occurred in October 1949.

20. Johnston to Ward, 16 Oct. 1949; reel 16.

21. All the wills are on reel 37. One is reminded of that standard film-noir plot in which the "personable" young doctor helps the old lady die a little faster so he can pocket her money. Whether St. Martin acted unscrupulously as her executor or as her doctor is simply unknowable. The St. Martins were an old New Orleans family, and the doctor who attended Johnston had a young son at the time who grew up to be a doctor also (although he remembers nothing about his father and Johnston).

22. Johnston to Lapeyre, 9 Oct. 1950.

23. If there was a later will, it is not with the rest of her papers. John Andreassen has already died, as has Dr. St. Martin, so this question cannot be easily resolved.

24. Notes on reel 37 give this asset total.

25. A corrected death notice added that she was taken to Memphis for cremation and then to Washington for burial (*Times Picayune New Orleans States,* 18 May 1952).

Concluding Thoughts

1. It is tempting to interpret Johnston's self-portraits in male clothes and fake mustache as a statement of her sexual preference, but we know from Banta, *Imaging American Women,* that cross-dressing was a common experiment in the 1890s–1900s. Indeed, Johnston's files have pictures of a number of subjects in drag or in blackface. See Banta, p. 280.

2. See Faderman, *Surpassing the Love of Men.*

3. See Sandweiss, *Laura Gilpin;* McCabe, *Clara Sipprell;* and Novotny, *Alice Austen's World.*

4. What little is now known of Hewitt post-Johnston, does not include any marriages. Jessie Tarbox Beals and her husband shared Hewitt's darkroom in St. Louis and moved to Manhattan in 1905. The same year Hewitt split up with Johnston, Beals left her husband. With Beals was the baby girl she'd conceived with another man . . . a girl who later went to work in Hewitt's New York studio. See Alland, *Jessie Tarbox Beals.*

5. See C. Duncan, "Virility and Domination."

6. For this definition of the colonial revival movement, see Green, "Looking Backward to the Future," pp. 1–16.

7. See Glenn and Rice, *Frances Benjamin Johnston.*

8. For this point of view, see Stange, *Symbols of Ideal Life.*

9. See San Francisco Museum of Art, *Women of Photography.* They estimate that the Hampton exposures, for example, were about twenty seconds long.

10. After the 1910s, Johnston took most people out of her frames anyway, except for close friends.

Bibliography

Adams, William Howard. *Atget's Gardens.* New York: Doubleday, 1979.

Alland, Alexander, Sr. *Jessie Tarbox Beals: First Woman News Photographer.* New York: Camera/Graphic Press, Ltd., 1978.

Anderson, James D. *The Education of Blacks in the South, 1860–1935.* Chapel Hill: University of North Carolina Press, 1988.

Andreassen, John C. L. "Frances Benjamin Johnston and Her Views of Uncle Sam." *Louisiana History* 1.2 (spring 1960): 130–36.

Axelrod, Alan. *The Colonial Revival in America.* New York: Norton, 1985.

Banta, Martha. *Imaging American Women: Idea and Ideals in Cultural History.* New York: Columbia University Press, 1987.

Barnet, Sylvan. *A Short Guide to Writing about Art.* 2d ed. Boston: Little Brown, 1985.

Baxter, Annette K., with Constance Jacobs. *To Be a Woman in America 1850–1930.* New York: Times Books, 1978.

Beaux, Cecilia. *Background with Figures.* Boston: Houghton Mifflin, 1930.

Benstock, Shari. *No Gifts from Chance: A Biography of Edith Wharton.* New York: Scribners, 1994.

———. *Women of the Left Bank: Paris, 1900–1940.* Austin: University of Texas Press, 1986.

Blatti, Jo, ed. *Past Meets Present: Essays about Historic Interpretation and Public Audiences.* Washington, D.C.: Smithsonian Institution Press, 1987.

Bloemink, Barbara J. *The Life and Art of Florine Stettheimer.* New Haven, Conn.: Yale University Press, 1995.

Boffin, Tessa, and Jean Fraser, eds. *Stolen Glances: Lesbians Take Photographs.* London: Pandora, 1991.

Brady, Kathleen. *Ida Tarbell.* New York: Seaview/Putnam, 1984.

Brock, Henry Irving, with photographs by Frances Benjamin Johnston. *Colonial Churches in Virginia.* Richmond, Va.: Dale Press, 1930.

Brown, Julie K. *Contesting Images: Photography and the World's Columbian Exposition.* Tucson: University of Arizona Press, 1994.

———. "Recovering Representations: U.S. Government Photographers at the World's Columbian Exposition Chicago 1893." *Quarterly of the National Archives and Records Administration* 29.3 (fall 1997): 219–32.

Butler, Nicholas, ed. *Education in the United States.* Albany, N.Y.: Lyon and Co., 1900.

Chadwick, Whitney. *Women, Art, and Society.* London: Thames and Hudson, 1990.

Christy, Howard Chandler. *The American Girl.* 1906. Reprint, New York: Da Capo, 1976.

Clarke, Graham. *The Photograph.* Oxford: Oxford University Press, 1997.

Close, Leslie Rose, curator. *Portrait of an Era in Landscape Architecture: The Photographs of Mattie Edwards Hewitt.* Exhibition catalog, Wave Hill. Bronx, New York, 1983.

Cogan, Frances B. *All-American Girl: The Ideal of Real Womanhood in Mid–Nineteenth-Century America.* Athens: University of Georgia Press, 1989.

Cosentino, Andrew, and Henry Glassie. *The Capital Image: Painters in Washington, 1800–1915.* Washington, D.C.: Smithsonian Institution Press, 1983.

Dahl-Wolfe, Louise. *A Photographer's Scrapbook.* New York: St. Martin's, 1984.

Daniels, Pete, and Raymond Smock. *A Talent for*

Detail: The Photographs of Miss Frances Benjamin Johnston, 1889–1910. New York: Harmony Books, 1974.

Davidov, Judith Fryer. *Women's Camera Work: Self/Body/Other in American Visual Culture.* Durham, N.C.: Duke University Press, 1998.

Davidson, James, and Mark Lytle. *After the Fact: The Art of Historical Detection.* New York: Knopf, 1982.

de Caro, Frank. *Folklife in Louisiana Photography: Images of Tradition.* Baton Rouge: Louisiana State University Press, 1990.

Department of Photographic Art, World Colombian Exposition. *Official Views of the World's Columbian Exposition.* Chicago: Chicago Photo-Gravure Co., 1893.

Dimock, Arthur. "The South and Its Problems." *Metropolitan Magazine* 27 (Oct. 1907): 1–11.

Diverse Images: Photographs from the New Orleans Museum of Art. New York: Amphoto, 1979.

Doherty, Amy. "Frances Benjamin Johnston, 1864–1952." *History of Photography* 4.2 (Apr. 1980): 97–111.

Doherty, Jonathan, ed. *Women at Work: 153 Photographs by Lewis W. Hine.* New York: Dover, 1981.

Du Bois, W. E. B. "The American Negro at Paris." *American Monthly Review of Reviews* 22.5 (Nov. 1900): 575–77.

Dulles, Foster Rhea. *Americans Abroad: Two Centuries of European Travel.* Ann Arbor: University of Michigan Press, 1964.

Duncan, Carol. "Virility and Domination in Early Twentieth Century Vanguard Painting." In *Feminism and Art History: Questioning the Litany,* ed. Mary Broud and Mary Garrard. New York: Harper and Row, 1982.

Duncan, D., et al. *Life into Art: Isadora Duncan and Her World.* New York: Norton, 1993.

Dwight, Eleanor. *Edith Wharton: An Extraordinary Life.* New York: Harry Abrams, 1994.

Eisler, Benita. *O'Keeffe and Stieglitz: An American Romance.* New York: Doubleday, 1991.

Faderman, Lillian. *Surpassing the Love of Men.* New York: Morrow, 1981.

Fern, Alan, et al. *Viewpoints: The Library of Congress Selection of Pictorial Treasures.* New York: Arno Press, 1975.

Fryer, Judith. "Women's Camera Work: Seven Propositions in Search of a Theory." *Prospects: An Annual of American Culture Studies* 16 (1991): 57–117.

Genthe, Arnold. *Isadora Duncan: Twenty-four Studies.* New York: Kennerley, 1929.

Glenn, Constance, and Leland Rice. *Frances Benjamin Johnston: Women of Class and Station.* Long Beach: Long Beach Art Museum and Galleries, California State University, 1979.

Goldberg, Vicki. *Margaret Bourke-White: A Biography.* New York: Harper and Row, 1986.

Gover, C. Jane. *The Positive Image: Women Photographers in Turn of the Century America.* Albany: State University of New York Press, 1988.

Green, Harvey. "Looking Backward to the Future: The Colonial Revival and American Culture." In *Creating a Dignified Past: Museums and the Colonial Revival,* ed. Geoffrey Rossano. Savage, Md.: Rowman and Littlefield, 1991.

Greenhalgh, Paul. *Ephemeral Vistas: The Expositions Universelles, Great Exhibitions and World's Fairs, 1851–1935.* Manchester, U.K.: Manchester University Press, 1988.

Grover, Jan Zita. "Dykes in Context: Some Problems in Minority Representation." In *The Contest of Meaning: Critical Histories of Photography,* ed. Richard Bolton. Cambridge, Mass.: MIT Press, 1989, 1993.

Guimond, James. *American Photography and the American Dream.* Chapel Hill: University of North Carolina Press, 1991.

Gwaltney, Janet, ed. *The Carnegie Survey of the Architecture of the South, 1927–1943.* Photographs by Frances Benjamin Johnston. Microfiche. Teaneck, N.J.: Chadwyck-Healey, 1985.

Hahn, Emily. *Romantic Rebels: An Informal History of Bohemianism in America.* Boston: Houghton Mifflin, 1967.

Hales, Peter. *Silver Cities: The Photography of American Urbanization, 1839–1915.* Philadelphia: Temple University Press, 1984.

Harlan, Louis R., et al., eds. *The Booker T. Washington Papers.* Urbana: University of Illinois Press, 1972–1979.

Harris, Ann Sutherland, and Linda Nochlin. *Women Artists, 1550–1950.* New York: Knopf, 1981.

Henkes, Robert. *Portraits of Famous American*

Women: An Analysis of Various Artists' Renderings of Thirteen Admired Figures. Jefferson, N.C.: McFarland and Co., 1997.

Heron, Liz, and Val Williams, eds. *Illuminations: Women Writing on Photography from the 1850s to the Present.* London: I. B. Tauris, 1996.

Heyward, Du Bose, with photographs by Frances Benjamin Johnston. "Dock Street Theatre." *Magazine of Art* 13.1 (Jan. 1938): 11–15.

Hine, Lewis. *Men at Work: Photographic Studies of Modern Men and Machines.* New York: Macmillan, 1932; Dover, 1977.

Homer, William. *A Pictorial Heritage: The Photographs of Gertrude Kasebier.* Exhibition catalog, Delaware Art Museum and Brooklyn Museum. Newark and Wilmington, Del., 1979.

Hosmer, Charles B. "The Broadening View of the Historical Preservation Movement." In *Material Culture and the Study of American Life,* ed. I. Quimby. New York: Norton, 1978.

———. *Presence of the Past: A History of the Preservation Movement in the United States before Williamsburg.* New York: G. P. Putnam's, 1965.

James, Jacqueline. "Uncle Tom? Not Booker T." *American Heritage* 19.5 (Aug. 1968): 50–63, 95–100.

Johnston, Frances Benjamin. "A Day at Niagara." *Demorest's,* Aug. 1893.

———. "The Evolution of a Great Exposition." *Demorest's,* Apr. 1892.

———. "The Foreign Legations at Washington." *Demorest's,* Apr.–July 1893.

———. "From the Depths of a Crystallized Sea." *Demorest's,* Feb. 1893.

———. "Mammoth Cave by Flashlight." *Demorest's,* June 1892.

———. "The New Tenants of the White House." *Ladies Home Journal,* Oct. 1897.

———. *Papers.* Shelf 18,597, with finding aids available, Manuscript Division, Library of Congress, Washington D.C.

———. "Small White House Orchids." *Demorest's,* June 1895.

———. "Some Homes under the Administration." *Demorest's,* July–Dec. 1890 (four parts).

———. "Students in the Art of War." *Illustrated American,* 23 June 1894.

———. "Through the Coal Mines with a Camera." *Demorest's,* Mar. 1892.

———. "Uncle Sam as Stamp-Maker." *Harper's Round Table,* 11 June 1895.

———. "Uncle Sam's Money." *Demorest's,* Dec. 1889–Jan. 1890.

———. "What a Woman Can Do with a Camera." *Ladies Home Journal,* Sept. 1897.

———. *The White House.* Washington, D.C.: Gibson Brothers Printers, 1893.

———. "The White House." *Demorest's,* May–June 1890.

Jussim, Estelle. *Slave to Beauty: The Eccentric Life and Controversial Career of F. Holland Day, Photographer, Publisher, Aesthete.* Boston: David Godine, 1981.

Kashey, Robert and Elizabeth. *The Julian Academy, Paris 1868–1939.* With essays by Catherine Fehrer. Exhibition catalog, Shepherd Gallery. New York, 1989.

Kavanaugh, Gaynor, ed. *Making Histories in Museums.* London: Leicester University Press, 1996.

Kling, Jean. *Alice Pike Barney: Her Life and Art.* Washington, D.C.: National Museum of American Art, 1994.

Knight, Kate Brannon. *History of the Work of Connecticut Women at the World Columbian Exposition.* Hartford, Conn.: The Hartford Press, 1898.

Lewis, Morris. "Paris and the International Exposition." *Colored American Magazine* 5 (Oct. 1900): 291–95.

LIFE. "Speaking of Pictures . . . These Are by a U.S. 'Court Photographer.'" *LIFE,* 25 Apr. 1949.

Lindsay, D. *Indians at Hampton Institute 1877–1923.* Urbana: University of Illinois Press, 1995.

Lockwood, Mary Smith. *Yesterdays in Washington.* Rosslyn, Va.: Commonwealth Company, n.d., but c. 1915.

Lowe, Sarah, ed. "Women in Photography," *History of Photography* 18.3 (fall 1994): 204–55.

Lowe, Sue Davidson. *Stieglitz: A Memoir/Biography.* New York: Farrar, Straus, Giroux, 1983.

Maddox, Jerald. "Essay on a Tintype." In *A Century of Photographs, 1846–1946,* ed. R. Shaw. Washington, D.C.: Library of Congress, 1980.

Mandell, Richard. *Paris 1900: The Great World's Fair.* Toronto: University of Toronto Press, 1967.

Marling, Karal Ann. *George Washington Slept Here: Colonial Revivals and American Culture 1876–1986*. Cambridge, Mass.: Harvard University Press, 1988.

McCabe, Mary Kennedy. *Clara Sipprell: Pictorial Photographer*. Fort Worth, Tex.: Amon Carter Museum, 1990.

Meltzer, Milton. *Dorothea Lange: A Photographer's Life*. New York: Farrar, Straus, Giroux, 1978.

Mhire, Herman, ed. *A Century of Vision: Louisiana Photography 1884–1984*. Lafayette, La.: University Art Museum, 1986.

Michaels, Barbara. *Gertrude Kasebier: The Photographer and Her Photographs*. New York: Harry Abrams, 1992.

———. "New Light on F. Holland Day's Photography of African Americans." *History of Photography* 18.4 (winter 1994): 334–47.

Middlestorb, Frances. *Frances Benjamin Johnston: What a Woman Can Do with a Camera*. Exhibition catalog, Library of Congress. Washington, D.C., 1984.

Milligan, Gladys. "The Society of Washington Artists." *Records of the Columbian Historical Society*, vols. 60–62. Washington, D.C.: Columbian Historical Society, pp. 282–89.

Mitchell, Margaretta. *Recollections: Ten Women of Photography*. New York: Studio Viking, 1979.

Moore, Clarence. "Women Experts in Photography." *Cosmopolitan* 14.5 (Mar. 1893): 580–90.

Morrison, Hugh. *Early American Architecture*. New York: Oxford University Press, 1952.

Morton, Brian. *Americans in Paris: An Anecdotal Street Guide*. Ann Arbor, Mich.: Olivia and Hill Press, 1984.

Moutessamy-Ashe, Jeanne. *Viewfinders: Black Women Photographers*. New York: Dodd, Mead and Co., 1986.

Naef, Weston. *The Collection of Alfred Stieglitz: Fifty Pioneers of Modern Photography*. New York: Studio Viking, 1978.

National Archives. *The American Image: Photographs from the National Archives, 1860–1960*. New York: Pantheon Books, 1979.

Nichols, Frederick Doveton. *The Architecture of Georgia*. Savannah, Ga.: Beehive Press, 1976.

———. *The Early Architecture of Georgia with a Pictorial Survey by Frances Benjamin Johnston*. Chapel Hill: University of North Carolina Press, 1957.

Niven, Penelope. *Steichen: A Biography*. New York: Clarkson Potter, 1997.

Novotny, Ann. "Alice Austen's World." *Heresies* 3 (fall 1977): 27–33.

———. *Alice Austen's World: The Life and Photography of an American Original: Alice Austen, 1866–1952*. Old Greenwich, Conn.: Chatham Press, 1976.

O'Connor, Diane Vogt. *Guide to Photographic Collections at the Smithsonian Institution: National Museum of American History*. Washington, D.C.: Smithsonian Institution Press, 1989.

Paris-Hachette 1900 Guide Pratique du Visiteur de Paris et de l'Exposition.

Peabody, Francis Greenwood. *Education for Life: The Story of the Hampton Institute*. Garden City, N.Y.: Doubleday Page, 1918; College Park, Md.: McGrath, 1969.

Pector, M. *Congrès International de Photographie: Proces-Verbaux, Rapports, Notes, et Documents Divers*. Paris: Gauthier-Villars, 1901.

Peterson, A. E. "Frances Benjamin Johnston: Crusader with a Camera." *Historic Preservation* 32.1 (Jan.–Feb. 1980): 17–20.

Peterson, Christian. *Alfred Stieglitz's Camera Notes*. New York: Norton; Minneapolis, Minn.: Minneapolis Institute of the Arts, 1993.

Pieterse, Jan. *White on Black: Images of Africa and Blacks in Western Popular Culture*. New Haven, Conn.: Yale University Press, 1992.

Pratt, Richard Henry. *Battlefield and Classroom: Four Decades with the American Indian 1867–1904*. Edited with an introduction by Robert Utley. Lincoln: University of Nebraska Press, 1964.

Przyblyski, Jeannene. "American Visions at the Paris Exposition, 1900: Another Look at Frances Benjamin Johnston's Hampton Photographs." *Art Journal* 57.3 (fall 1998): 60–68.

Quimby, Ian M. G. *Material Culture and the Study of American Life*. New York: Norton, 1978.

Rappaport, Doreen. *The Flight of Red Bird: The Life of Zitkala-Sa*. New York: Dial Books, 1997.

Rathbone, Belinda. *Walker Evans*. New York: Houghton Mifflin, 1995.

Root, Nina J. "Portraits of Tuskegee." *Natural History,* Feb. 1997.

Rosenblum, Naomi. *A History of Women Photographers*. New York: Abbeville, 1994.

Saarinen, Aline. *The Proud Possessors: The Lives, Times and Tastes of Some Adventurous American Art Collectors*. New York: Vintage Books, 1958, 1968.

Sandweiss, Martha. *Laura Gilpin: An Enduring Grace*. Fort Worth, Tex.: Amon Carter Museum, 1986.

San Francisco Museum of Art. *Women of Photography: An Historical Survey*. San Francisco: San Francisco Museum of Art, 1975.

Schwartz, Judith. *Radical Feminists of Heterodoxy: Greenwich Village, 1912–1940*. Norwich, Vt.: New Victoria Press, 1986.

Seroff, Victor. *The Real Isadora*. New York: Dial Press, 1971.

Shaw, Albert. "Learning by Doing at Hampton." *American Monthly Review of Reviews* 21.4 (Apr. 1900): 417–32.

Shaw, Renata. *A Century of Photographs 1846–1946*. Washington, D.C.: Library of Congress, 1980.

Smith, Bonnie G. *The Gender of History: Men, Women, and Historical Practice*. Cambridge, Mass.: Harvard University Press, 1998.

Sontag, Susan. *On Photography*. New York: Delta, 1973, 1977.

Southern Workman and Hampton School Record 29.1 (Jan. 1900). (See report titled "Every Day Affairs.")

Stange, Maren. *Symbols of Ideal Life: Social Documentary Photography in America 1890–1950*. Cambridge, U.K.: Cambridge University Press, 1989.

Stephens, Autumn. *Wild Women*. Berkeley, Calif.: Conari Press, 1992.

Stoney, Samuel, with photographs by Frances Benjamin Johnston. *Plantations of the Carolina Low Country*. Charleston, S.C.: Carolina Art Association, 1938, 1945.

Sullivan, Constance, ed. *Women Photographers*. New York: Harry Abrams, 1990.

Torre, Susana, ed. *Women in American Architecture: A Historic and Contemporary Perspective*. New York: Whitney Library of Design, 1977.

Trachtenberg, Alan. *Reading American Photographs: Images as History, Matthew Brady to Walker Evans*. New York: Hill and Wang, 1989.

Tucker, Ann, ed. *The Woman's Eye*. New York: Knopf, 1973.

Vanderbilt, Paul. "Frances Benjamin Johnston." *Journal of the American Institute of Architects* 18.11 (Nov. 1952): 224–28.

Van Nimmen, Jane. "F. Holland Day and the Display of a New Art: Behold It Is I." *History of Photography* 18.4 (winter 1994): 368–82.

Vestal, David. *The Craft of Photography*. New York: Harper and Row, 1975.

Via, Marie, and Marjorie Searl, eds., *Head, Heart and Hand: Elbert Hubbard and the Roycrofters*. Rochester, N.Y.: University of Rochester Press, 1994.

Waller, Susan. *Women Artists in the Modern Era: A Documentary History*. Metuchen, N.J.: Scarecrow Press, 1991.

Washington, Booker T., ed. *Tuskegee and Its People: Their Ideals and Achievements*. New York: Appleton, 1906.

———, with illustrations by Frances Benjamin Johnston. *Working with the Hands*. New York: Doubleday, 1904; New York: Negro Universities Press, 1969.

Waterman, Thomas, with photographs by Frances Benjamin Johnston. *Dwellings of Colonial America*. Chapel Hill: University of North Carolina Press, 1950.

———, with photographs by Frances Benjamin Johnston. *The Early Architecture of North Carolina*. Chapel Hill: University of North Carolina Press, 1941, 1947, 1959.

———, with photographs by Frances Benjamin Johnston. *The Mansions of Virginia*. Chapel Hill: University of North Carolina Press, 1946.

Watts, Jennifer A. "Frances Benjamin Johnston: The Huntington Library Portrait Collection." *History of Photography* 19.3 (fall 1995): 252–62.

Weinberg, H. Barbara. *The Lure of Paris: Nineteenth Century American Painters and Their French Teachers*. New York: Abbeville, 1991.

Weisberger, Bernard, and the eds. of Time-Life

Books. *The District of Columbia.* New York: Time-Life, 1968.

West, Rebecca. *1900.* New York: Studio Viking, 1982.

Westcott, Edith, with photographs by Frances Benjamin Johnston. *The New Education Illustrated.* Richmond, Va.: B. F. Johnson, 1900.

Wexler, Laura. "Black and White and Color: American Photographs at the Turn of the Century." *Prospects: An Annual of American Culture Studies* 13 (1988): 341–90.

Wharton, Edith. *Italian Villas and Their Gardens.* 1904; New York: Da Capo, 1976.

Whelan, Richard. *Alfred Stieglitz: A Biography.* Boston: Little, Brown, 1995.

———. *Double Take: A Comparative Look at Photographs.* New York: Clarkson Potter, 1981.

———. *Robert Capa: A Biography.* New York: Knopf, 1985.

Willis, Deborah, ed. *Picturing Us: African American Identity in Photography.* New York: New Press, 1994.

Willis-Thomas, Deborah. *Black Photographers, 1840–1940: An Illustrated Bibliography.* New York: Garland, 1985.

Withers, Josephine. *Women Artists in Washington Collections.* College Park: University of Maryland Art Gallery, 1979.

Index

Italicized page numbers refer to illustrations

Designer and typesetter: Gary Gore
Text and display type: ITC Berkeley
Printer and binder: Thomson-Shore, Inc.
Paper: 70 pound Fortune Matte